The Undersea World of
WYLAND

*"I think that anybody
who has spent a lot of time in the water,
especially diving, understands this great feeling
you get, like being born again."*

—*Wyland*

The Undersea World of

WYLAND

FOREWORD BY SYLVIA A. EARLE

TIME®
LIFE
BOOKS

Time-Life Books is a division of Time Life Inc.

TIME LIFE INC.
PRESIDENT AND CEO: George Artandi

TIME LIFE BOOKS
PRESIDENT: Stephen R. Frary

TIME-LIFE CUSTOM PUBLISHING

VICE PRESIDENT AND PUBLISHER	Terry Newell
Vice President of Sales and Marketing	Neil Levin
Editor	Linda Bellamy
Director of Design	Christopher M. Register
Production Manager	Carolyn Clark
Quality Assurance Manager	James D. King

First printing. Printed in China.

TIME-LIFE is a trademark of Time Warner Inc. U.S.A.

Library of Congress Cataloging-in-Publication Data
Wyland, 1956–
 The undersea world of Wyland/foreword by Sylvia Earle.
 p. cm.
 ISBN 0-7370-0007-4
 1. Wyland, 1956– —Themes, motives. 2. Whales in art.
3. Dolphins in art. 4. Marine art—United States. I. Title.
N6537.W94A4 1998
759.13—dc21 98-16906
 CIP

THE UNDERSEA WORLD OF WYLAND was prepared by:
 Lionheart Books, Ltd.
 5105 Peachtree Industrial Boulevard
 Suite 250
 Atlanta, Georgia 30341

 Design: Carley Wilson Brown

Books produced by Time-Life Custom Publishing are available at a special bulk discount for promotional and premium use. Custom adaptations can also be created to meet your specific marketing goals. Call 1-800-323-5255.

TABLE OF CONTENTS

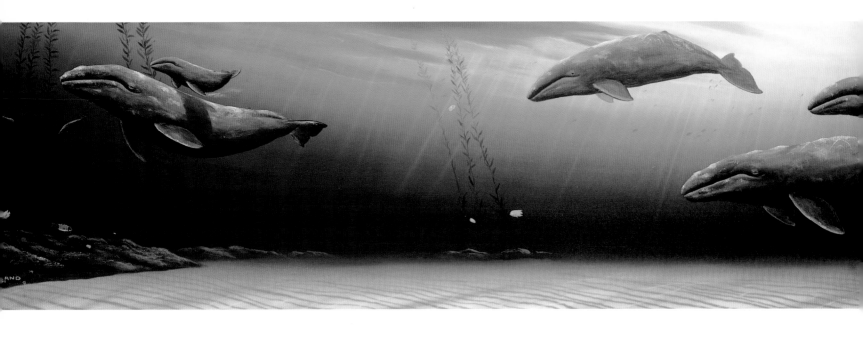

"Unless someone like you cares a whole awful lot,
nothing is going to get better.
It's not."

—*Dr. Seuss,* THE LORAX

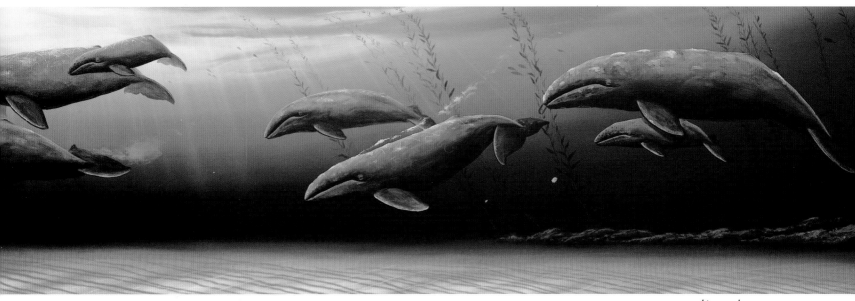

ANNUAL MIGRATION (*diptych*)

*This book is dedicated to my hero Jacques-Yves Cousteau
who early on instilled in me a passion for the marine environment and
all life in the sea.*

*Like most proud sons I would like to thank my mom, Darlene,
who raised me and my brothers Steve, Bill, and Tom, and my dad, Bob—
all of whom have supported my efforts to this day.*

*I would also like to thank Angela Eaton and my crew, Team Wyland,
along with Michael Reagan for believing in me and creating this beautiful book.*

*Thank you to my supporters throughout the world for allowing me to share
the beauty of the sea through my art.*

It is my hope that this book in some way will make a difference.

WYLAND

"Perhaps with knowing will come caring,
and with caring, impetus toward the needed sea change in attitude,
one that combines the wisdom of science and the sensitivity of art
to create an enduring ethic."

—*Sylvia A. Earle,* SEA CHANGE

FOREWORD

by Sylvia A. Earle

Driving to Boston after a meeting in Woods Hole about whales in 1993, my thoughts were far away—underwater, in fact, where I had first encountered humpback whales eye to eye in 1977. That year, whale biologist Roger Payne, underwater photographer Al Giddings, and I, marine scientist and enthusiast for anything wild and wet, had convinced several institutions to support an idea we all shared: to get to know whales underwater, to try to correlate their mysterious sounds and songs with behavior we might observe and document. My personal dream was to emulate Jane Goodall's approach to learning about chimpanzees—to be with the whales on their own terms, and get to know *individuals* over many months and years. Then came the reality.

Five whales approached the small rubber boat where I perched, more than a mile off the coast of Lahaina, Hawaii. They swam upside down, cruising by as gracefully as swallows. A moment later, I was in the water. Looming far below but fast approaching was the largest creature I had ever seen . . . a plump whale, now 50 feet away, then 30 feet and closing. It seemed I was about to make colossal contact with a creature 800 times my size. One moment, all I could see was a massive black head and huge flippers; then, in a blur, the whale swept by. She tilted her great eye slightly as she passed, enough to suggest that her approach had been intentional. I had come to Hawaii to observe the whales, and, in the first of numerous encounters, discovered that the term "whale watching" has a double meaning.

Recalling such times enlivens boring meetings, long waits at checkout counters, and the monotony of traffic jams—such as the one I was now trapped in, when, suddenly, my day-dreaming took shape. Dead ahead I could see whales, not drifting across my mind's eye, but *right there in front of me!* I laughed out loud, realizing then that what I beheld was a giant painting splashed across the Summerfield building, 12^1/$_2$ stories high, 120 feet wide, arising like a humungous Rene Magritte rendition amid gray buildings and traffic. Wyland, that dashing young artist with a flying brush, had been at it again.

I had already been captivated by the Wyland magic, having seen his life-sized portrayals of marine life on walls in Hawaii, southern California, Seattle, and Vancouver, and was aware that he had been making a tremendous difference in sensitizing people to the nature of creatures that few have had a chance to meet personally. I had not yet met that would-be marine mammal, Wyland, above the ocean or below, but already respected him as a friend of the ocean and therefore a

friend of mine, one who took pains not only to interpret the spirit of the sea as only an artist can, but also to portray *individual* whales. In Vancouver, he paid an eloquent whale-sized tribute to the A-30 pod of orcas and, in Seattle, the notorious J-pod. Now on the Boston wall, was an enduring image of Salt, a humpback whale known for more than twenty years at Stellwagen Bank off the coast of Massachusetts by distinctive tail markings and a salty white patch on her dorsal fin. It was inexpressibly satisfying to see whales alive being celebrated in a city where fortunes had once been made by catching and killing these now-endangered ocean giants.

Though protected by an international moratorium since 1981, populations of many of the great whales are but a fraction of what they were before commercial whaling operations decimated them. Harvard biologist E. O. Wilson remarks that, over the ages, as human population expanded and spread, "mankind soon disposed of the large, the slow, and the tasty." In North America, more than seventy percent of the large mammal genera that existed at the time human hunter-gatherers crossed the Bering Strait from Siberia are now extinct.

The historic pattern of annihilation of large land mammals has been reenacted recently with the nine species of great whales and their cousins, more than fifty kinds of "small" dolphins, whales, and porpoises. Seals, sea lions, and many kinds of fish, from tuna and swordfish to the once-common cod, capelin, halibut, and haddock have been swiftly reduced to frighteningly low levels, victims of relentless high-tech methods applied to finding and taking ocean wildlife by a single species: a voracious, primate predator. Entire ecosystems are also at risk, including coral reefs and kelp forests, places some rightly refer to as the "rainforests of the sea" because of the extraordinary abundance and diversity of life they host.

Part of the problem relates to the millions of tons of ocean wildlife taken out of the sea every year for food, fertilizer, and other products, often using methods that can be likened to capturing squirrels and songbirds with a bulldozer. Other stresses to ocean health relate to noxious substances we put into the sea—airborne pollution, coupled with herbicides and other biocides, excess fertilizer, debris, and other materials that are dumped or flow via rivers and groundwater into the sea. But far and away the greatest threat to the sea, and thus to the state of earth's life-support system—and the future of humankind—is *ignorance*.

The good news is that there is growing public awareness that the ocean is vital to human survival and well-being. Climate, weather, temperature, and basic planetary chemistry are shaped by the sea, and it is also home for most of life on earth. It is, in short, the life-support system not just for turtles, fish, dolphins, and whales, but for the rest of life on earth as well—humankind very much included. Marine mammals generally, and whales in particular, have become poignant and eloquent symbols of ocean health.

A fateful meeting took place in 1971 between a small group of California gray whales and the young Robert Wyland, who was soon to become an effective ambassador for their kind—and for the oceans as a whole. Ten years later, he memorialized that encounter with the first of dozens of now famous "Whaling Walls" that make hearts race—while stopping traffic—in cities all over the world.

I don't know how he does what he does, nor do I know exactly why, but I am among the millions of admirers, above the ocean and below, who is enriched, thrilled, inspired, and otherwise delighted that Wyland—a dashingly handsome Peter Pan with a disarming smile, stunning blue eyes, an extraordinary talent, and a way with whales, children, and all who are young at heart—has chosen his particular path.

Wyland has *tried* to explain something of "how" he goes about developing some of his creations. The bronze sculptures, for example, begin with a drawing then proceed to an original carving that then goes through months of foundry work—moldmaking, wax replicas, spruing, investment, de-waxing, casting, welding, and finally adding a distinctive finish. Paintings take far less time but draw on the same well-spring of

vision and inspiration, coupled with talent honed by years of experience. He says he considers himself a "sculptor who paints," perhaps one of the reasons his images are so convincing, so like the three-dimensional creatures who seem to swim right off of Wyland's canvas—or wall—and into the heart and mind of the observer. Of the one entitled "First Breath," a depiction of a mother whale lifting her calf to touch air for the first time, Wyland says, "When an image comes to me, I become obsessed to paint it, and this one actually painted itself."

Wyland makes it sound easy: "Painting large murals is no big thing—you just have to have big brushes and lots of paint!" That and a dedicated crew who travels with you, shares the frustration of bad weather, agonizes over arrangements, packs and unpacks hundreds of pounds of gear, organizes the scaffolding, helps pressure wash the chosen surface, applies the two-part epoxy primer, and stands by, exhausted, as Wyland—who is involved with everything—applies different bands of color while beginning to visualize how large the surface is. He says, "I simply try not to think of the overall scale. The best way to explain how I paint is to envision a giant Polaroid photograph developing before your eyes . . . a mass of color slowly coming into sharp focus. While I'm standing on the scaffolding, in close proximity to the wall, my mind's eye is several blocks away looking at the entire mural."

I had a chance to watch him work his magic on two murals in San Francisco at Pier 39: one of two California gray whales spyhopping and a second where a mother and calf seem to swim around the corner of a building bathed in what Wyland calls, "that sweet light from the afternoon sun. It's as if the viewer and the whales are sharing the same sunset."

He suggests that in the early stages, the murals look like "big mistakes," pointing out that the public would never see an unfinished canvas in an artist's studio. But when painting a giant mural, every move is scrutinized. Many would shrink from the risk of ridicule, the challenge of "getting it right" while hundreds, often thou-

sands, watch as your vision takes form. Curiously, Wyland appears to tap into a crowd's energy. "The crazier it gets, the better I paint," he says. Roger Payne, observing a scene bursting with pressure and madness, said, "He seems to be the person having the most fun." But it's much more than just fun. Whale researchers Mark Ferrari and Debbie Glockner-Ferrari nail the substance of Wyland's underlying power: "He has been able to strike our collective consciousness with the truth of knowledge."

As to *why* Wyland does what he does, he says that after his first encounter in 1971, he became motivated to share his perspective on whales with others. Wyland saw whales as whales see whales, and obsessively devoured everything he could about them and other marine life. He says, "Something about the ocean and its creatures moved me to a higher level of consciousness. There's nothing comparable to swimming with whales and seeing and hearing them as they live and breathe . . . to be eye to eye with a humpback whale is the epitome of spirituality."

Cousteau made films and wrote books. Others take photographs. Some write, or sing or conduct research. Wyland paints, but he also conveys to an ever-widening audience his concern and passion for taking care of the natural systems that take care of us by involving us in spectacular, engaging, moving ways.

This is a time of pivotal, magnified significance for humankind. The fabric of life and the physical and chemical nature of the planet have been significantly altered through decisions already made by our predecessors and those now living; what happens next depends on what we do, or do not do, individually and collectively, in the next few decades. Will there or will there not be old-growth forests, coral reefs, manta rays, or manatees a century hence? Will the haunting songs of humpback whales still resonate in the vaulted chambers of the deep sea? If so, one individual who has surely helped make it so is Wyland, one who is driven by a dream that "yet unborn children will be able to see a great whale swimming free."

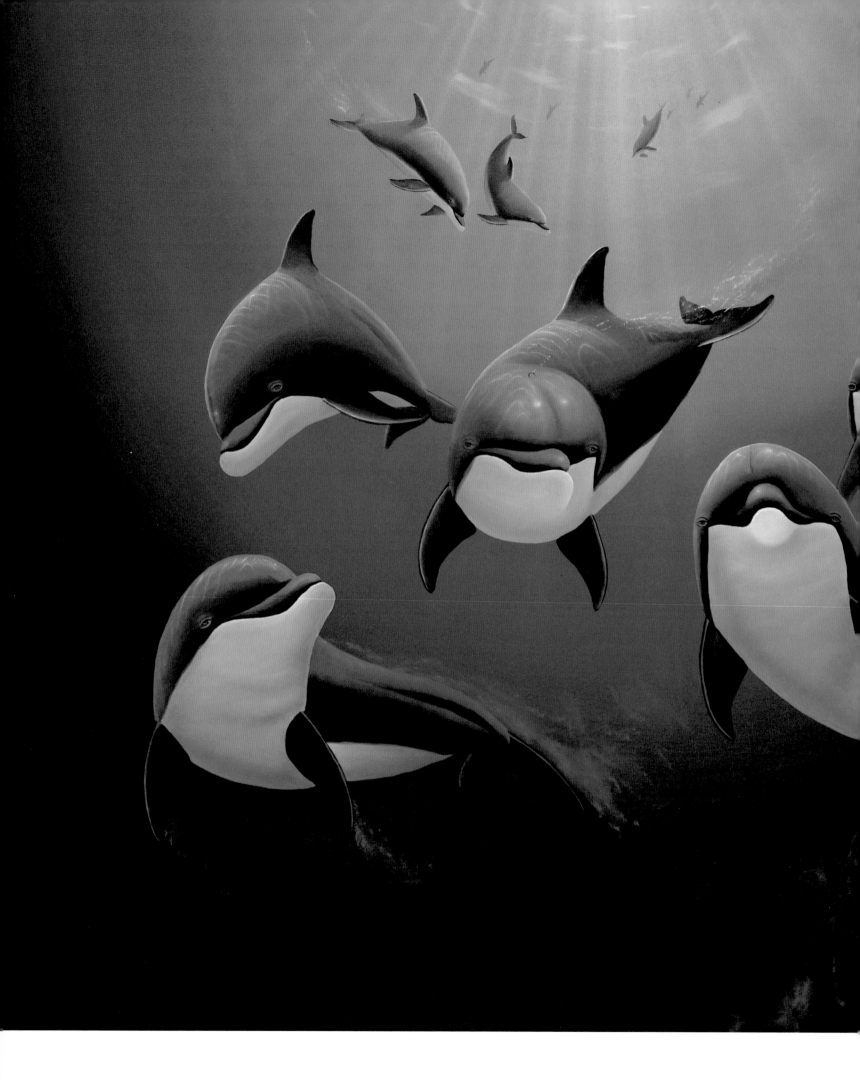

DOLPHIN LIFE II

"If you want
a lesson in beauty,
in harmony,
in balance,
just swim with
whales or dolphins."

—Wyland

*"I believe this is the signature
of my work—trying to reveal the spirit
of these beautiful animals."*

Until twenty years ago, mankind and these magnificent creatures of the sea remained essentially worlds apart. But now it's possible to enter the realm of the whales and the dolphins— to see how they move, how the light reflects on them, how they function in their own environment, how they live and relate to each other, and this, in turn, gives us a glimpse of their spirit. I believe this is the signature of my work—trying to reveal the spirit of these beautiful animals.

My first experience swimming with whales was on a perfect Maui day with 150-foot visibility . . . which means crystal clear water. Below us the ocean was deep blue, and we couldn't see the bottom. I dove down about ten feet and leveled off looking for what I expected to be their huge shapes. I was suspended in a pyramid of light cascading down into a laser-sharp point below me.

The first thing I noticed was the sound. It was the beautiful haunting song of the Humpback. It's hard to characterize . . . the most extraordinary sound . . . like nothing I had ever heard. I knew the whales were communicating with one another, and wondered if they were talking about us.

Suddenly something massive materialized before me, I realized it was a mother and her calf swimming straight toward me. At that moment I had to surface for air. My heart racing, I inhaled the fresh air and went right back down as fast as I could. The two whales were still there, not the least alarmed that, like them, I had to surface in

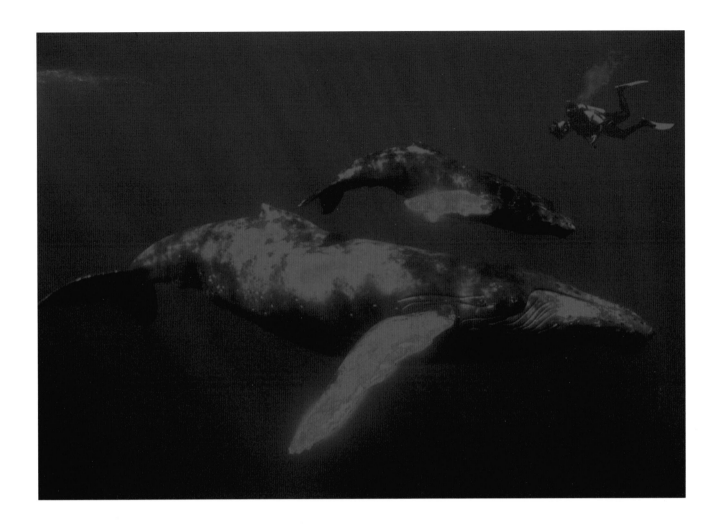

order to breathe. They slowly started swimming right over me. Despite their size they looked like dancers in a ballet, gliding in slow, graceful motions through the crystalline cathedral of light.

I was so entranced that I didn't realize I was swimming toward them as well. At the very last moment as we almost collided, the mother deftly raised her long flipper over my head to avoid hitting me. It was incredible . . . she was totally in tune with where I was and the distance between us. She appeared to have sensed that her awesome size could have damaged me, and went out of her way to dodge me.

It was mesmerizing to be that close to these great mammals. I could see both of them from head to tail, every detail, but the image that still burns in my memory was the eyes. I was probably fifty feet away from them when they first started swimming toward me. As they drew closer the great creature looked right into my eyes and into my soul. I felt like I was looking into her soul too, the soul of a very ancient being. I could see every detail of her eyes—all the colors. I wanted to stay down with them so badly that I almost forgot to breathe.

When I surfaced they swam past me, and I noticed a third whale, their escort, trailing behind and executing a beautiful bubble blow. It was a phenomenal learning experience. I remember being surprised by their great girth and oversize

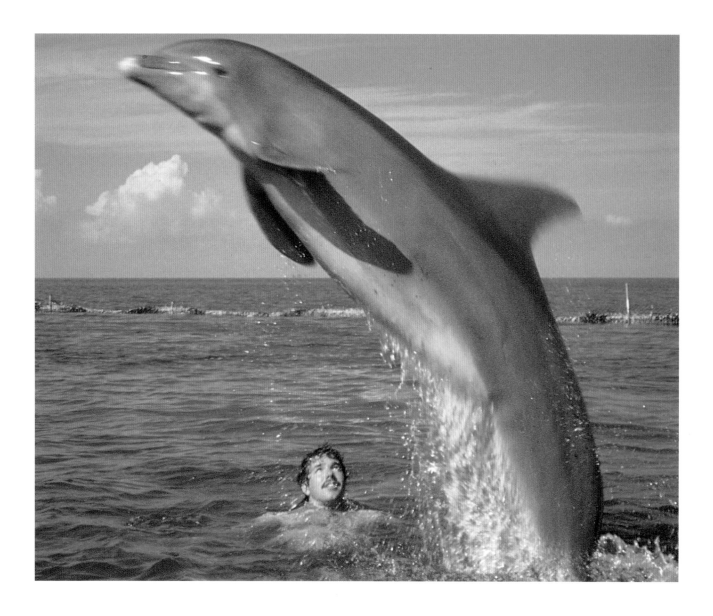

flippers. Whales are like icebergs—you only see a small portion of them on the surface and even that is rare. I realized that if I could paint the entire animal and educate the viewer to what's below the surface, then people might begin to understand how magnificent they really are. They have both power and restraint, a rare combination in our world.

Most people will never have this incredible opportunity, but I've been blessed to be able to spend a great part of my life in intimate proximity to dolphins and whales. I've come to the wonderful realization that these creatures are every bit as unique and individual as human beings. Each has its own distinct physical characteristics, personality, and special presence.

The result of absorbing this knowledge has been an immense change in my work, in my whole approach. Instead of painting more or less generic whales and dolphins, which is what I started out doing, I now paint individuals. The more time I spend with them in their own environment, the stronger this element of my work becomes, and the more distinct—and more soulful—each individual becomes.

I love to swim with the whales and dolphins, to see them up close, to be able to paint them accurately and—even more importantly—with a deep feeling for them as fellow creatures.

Honestly, though, I resist the impulse to personify them. I would rather respect them for what they are and not try to make them seem like human beings. After all, they've been here a whole lot longer than we have. In terms of their evolution, they started out in the water, came on to the land, and then decided to go back. *What does that tell you?*

Maybe this is going too far, but they seem to have such a positive attitude toward me, when I'm in the water with them, that I can't help but wonder if they somehow realize that I'm there for a very good reason. It may be that whales and dolphins are just smart enough to understand what I'm doing, and they go out of their way to show themselves to me.

Whales have navigated the world's oceans for 40 million years—they are of the sea, unmatched in their beauty and grace as they move with absolute control through their underwater world. The struggle to save these majestic creatures is one of our greatest challenges.

"We must see them not only with our eyes but with our hearts.
If the oceans are calling, it must be the song of the whales,
the laughter of dolphins."

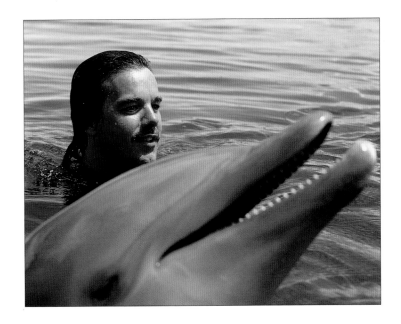

WYLAND

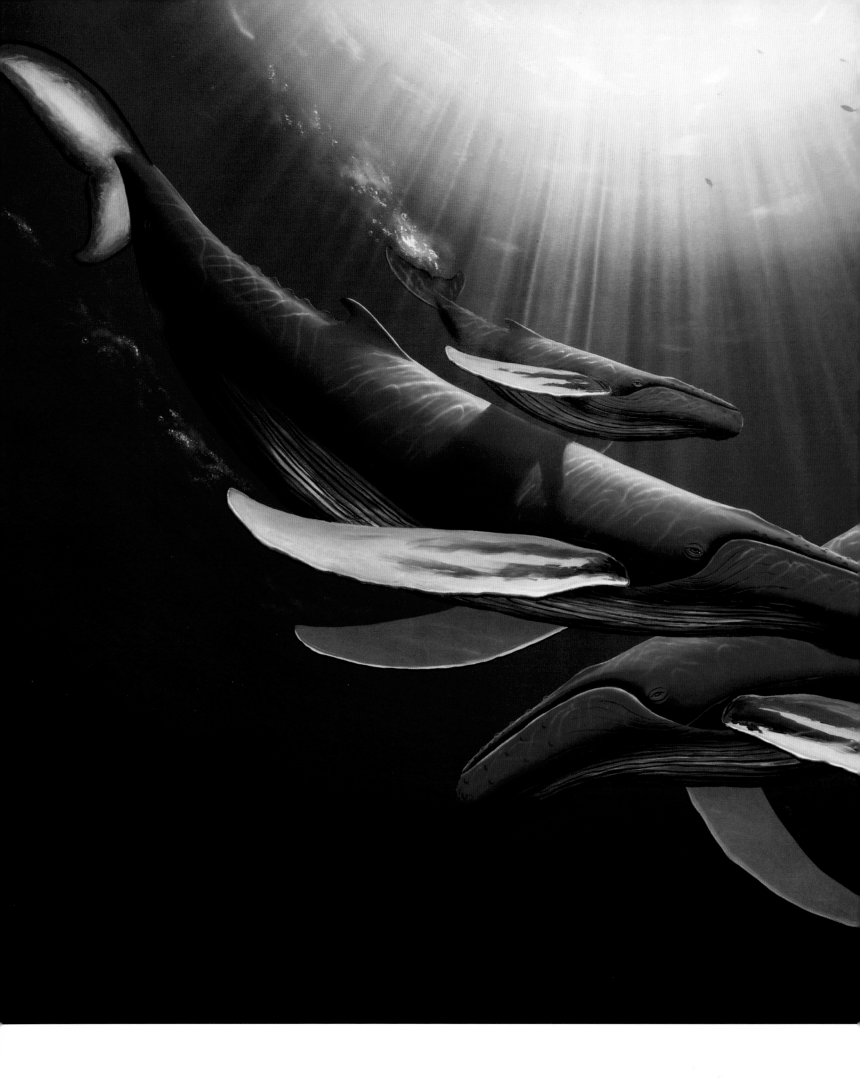

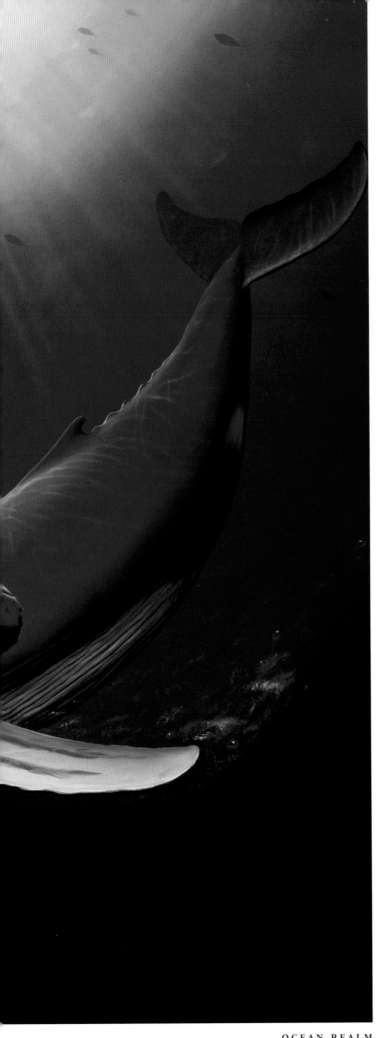

Whales

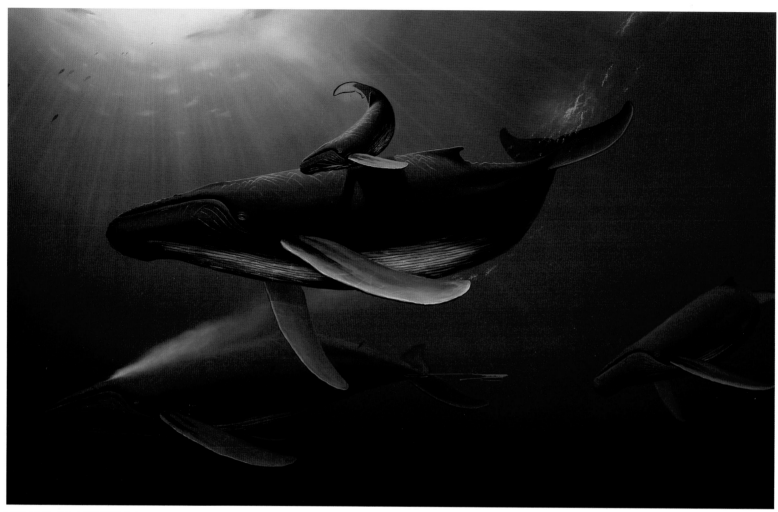

WHALE PROTECTION

"From space the planet is blue,
from space the planet is the territory,
not of humans, but of the whales."

—*Heathcote Williams,* WHALE NATION

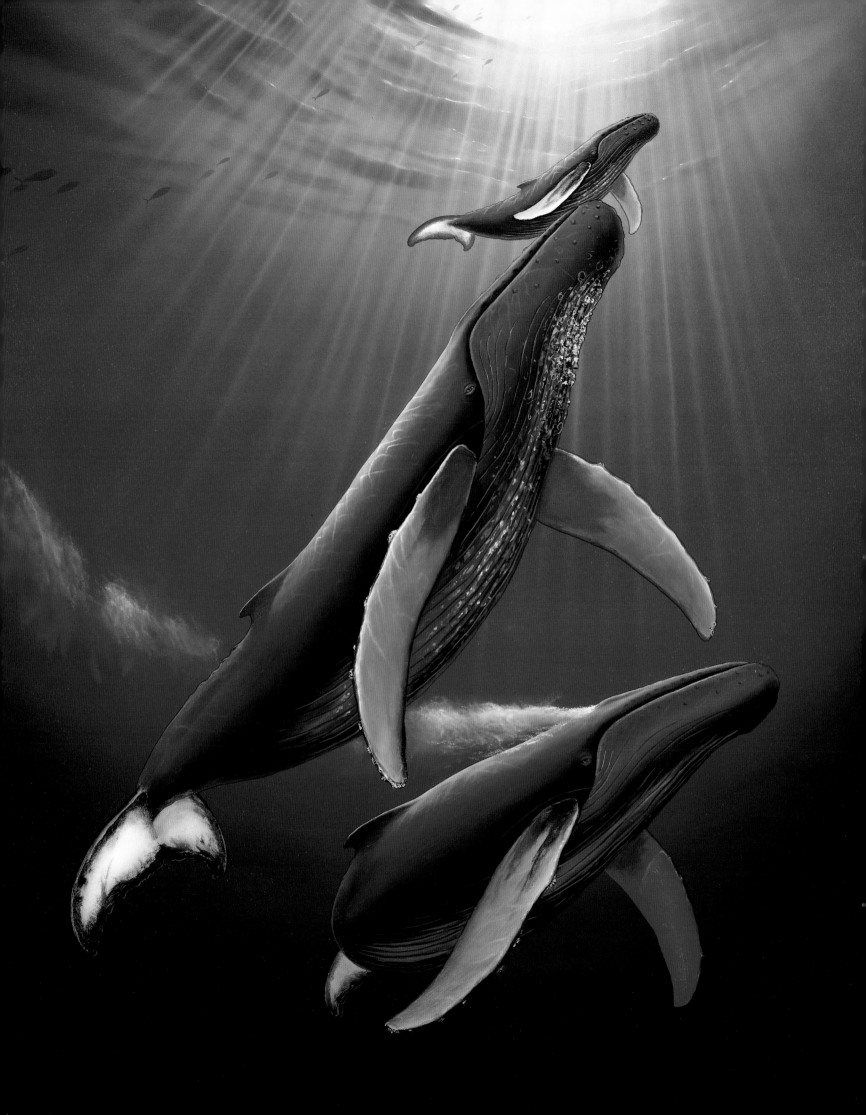

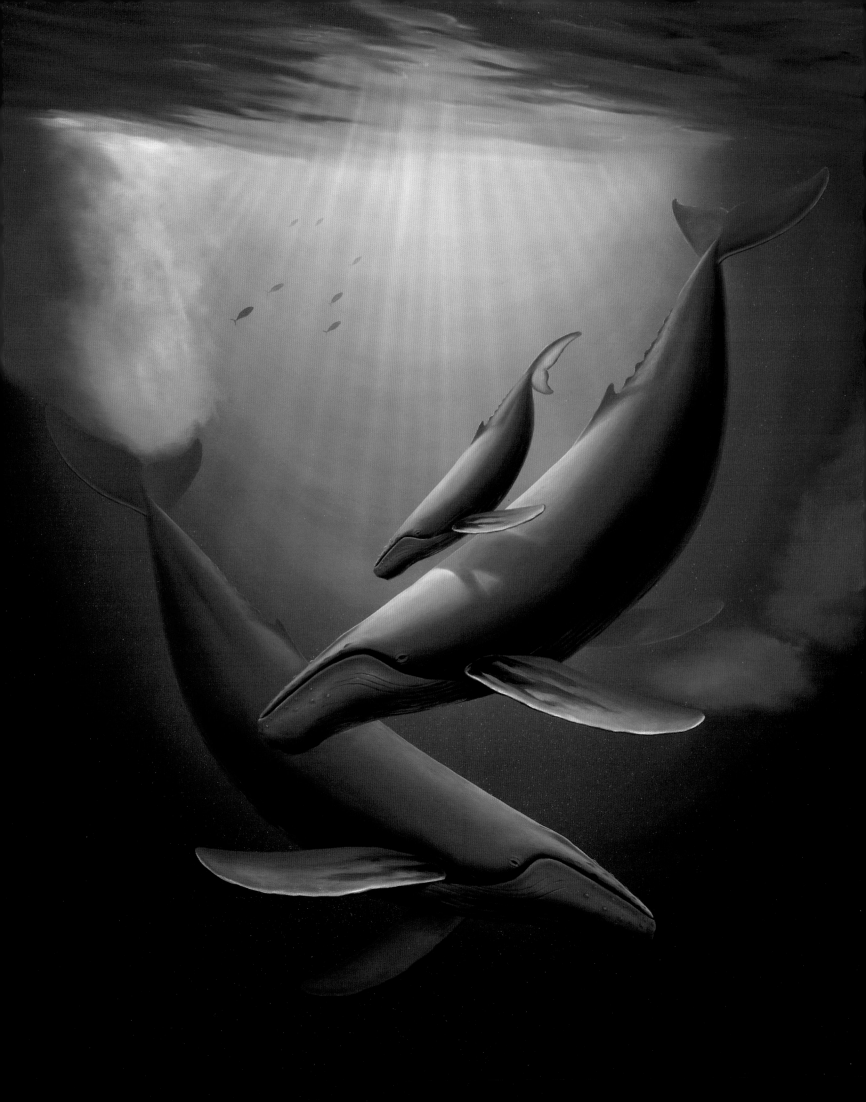

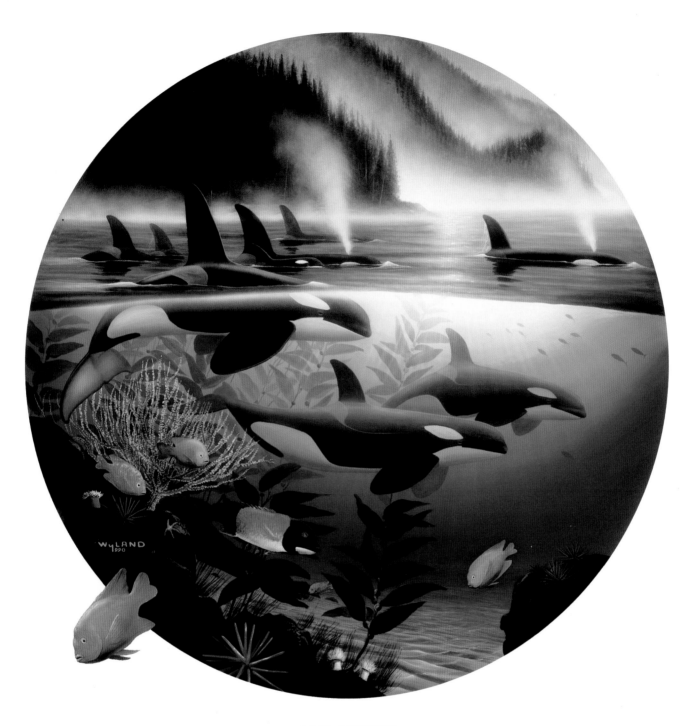

ORCA JOURNEY

"They are sleek and elegant and gorgeous, among the most exquisite creatures on the planet. They move like ballerinas."

—*Sylvia A. Earle,* ACADEMY OF ACHIEVEMENT *interview*

THE ART OF SAVING WHALES

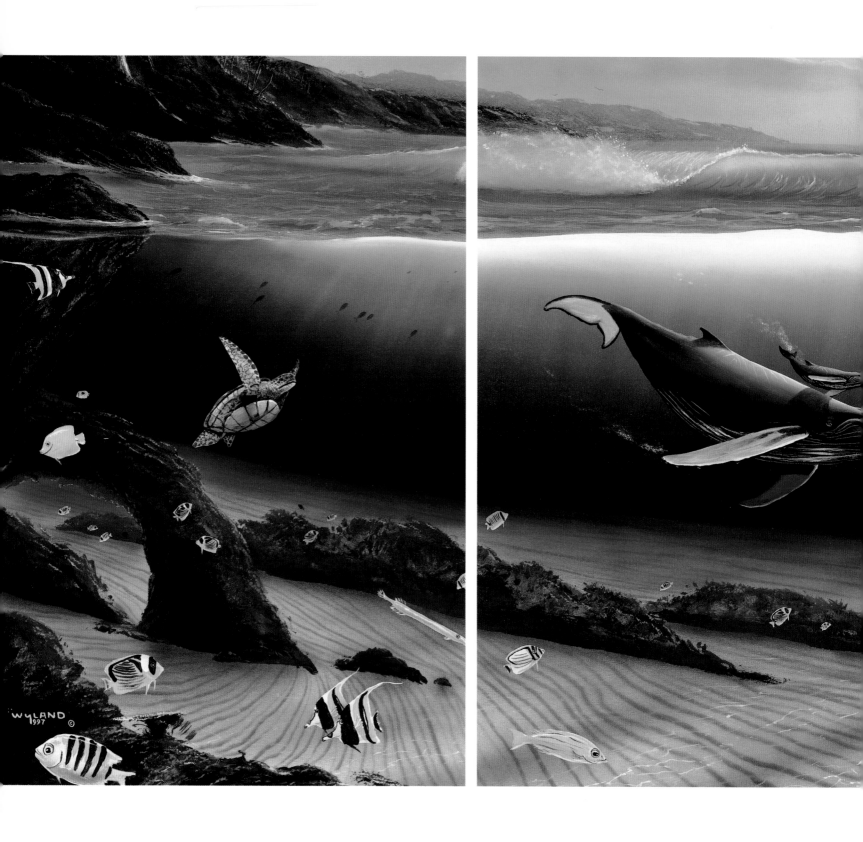

"Every whale everywhere moves in a sea of total sound.
From the moment of its birth until its final hour, day and night
it hears the endless orchestra of life around its massive frame.

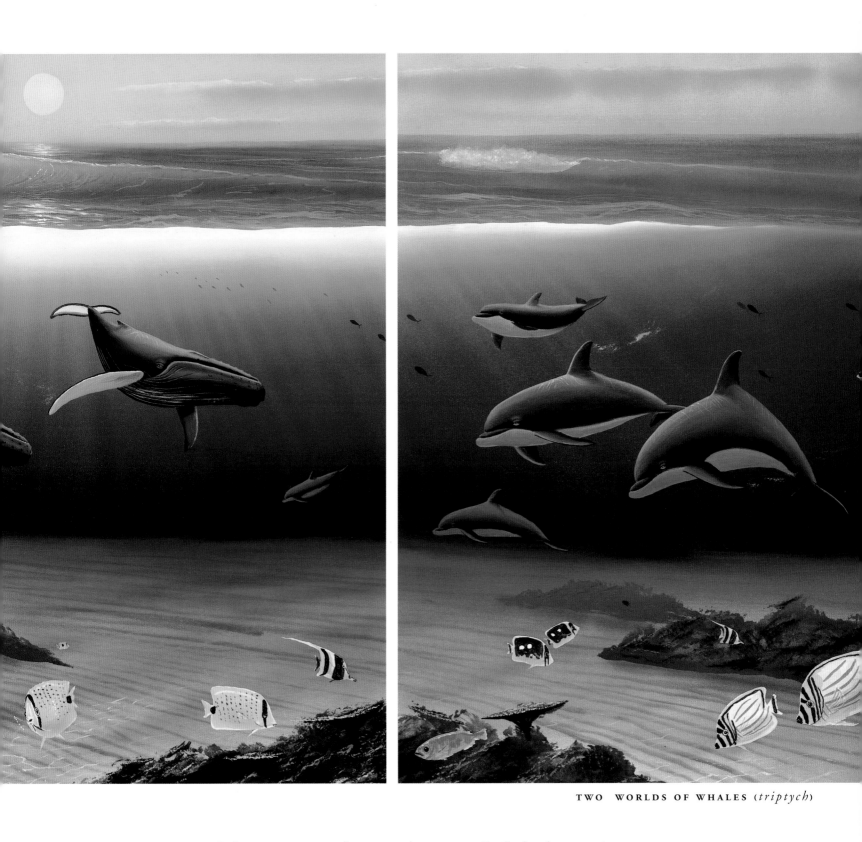

TWO WORLDS OF WHALES (*triptych*)

Silence is an unknown thing ... It feels the music too,
for water presses firmly on its frame—a smooth continuous sounding board."

—*Victor B. Scheffer,* THE YEAR OF THE WHALE

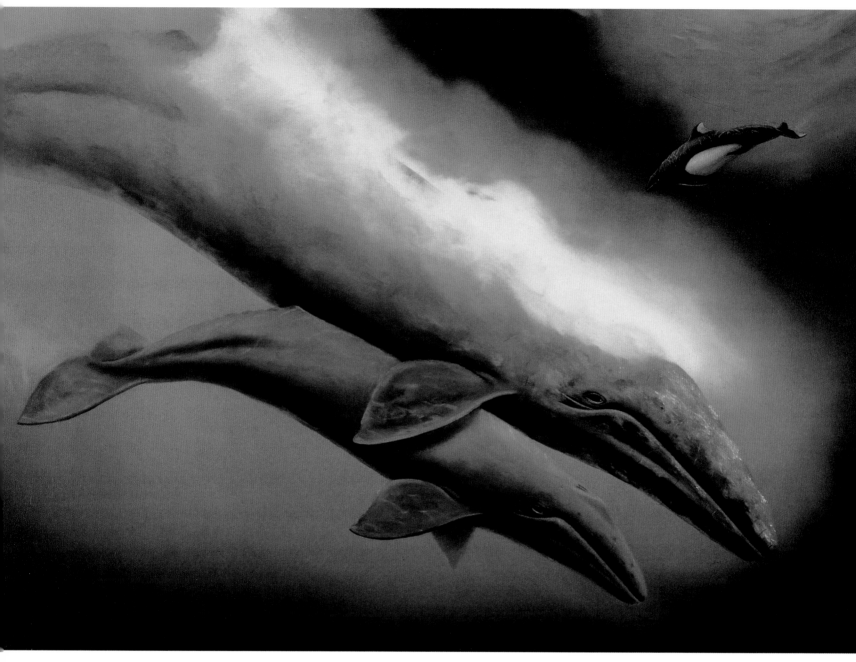

GRAY WHALES

"In the smell of death
In the luxe of plants
In the blood of the whale …
Is the knowledge of the end of time."

—David Mamet

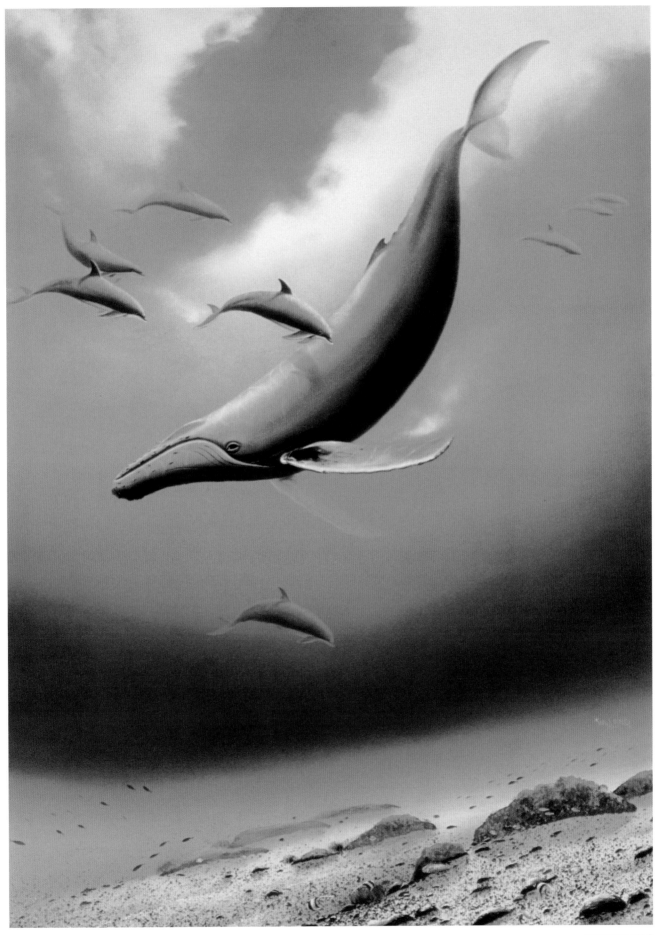

SOUNDING

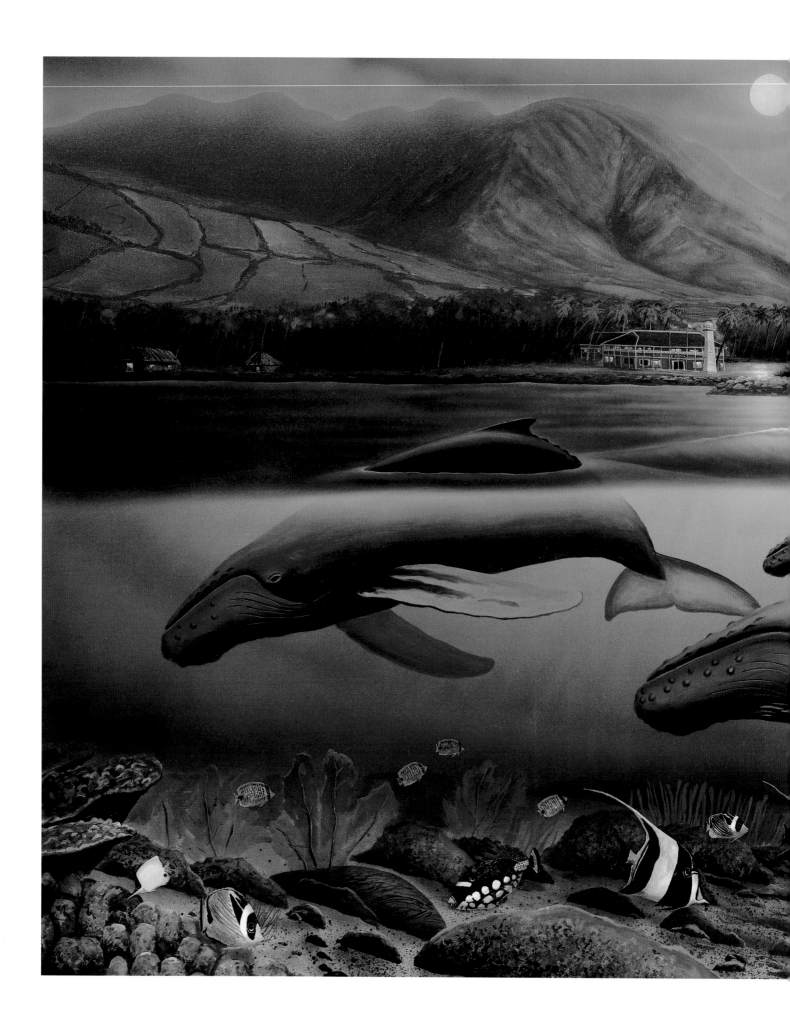

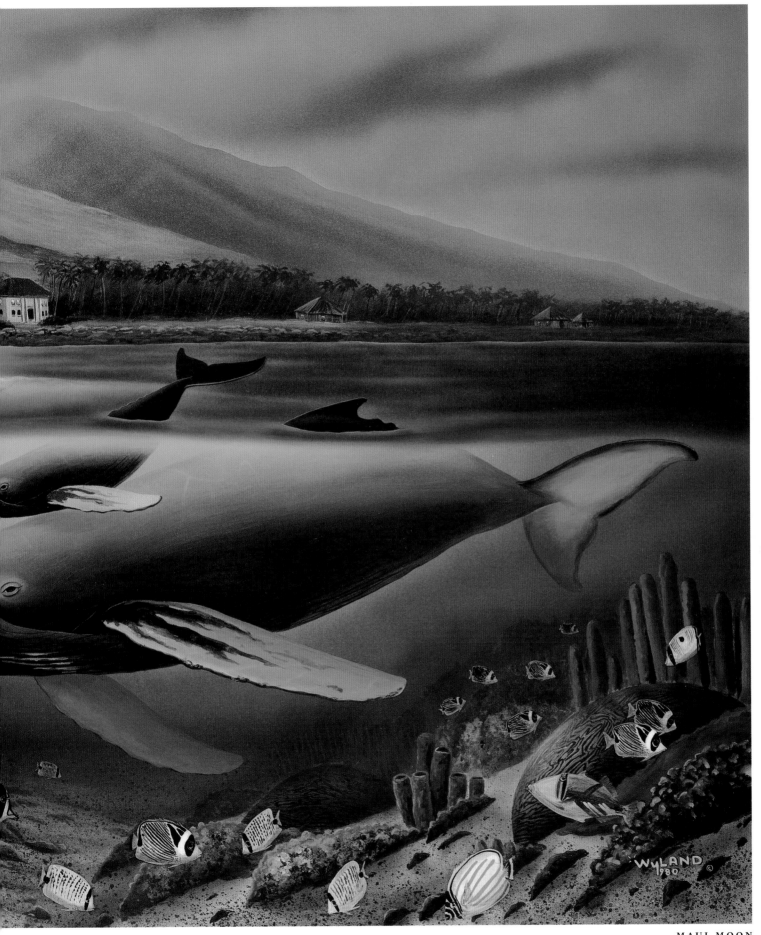

MAUI MOON

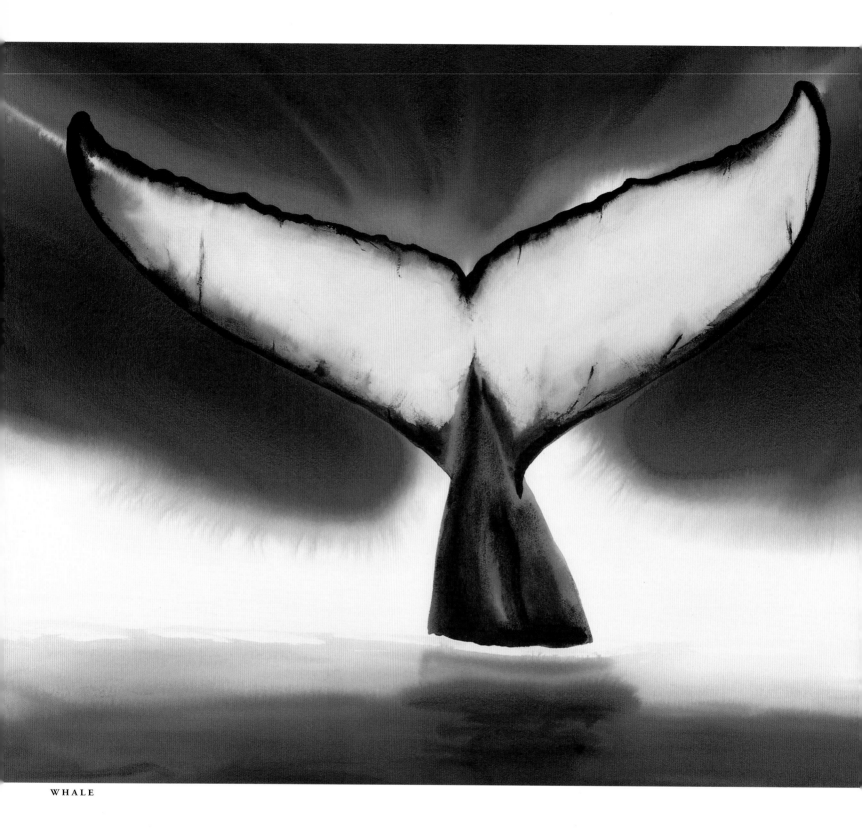

WHALE

"The moot point is, whether Leviathan can long endure so wide a chase, and so remorseless a havoc; whether he must not at last be exterminated from the waters, and the last whale like the last man, smoke his pipe, and then himself evaporate in the final puff."

—*Herman Melville,* MOBY DICK

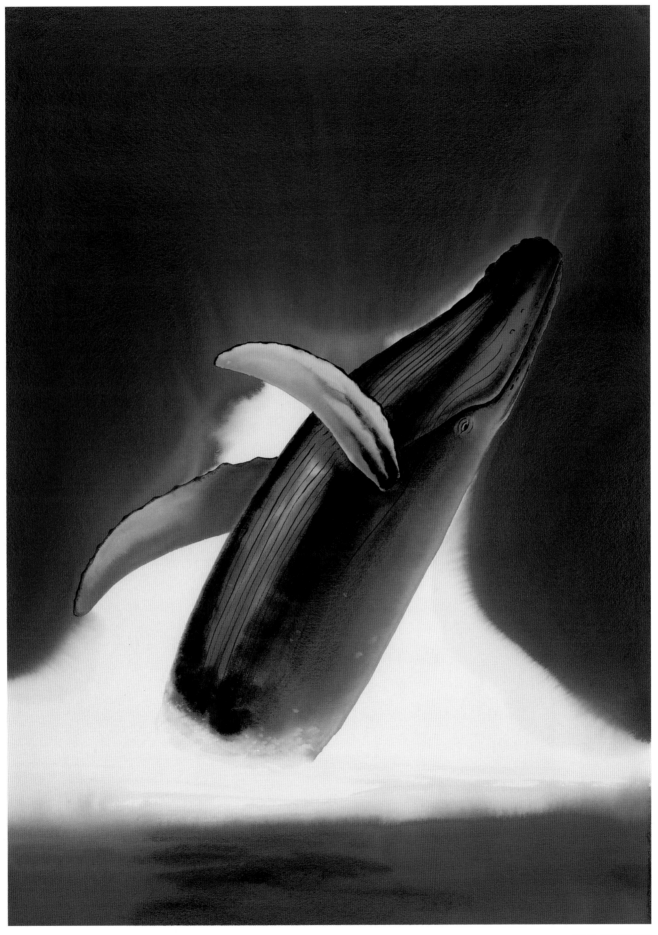

BIG BREACH

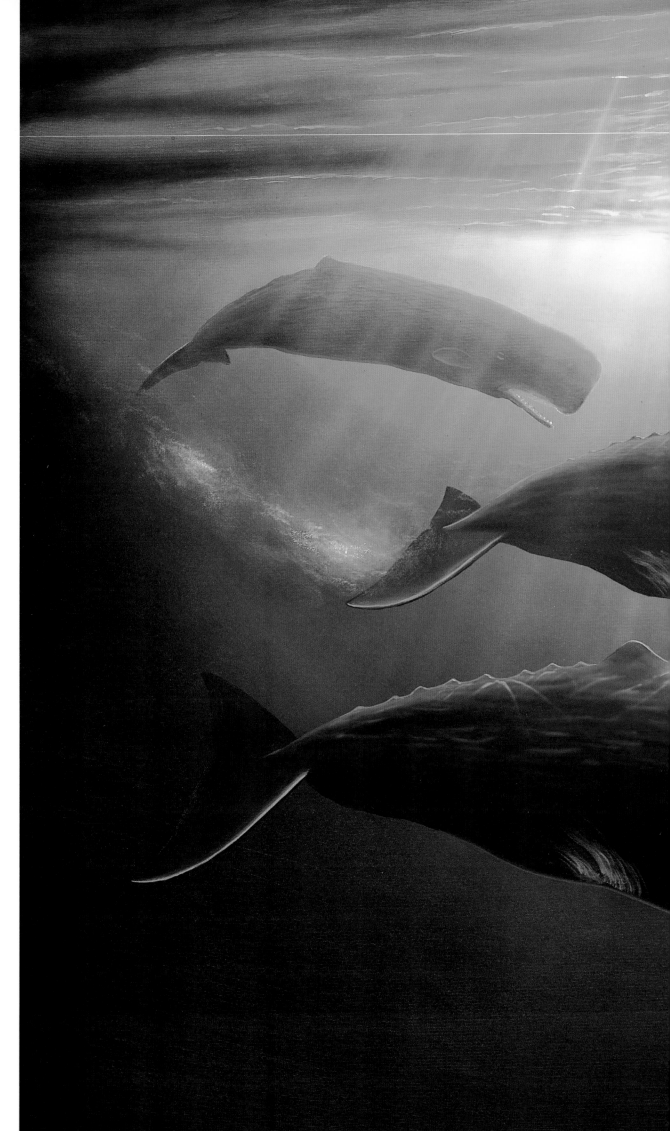

THE GREAT SPERM
WHALES

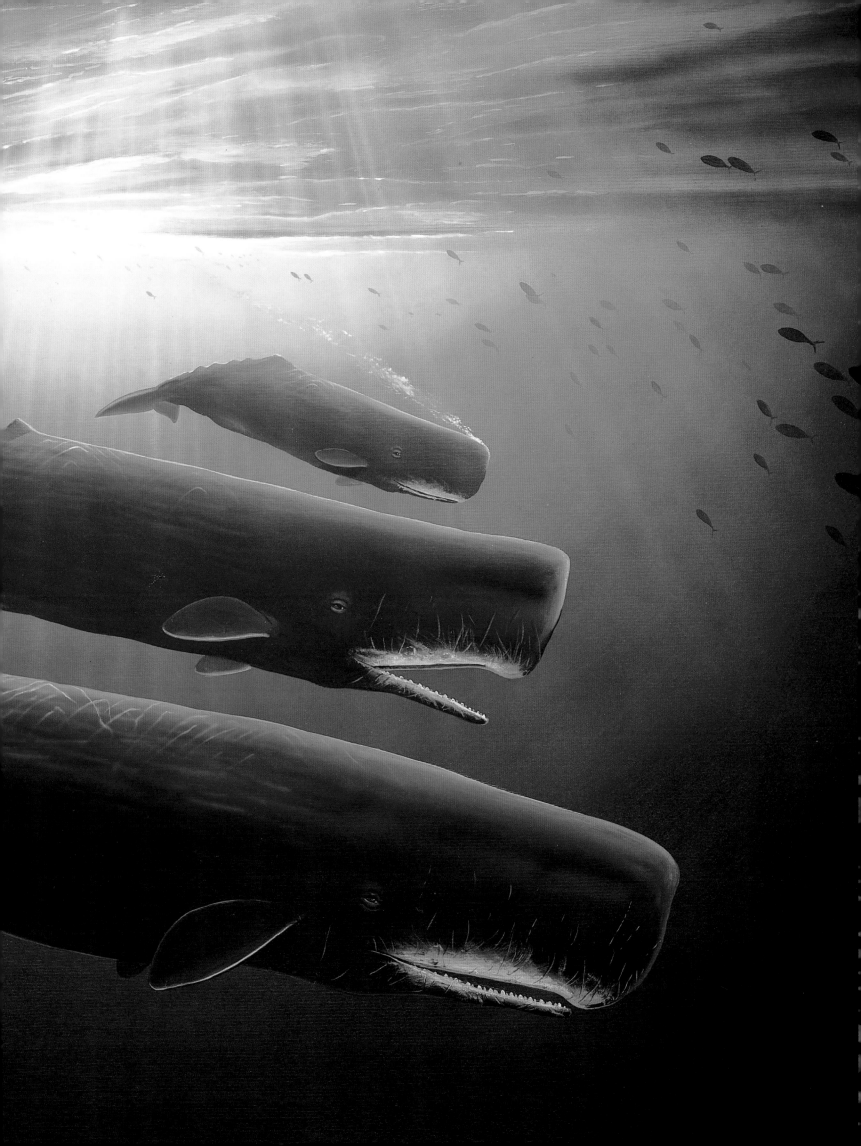

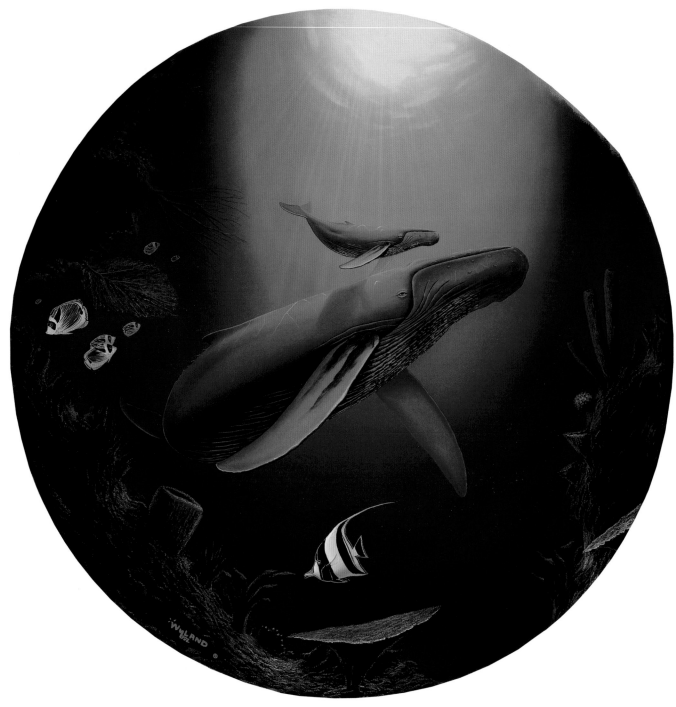

INNOCENT AGE

"Moving through a dim, dark, cool, watery world of its own, the whale is timeless and ancient; part of our common heritage and yet remote, awful, prowling the ocean floor ... under the guidance of powers and senses we are only beginning to grasp."

—*Victor B. Scheffer,* THE YEAR OF THE WHALE

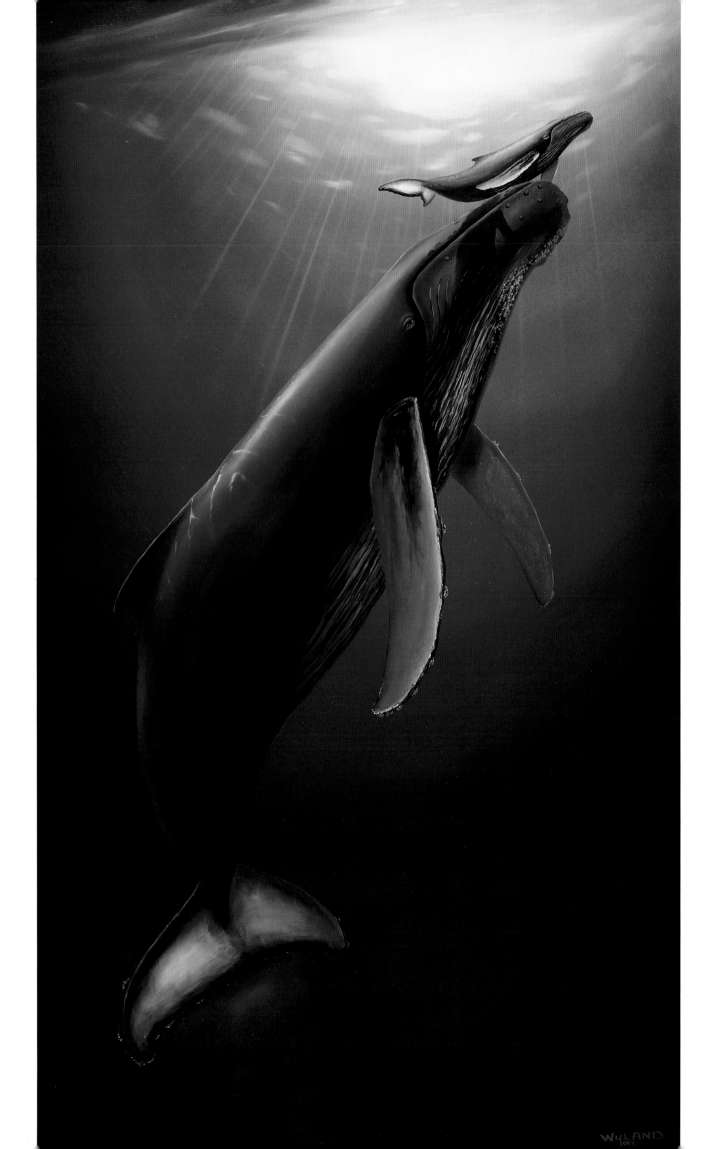

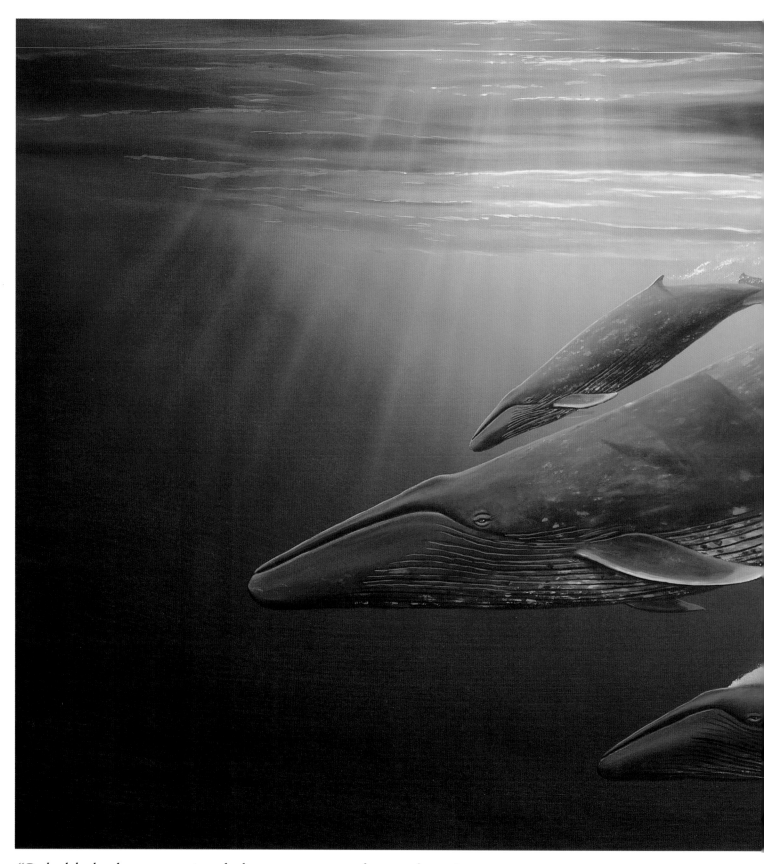

"Behold the largest animal that ever roamed our planet!
When it dives, its rolling back looks like an island in motion . . .

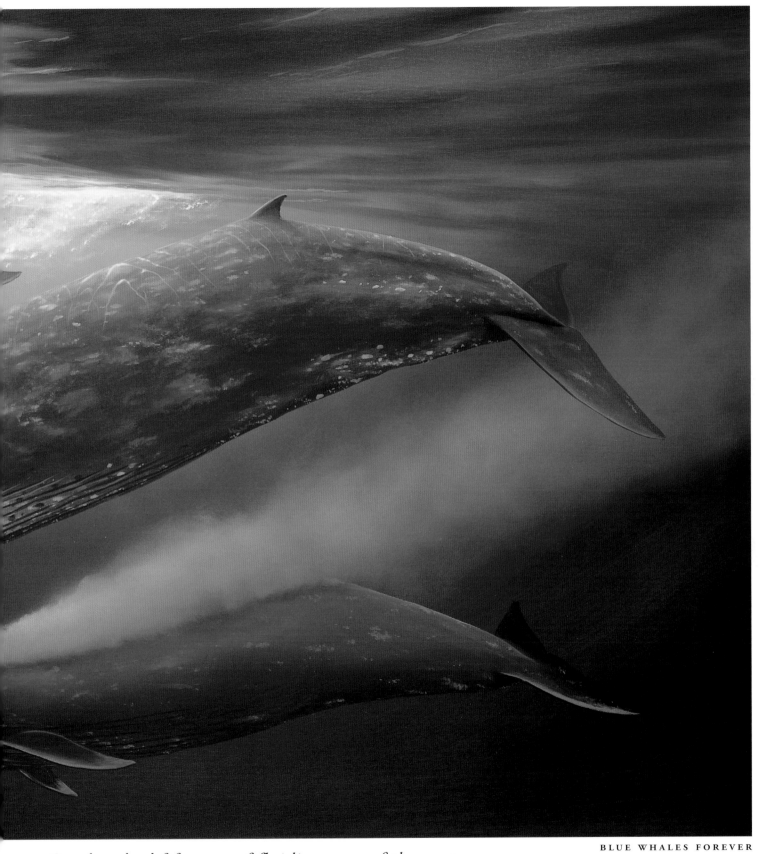

One hundred fifty tons of fluidity—one of the most

stupendous achievements ever shaped by the forces of nature."

—*Jacques-Ives Cousteau,* WHALES

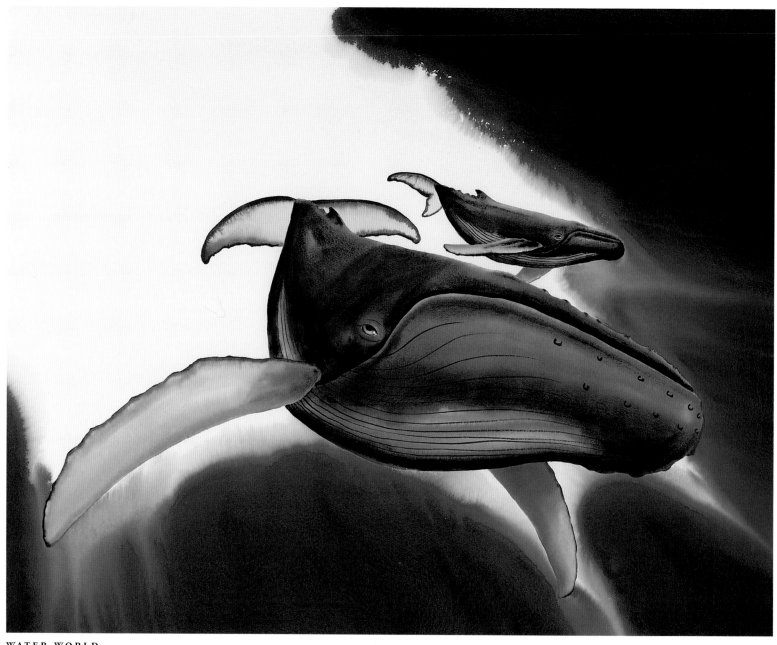

WATER WORLD

"It is difficult to do justice to the humpback's enormous flippers ... aquatic angel's wings with edges scalloped like cumulus clouds, powerful yet tender appendages that are constantly in motion, constantly communicating, protecting young, or locked in passionate embraces during mating season."

—Jacques-Ives Cousteau, WHALES

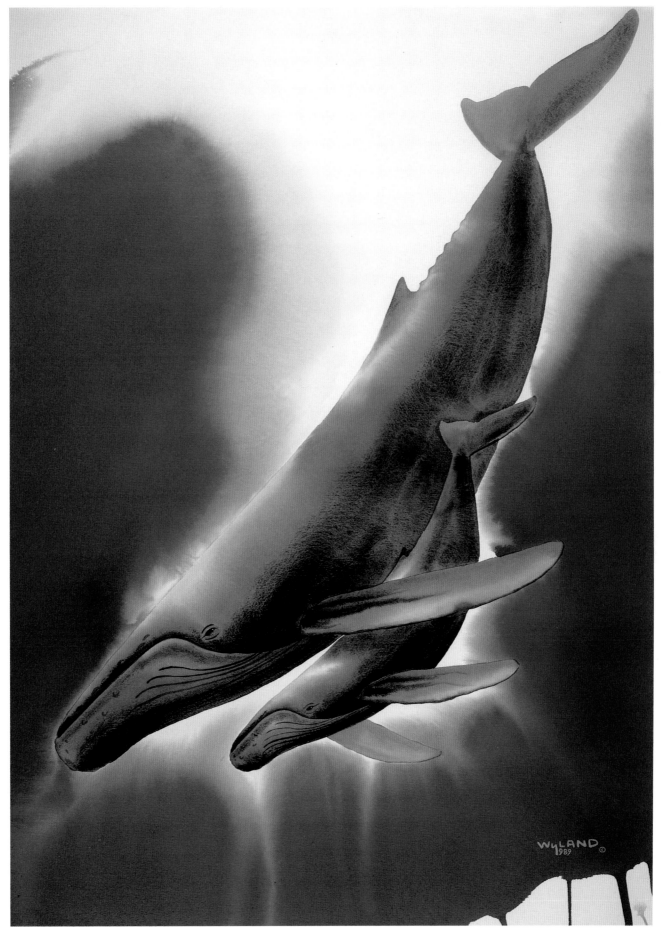

HUMPBACKS DIVING

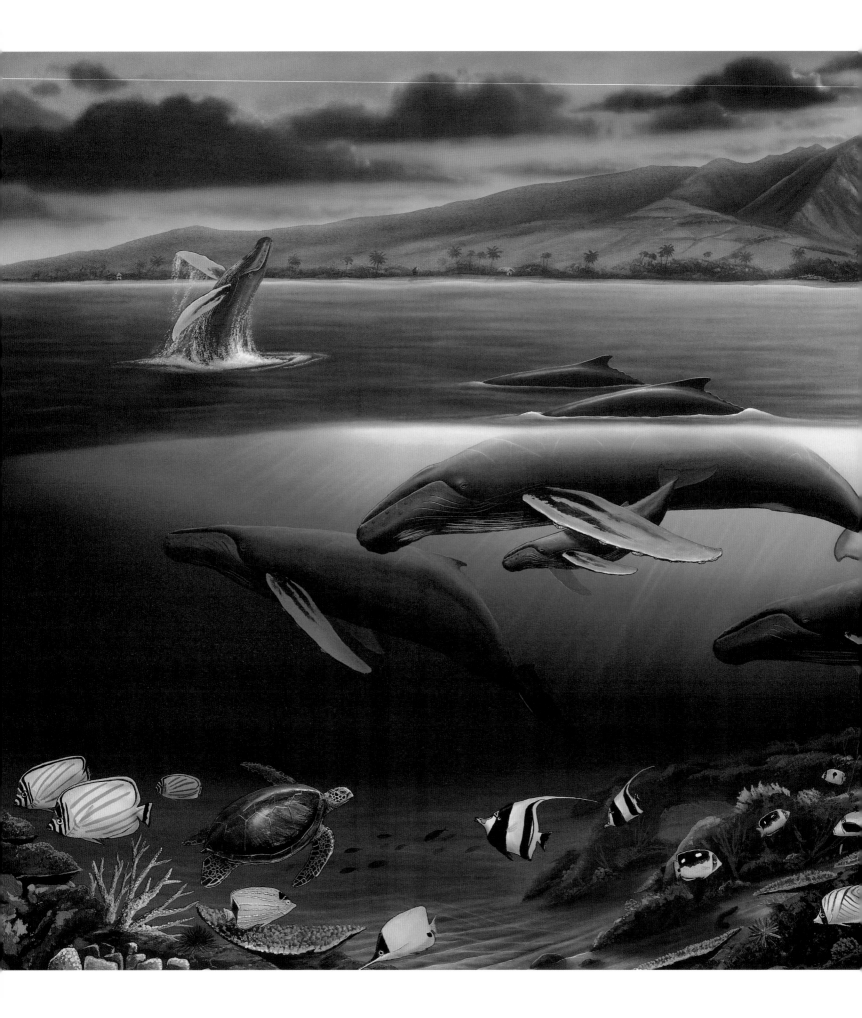

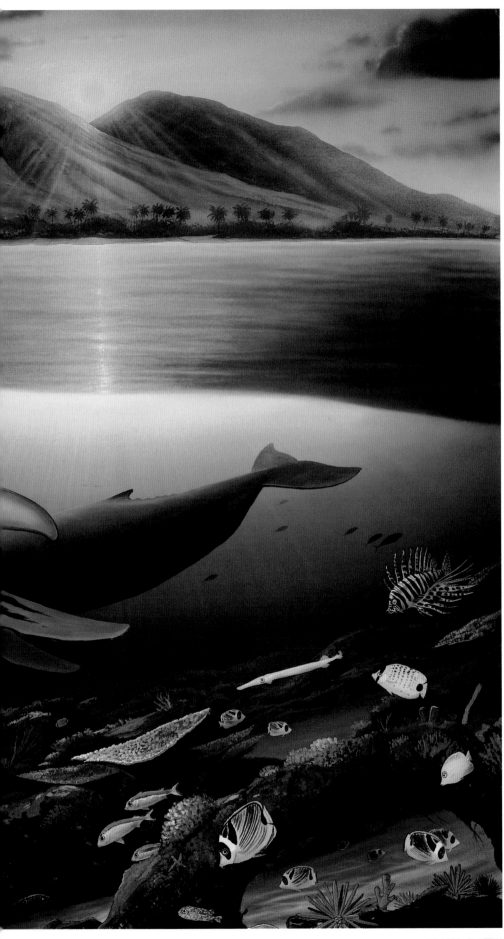

MAUI DAWN

"*I dream of places where man has never been—only whales.*"

—*Wyland*

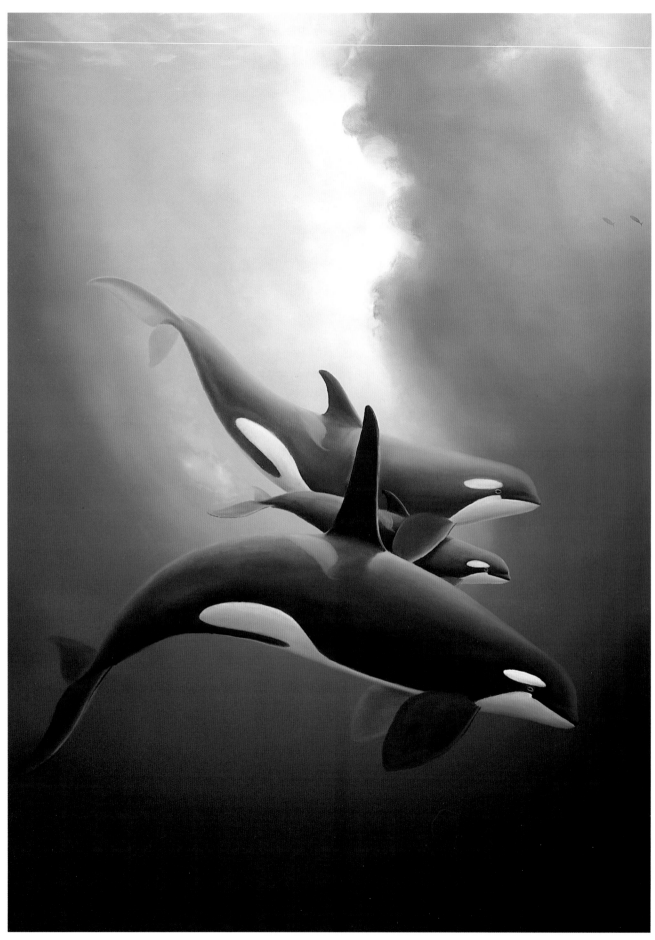

ORCA TRIO

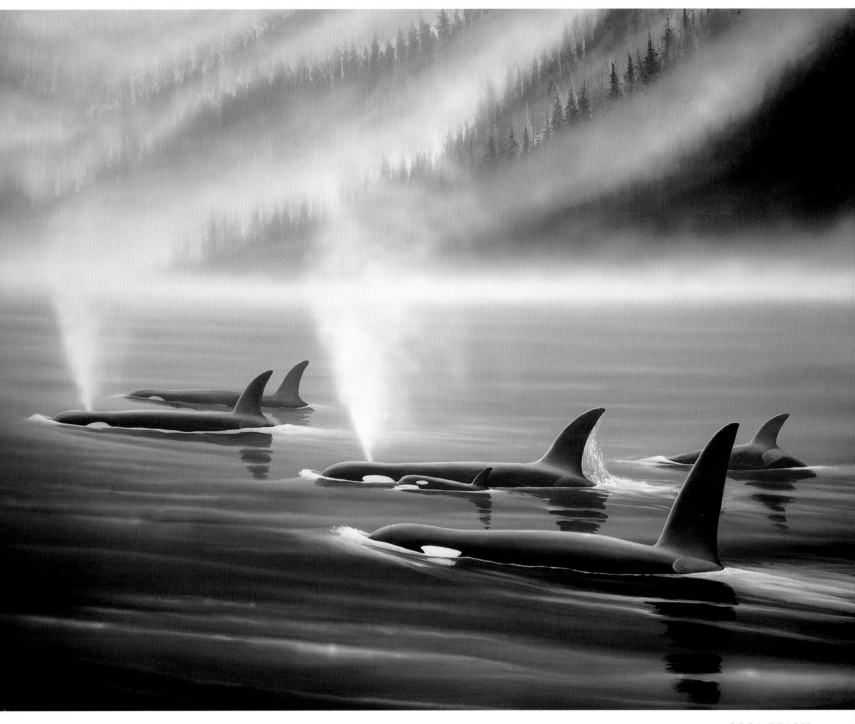

"*Orca is an incredibly powerful and capable creature, exquisitely self-controlled and aware of the world around it, a being possessed of a zest for life and a healthy sense of humor....*"

—*Paul Spong,* MIND IN THE WATER

*"Many people
seem to wish to believe
that whales are communicating
with us at the deepest levels,
but since the dawn of human history
we have always greeted whales
not by communicating
with them but by
killing them."*

—*Roger Payne,* AMONG WHALES

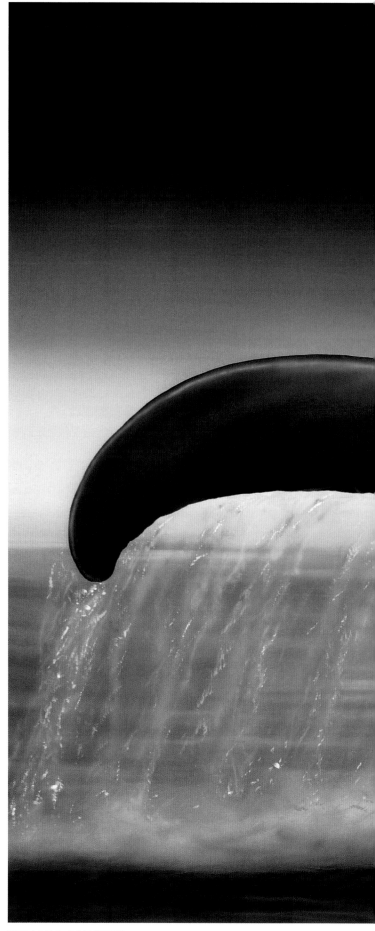

WHALES FOREVER

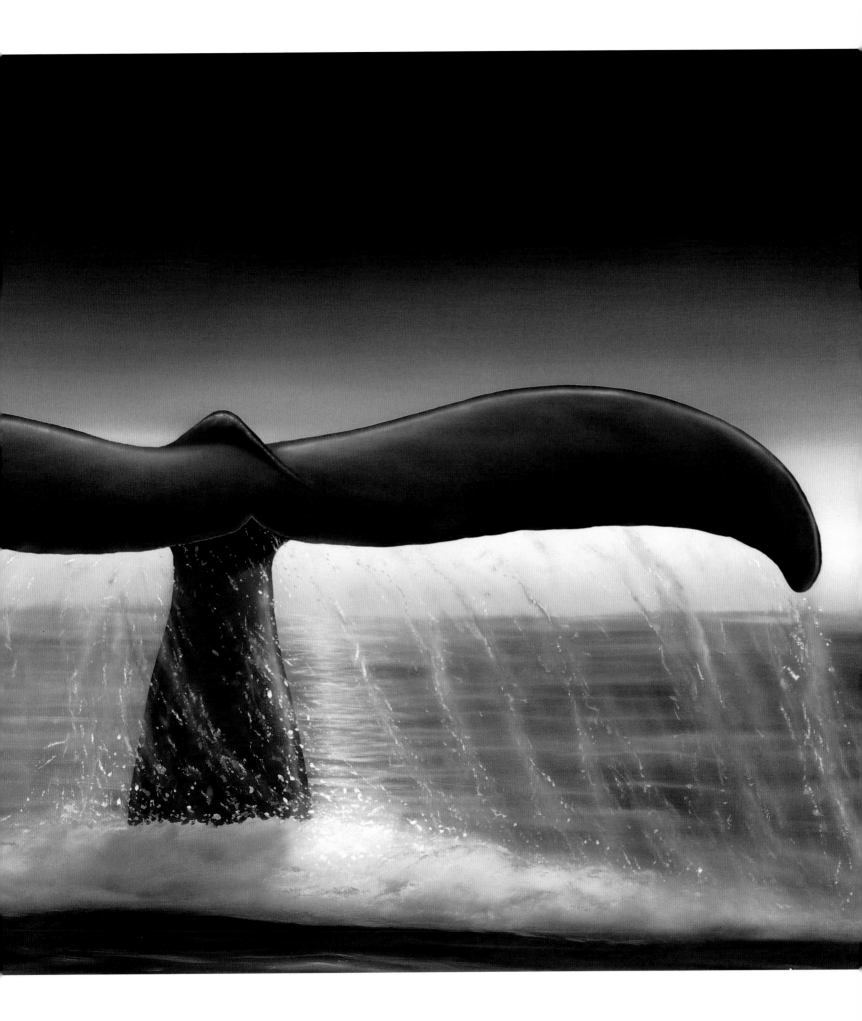

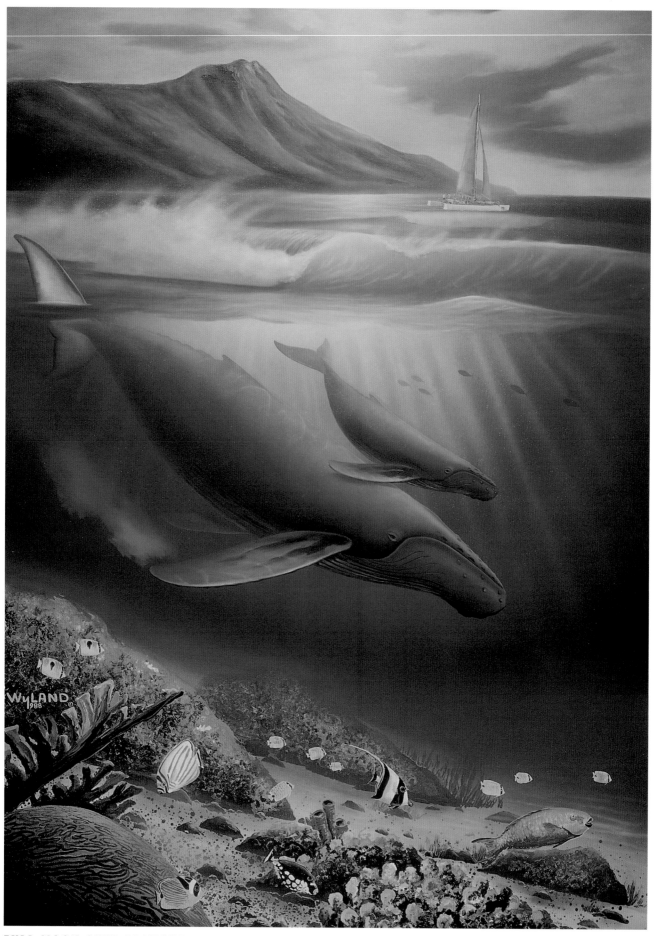

FULL MOON OVER DIAMOND HEAD

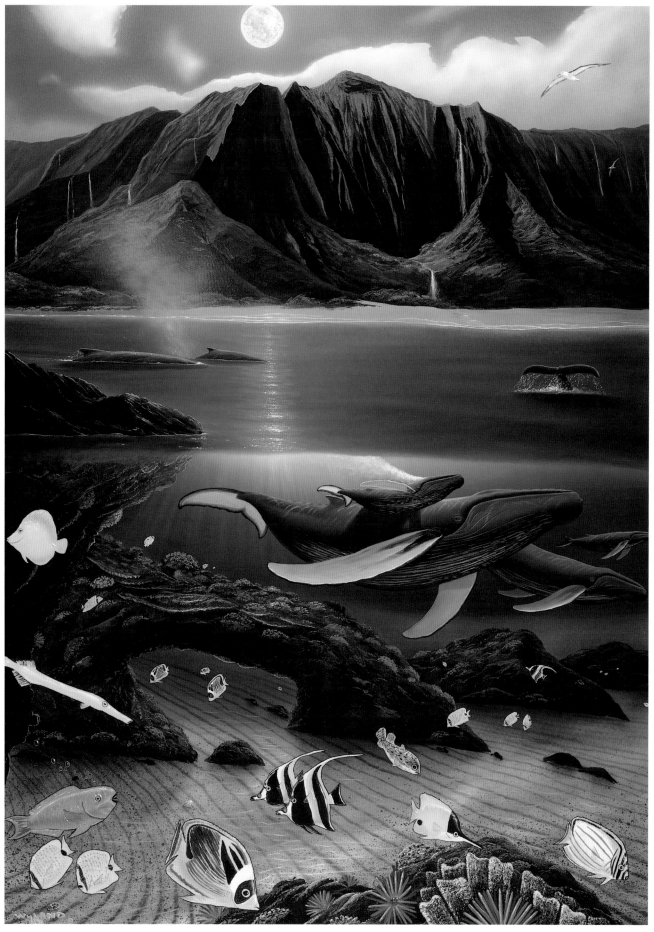

KAUAI MOON

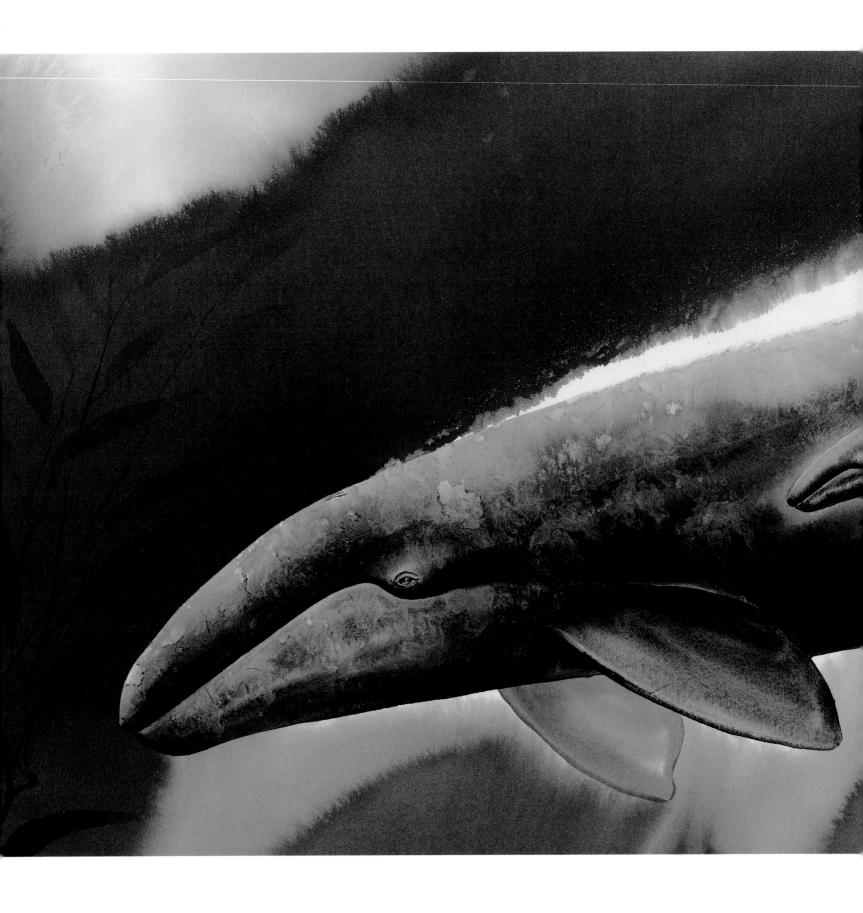

"No word conveys the eeriness of whale song, tuned by the ages to a purity beyond refining,

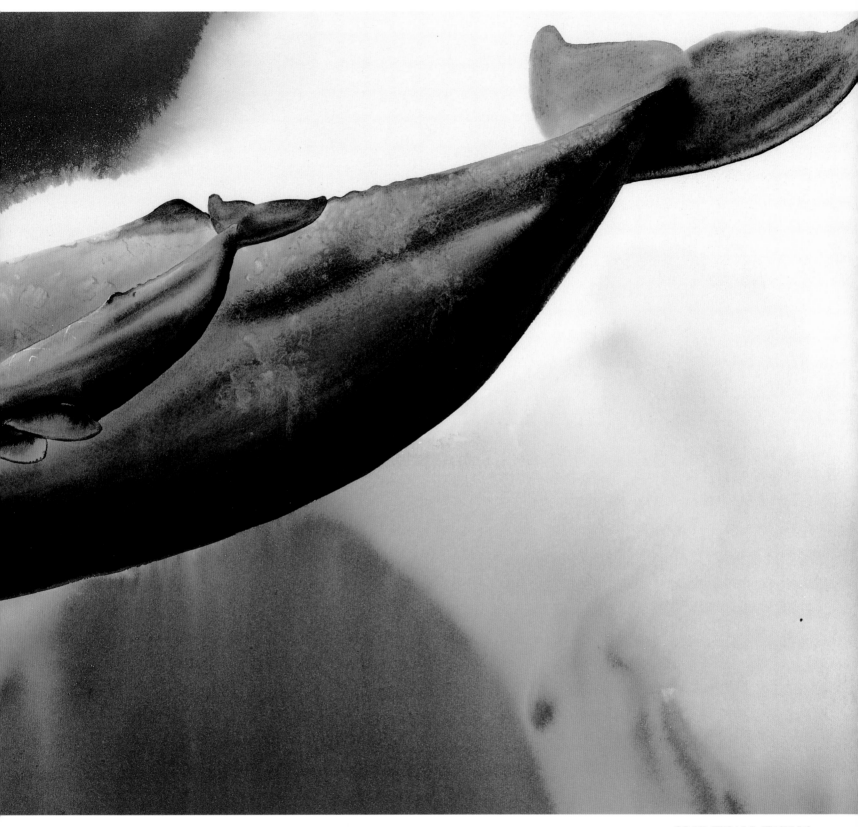

GRAY WHALE WATERS

a sound that man should hear each morning to remind him of the morning of the world."

—*Peter Matthiessen,* BLUE MERIDIAN

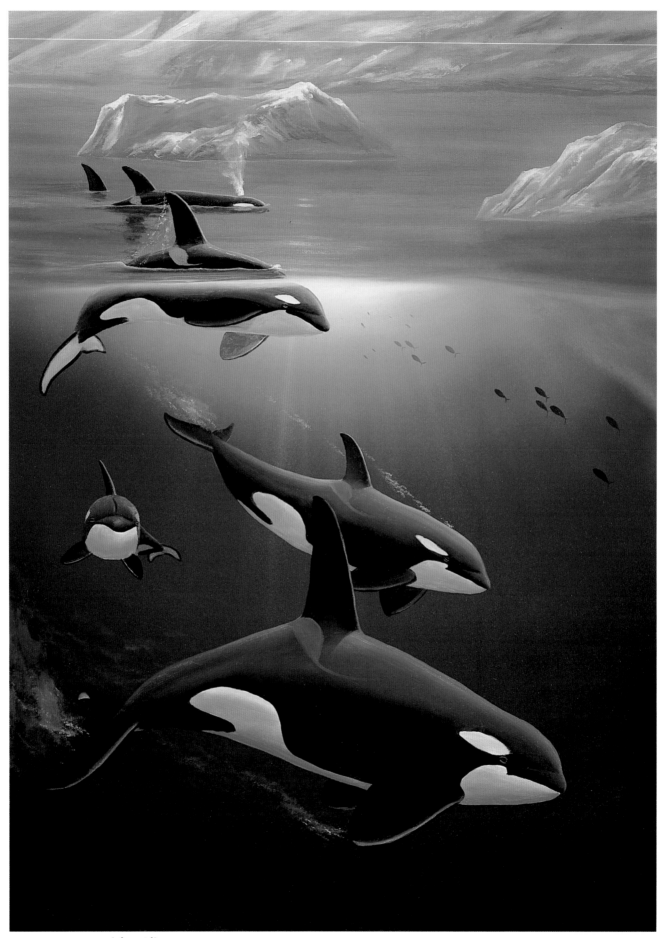

ARCTIC ORCAS (*detail*)

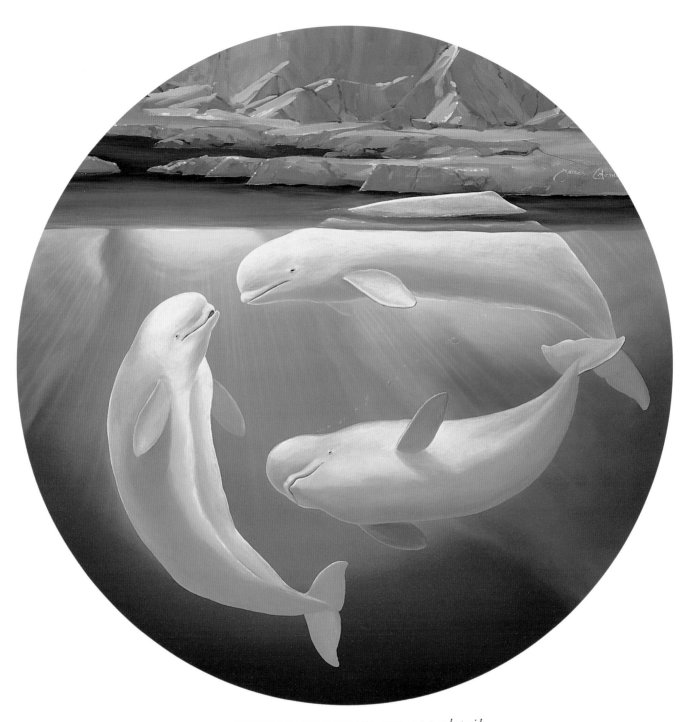

BELUGAS, THE WHITE WHALES (*detail*)

*"The greatest resource of the ocean is not material
but the boundless spring of inspiration and
well-being we gain from her."*

—*Jacques-Ives Cousteau,* THE SILENT WORLD

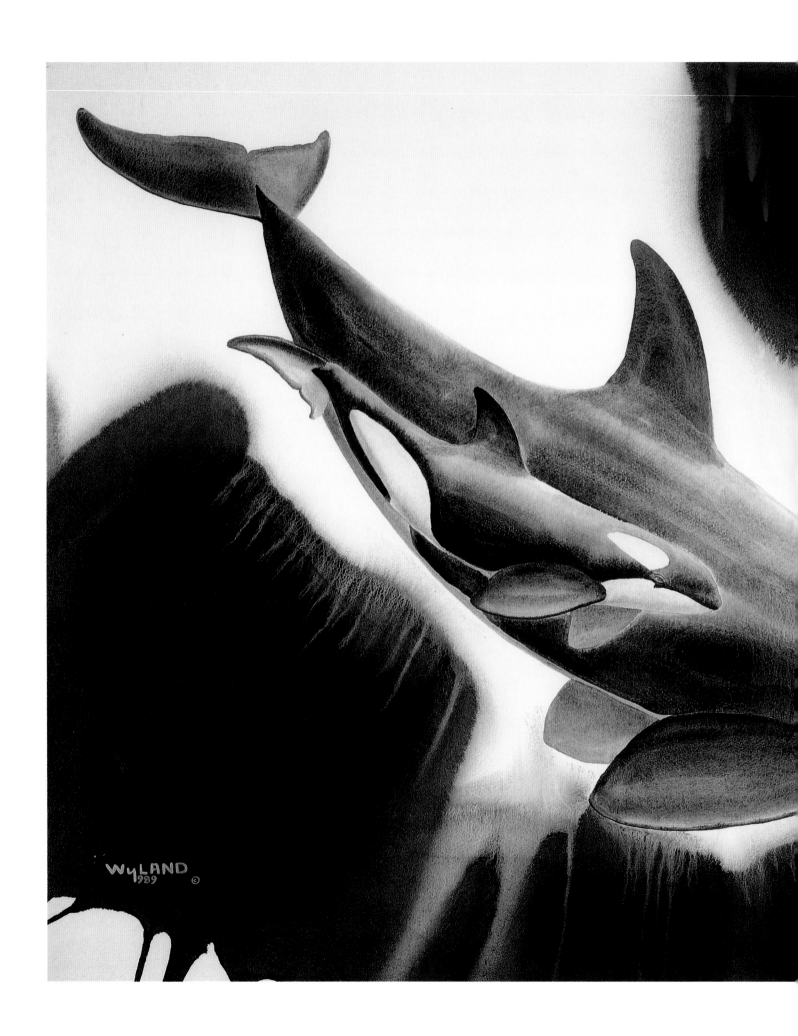

"…*power and restraint,*
a rare combination
in our world."

—*Wyland*

ORCAS DIVING

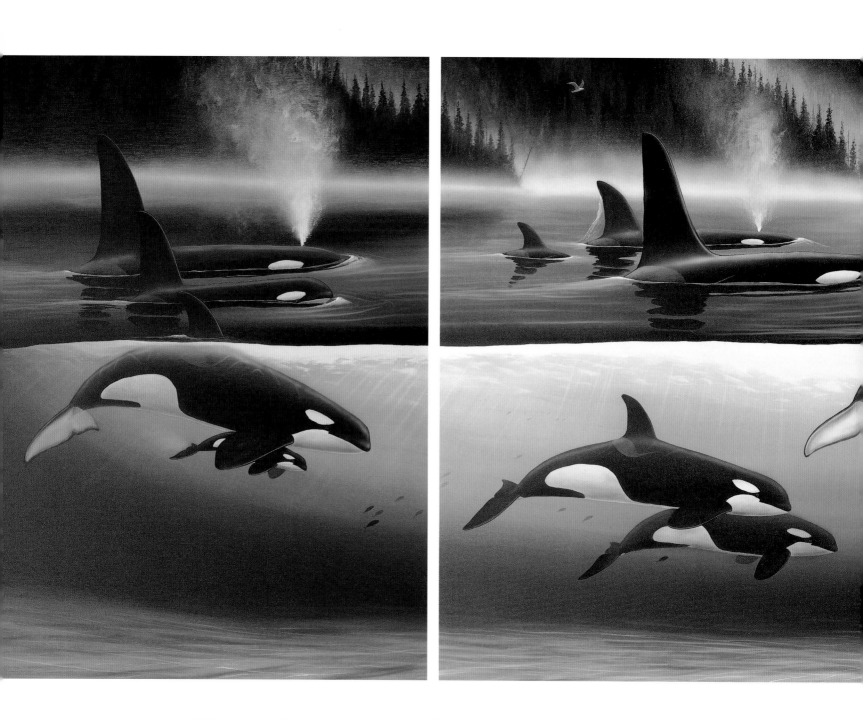

"They say the sea is cold, but the sea contains the hottest blood of all,
and the wildest, the most urgent....

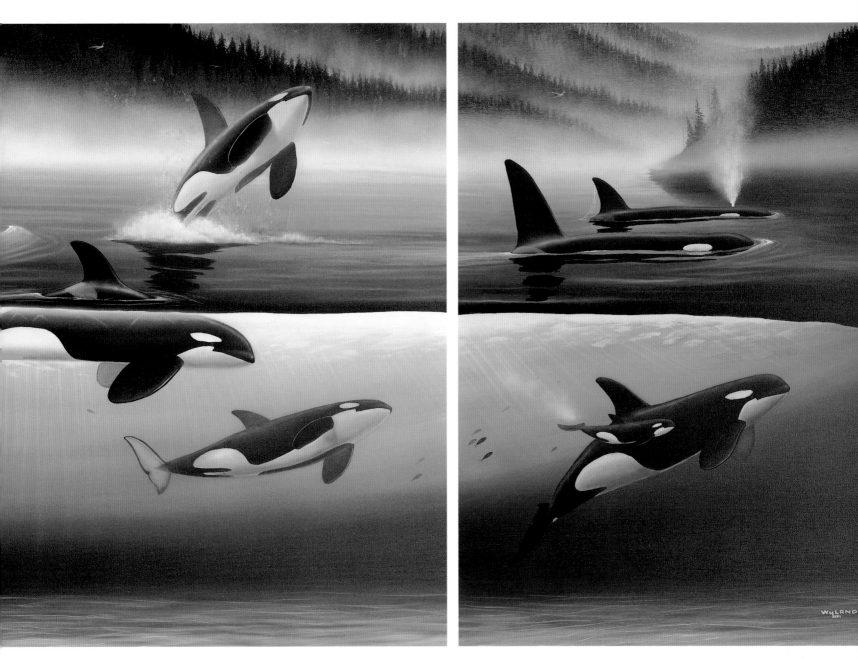

NORTHERN MIST (*triptych*)

There they blow, there they blow, hot wild white breath out of the sea."

—*D.H. Lawrence*, WHALES WEEP NOT

"Blue seas ...
are the domain of the largest
brain ever created.
With a fifty million year old smile."

—*Heathcote Williams,* WHALE NATION

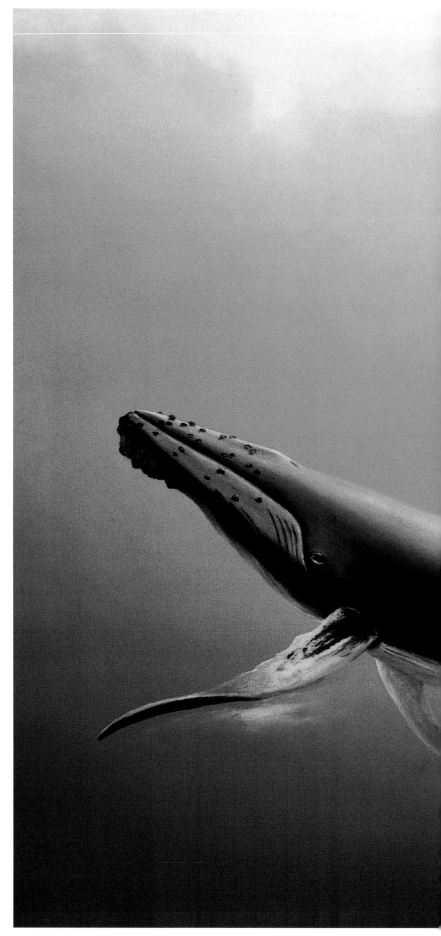

HUMPBACK WITH DOLPHINS

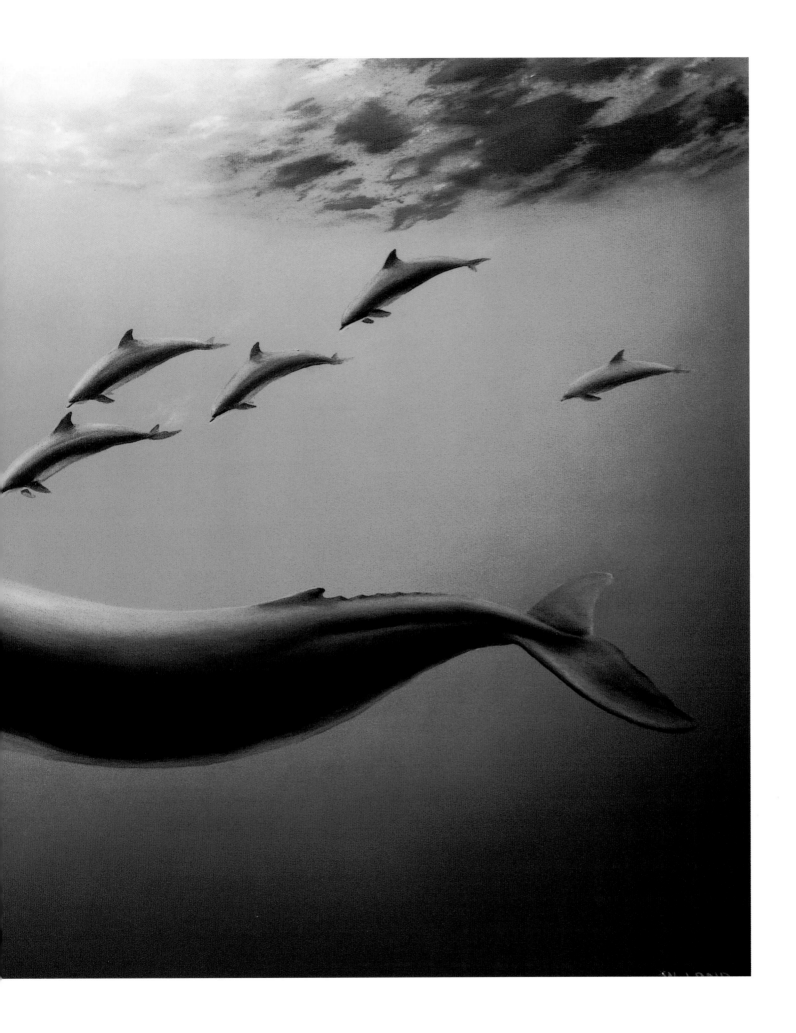

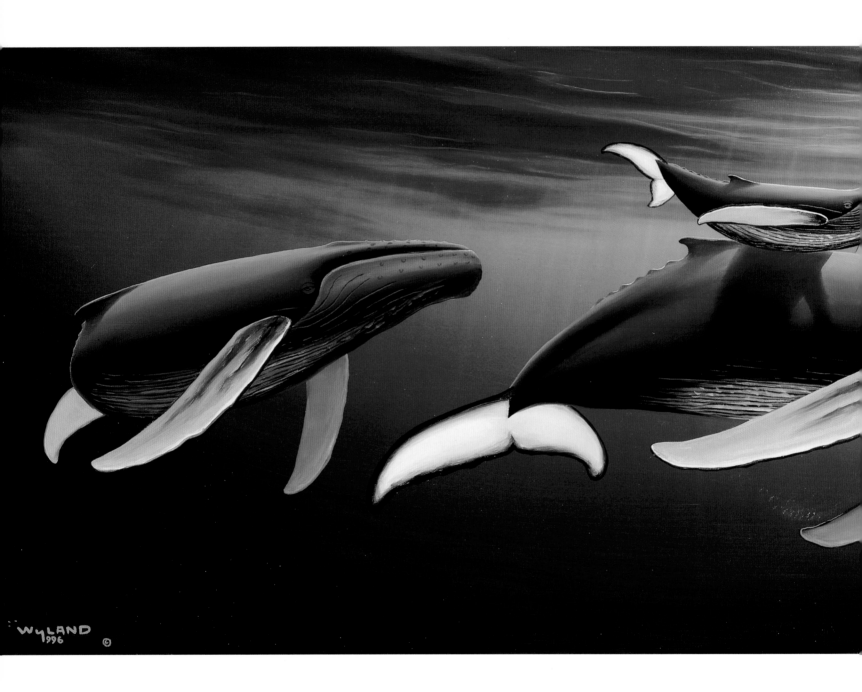

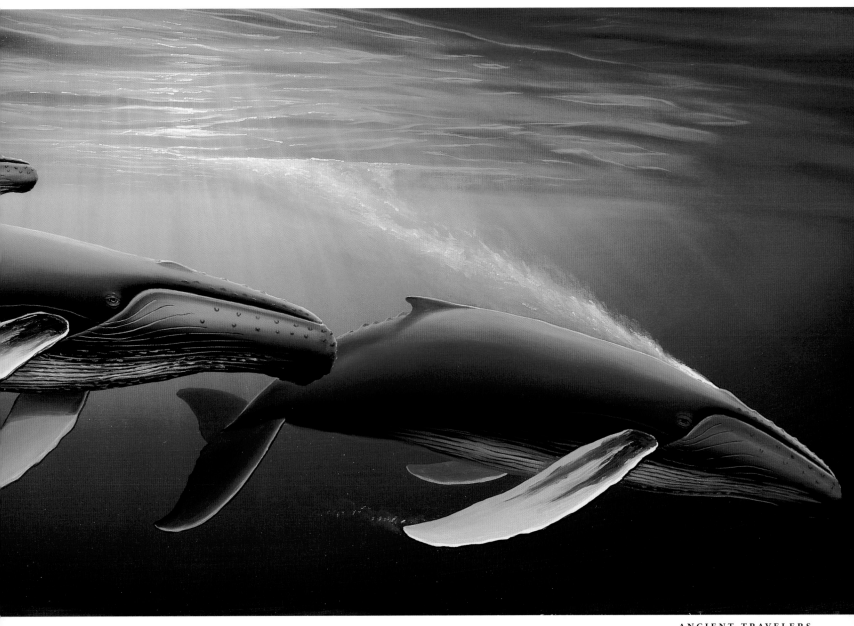

ANCIENT TRAVELERS

"I hope yet unborn children will still be able to see a great whale swimming free."—Wyland

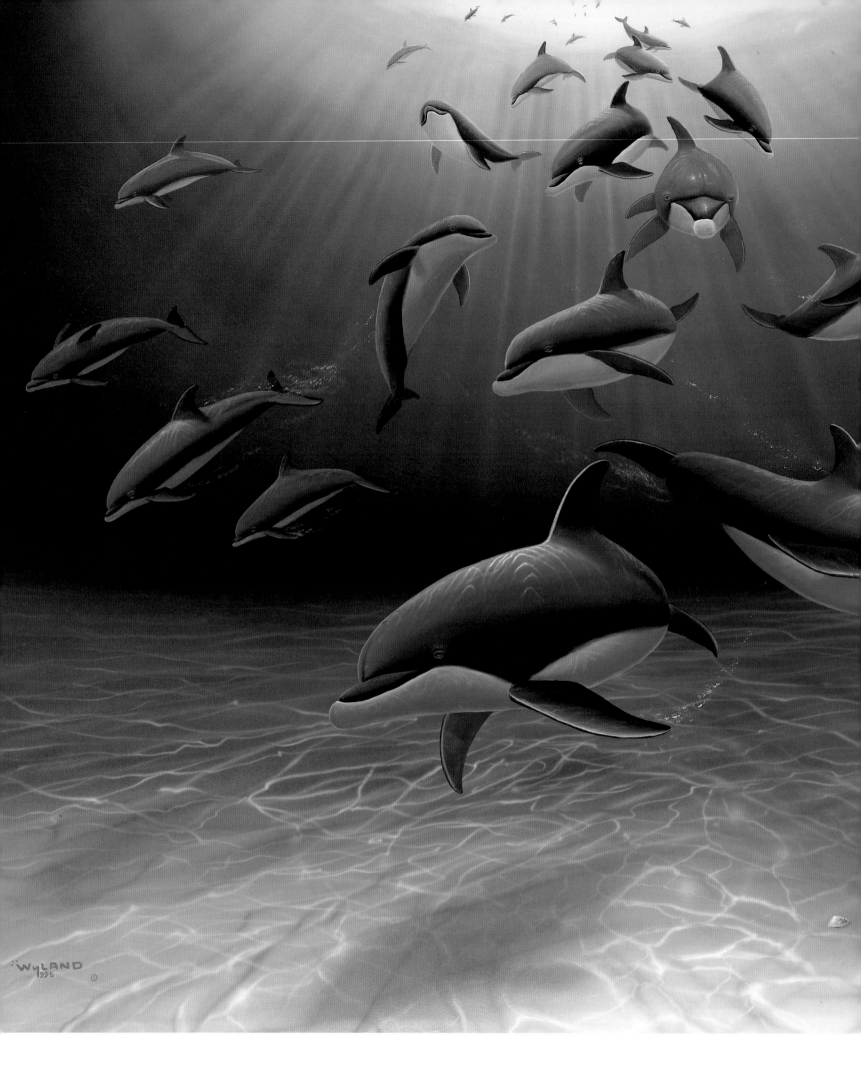

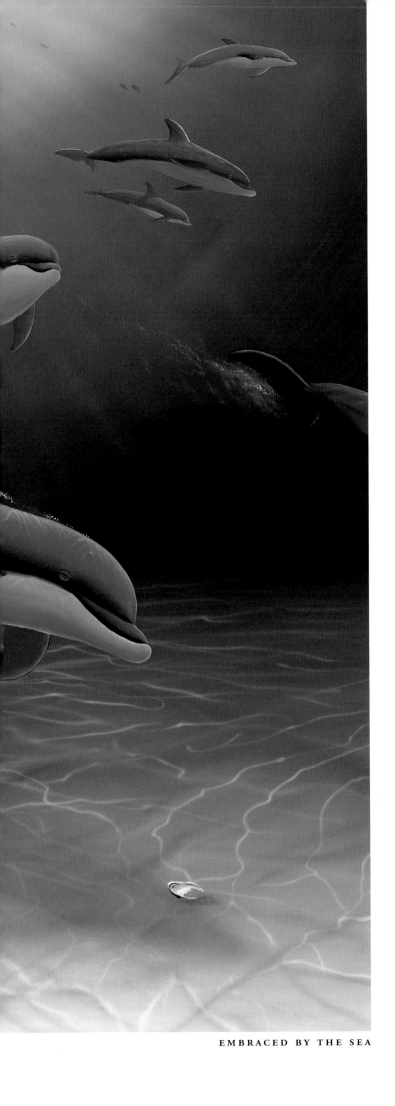

Dolphins, Manatees, & Other Sea Life

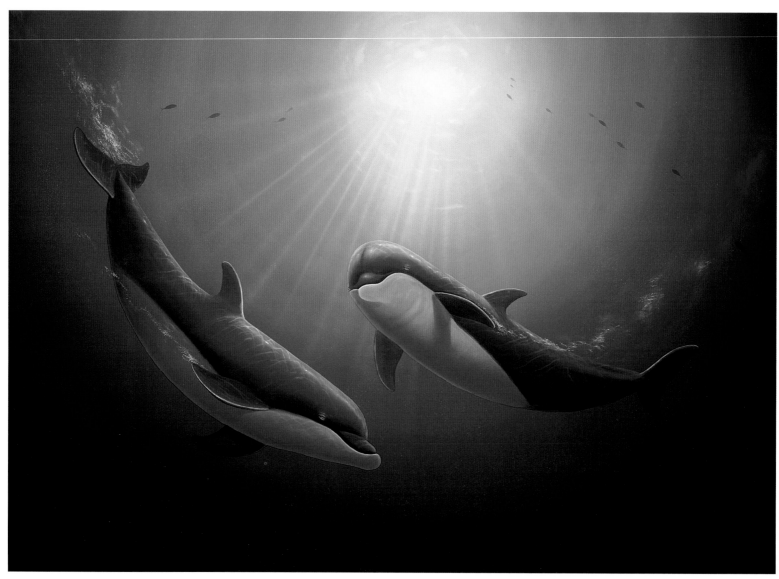

OCEAN COMPANIONS

"To the dolphin alone, beyond all others,

nature has granted what the best philosophers seek:

friendship for no advantage."

—Plutarch, (62 A.D.)

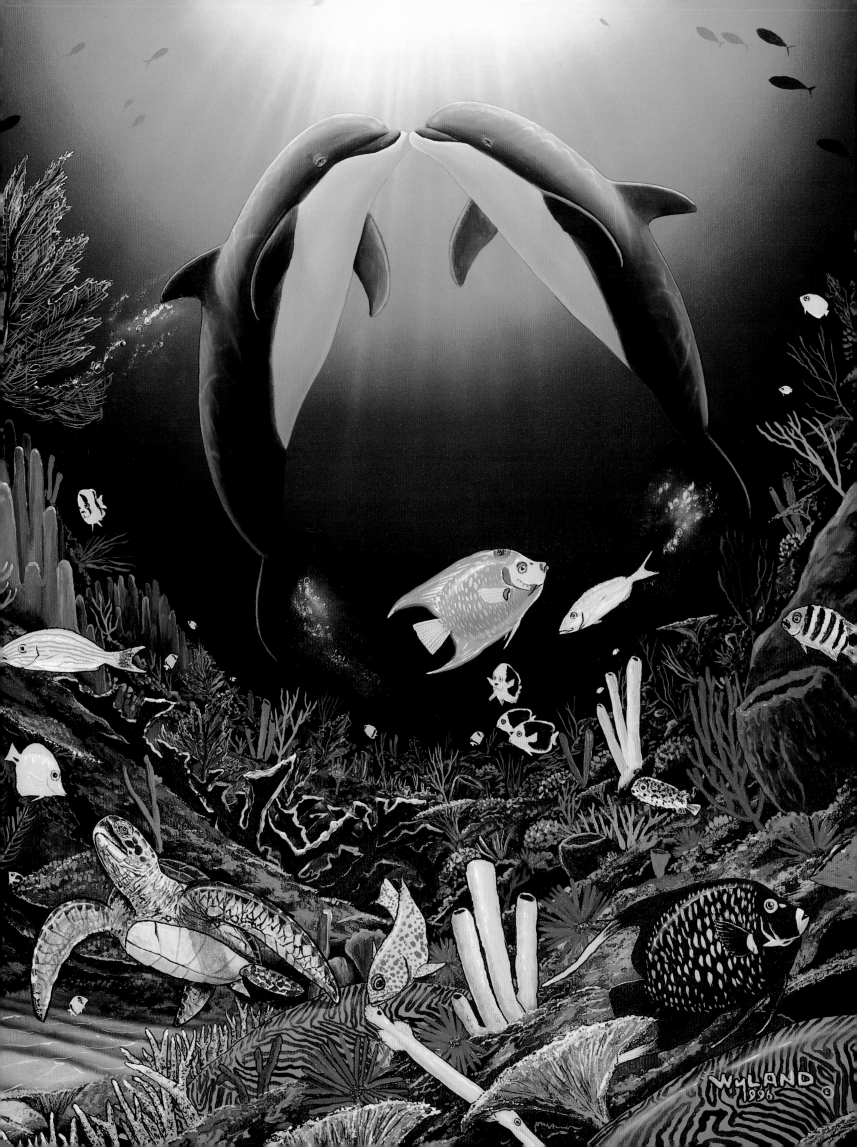

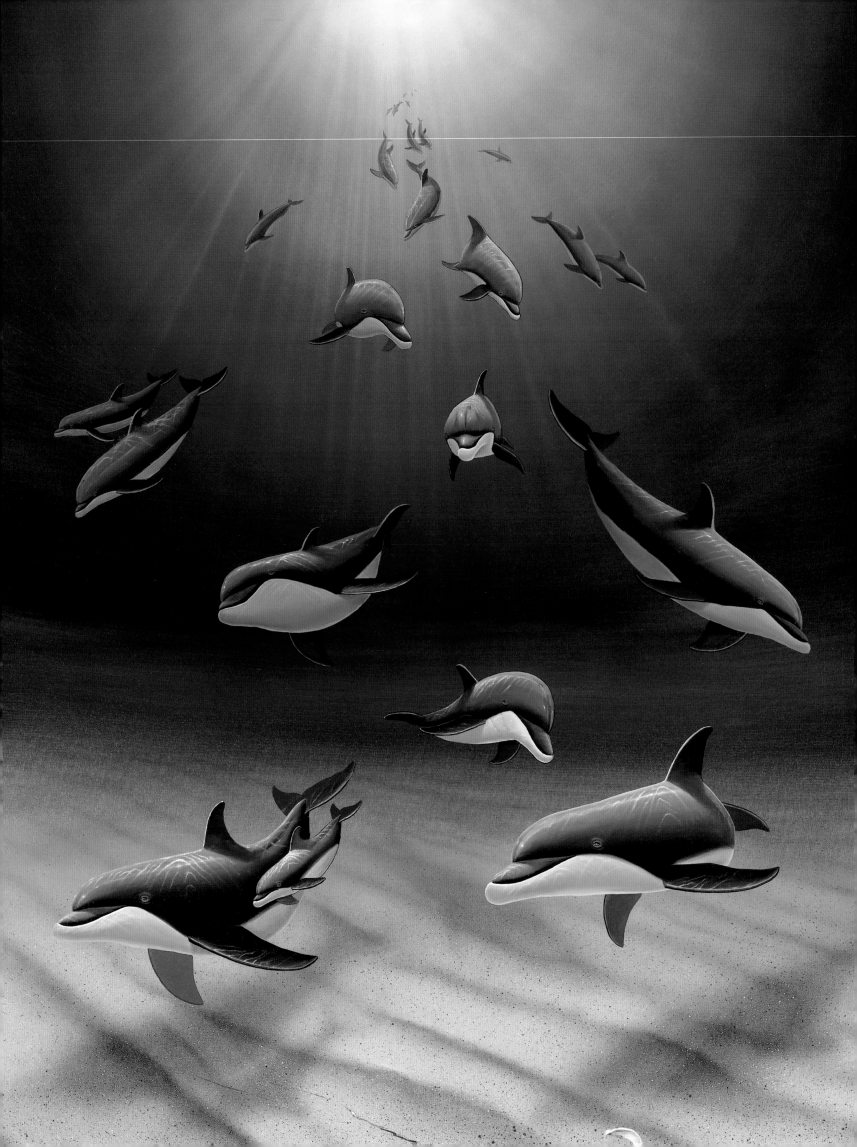

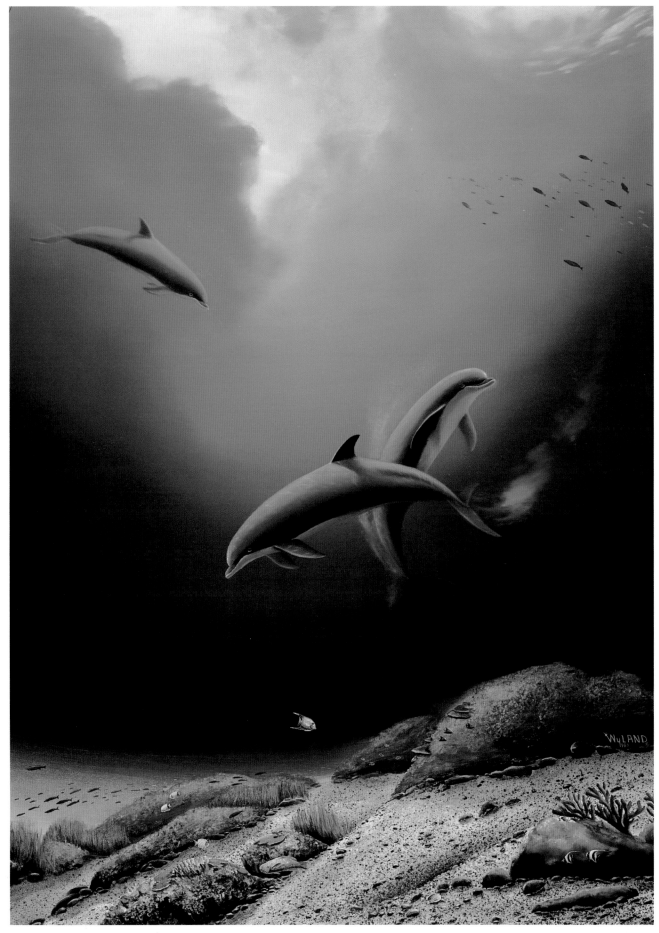

CHILDREN OF THE SEA

DOLPHIN HEAVEN

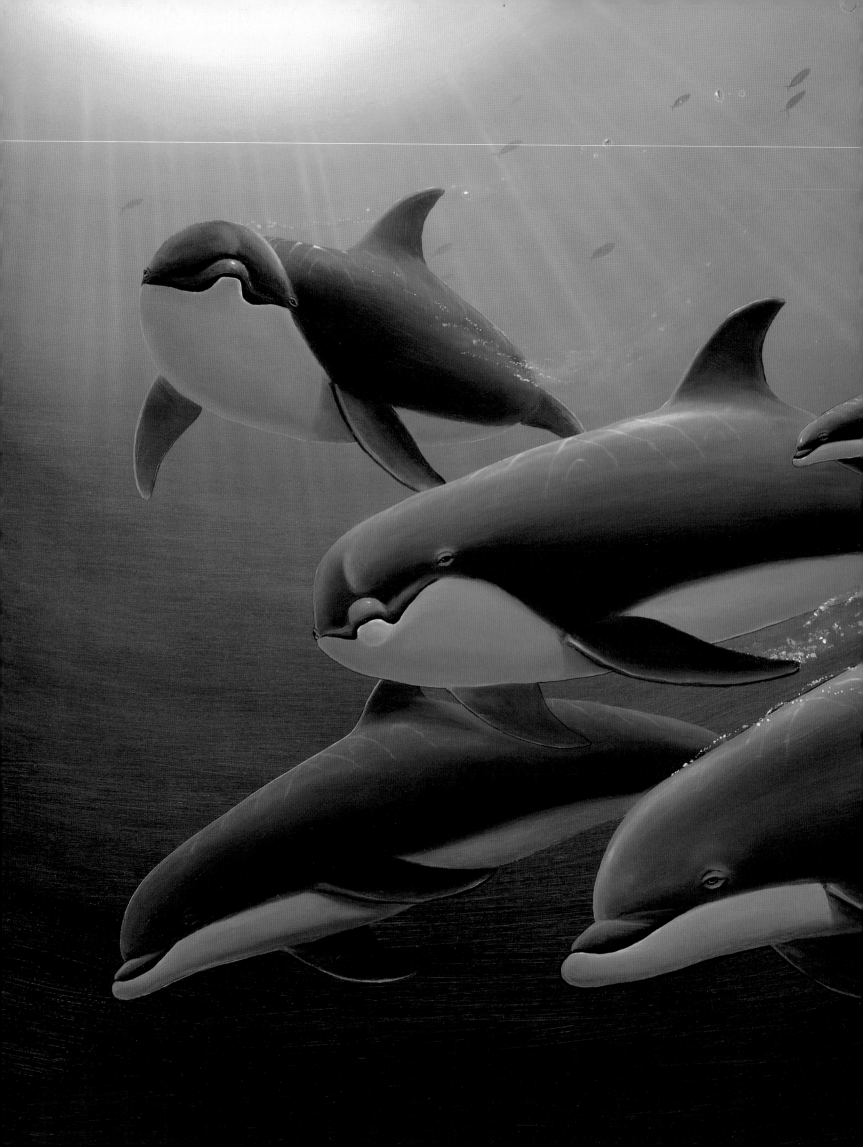

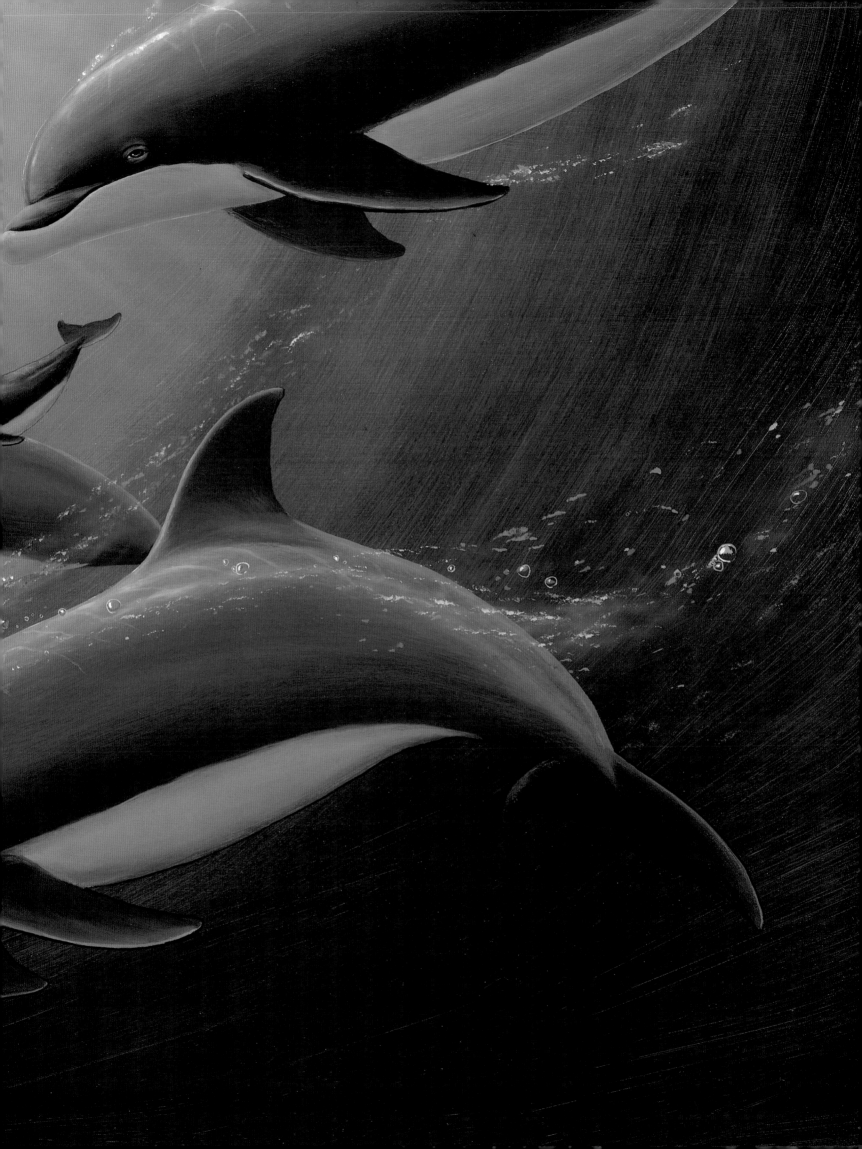

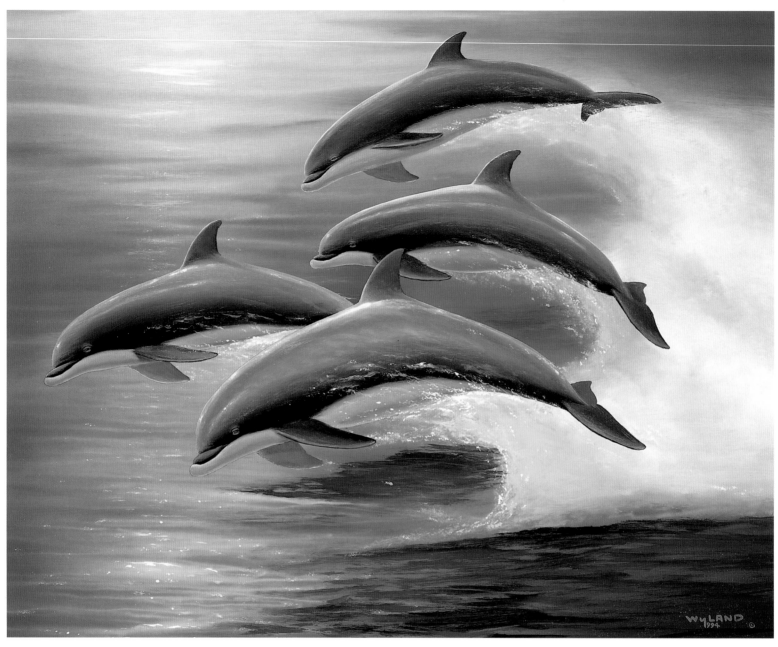

OCEAN TRAVELERS

"To say that dolphins echolocate is like saying

Michelangelo painted church ceilings."

—*Patrick W. B. Moore,* DOLPHIN SOCIETIES: DISCOVERIES AND PUZZLES

DOLPHIN SPIRIT (*previous page*) **FRIENDS OF THE SEA**

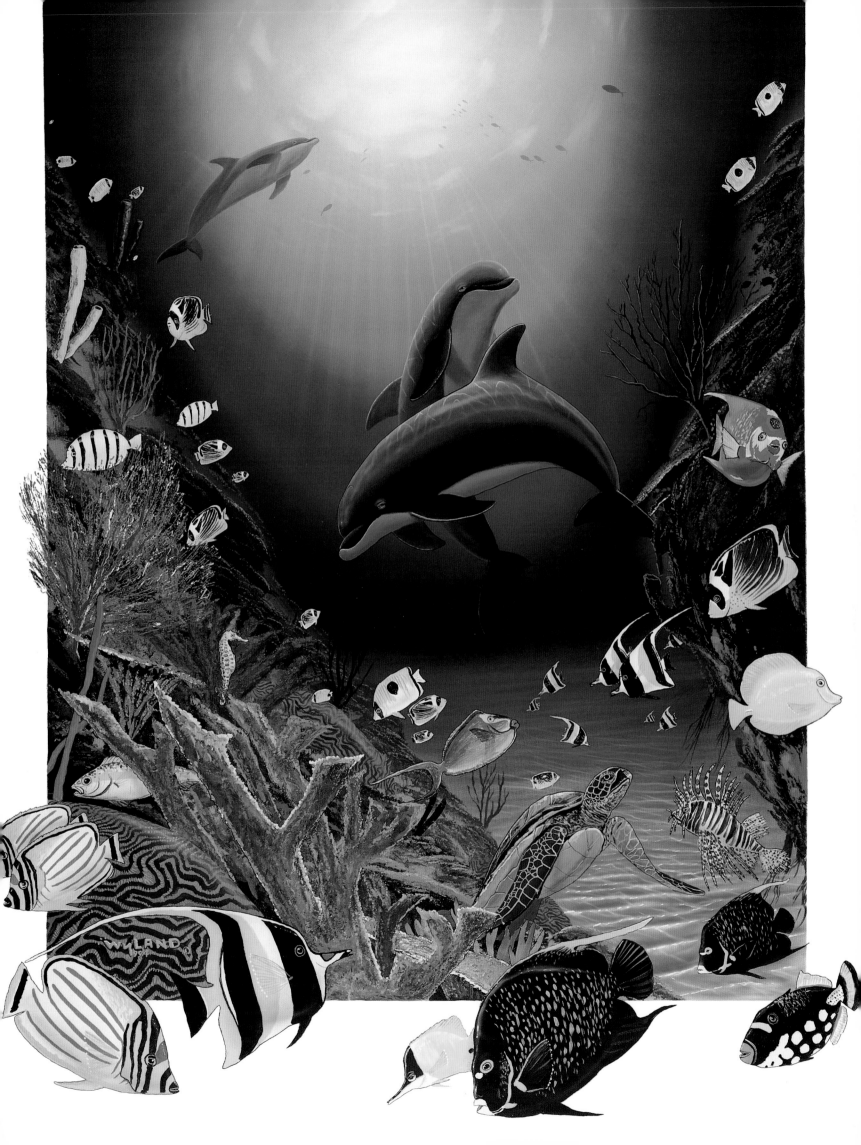

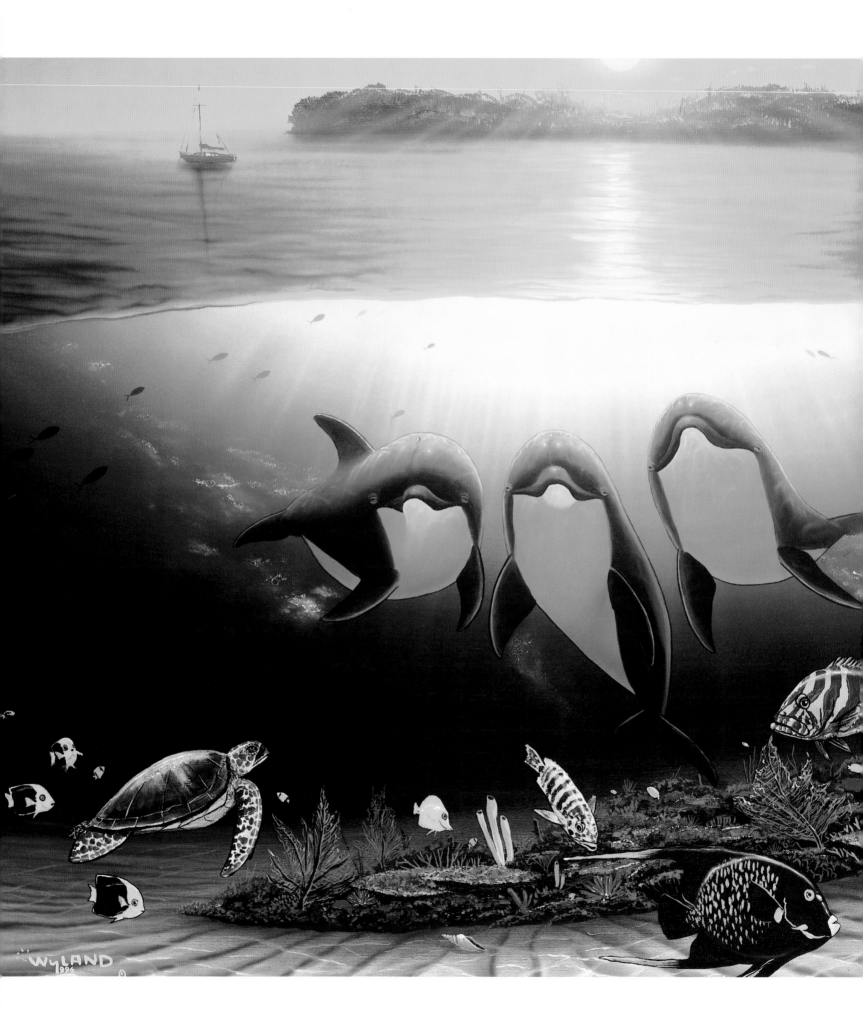

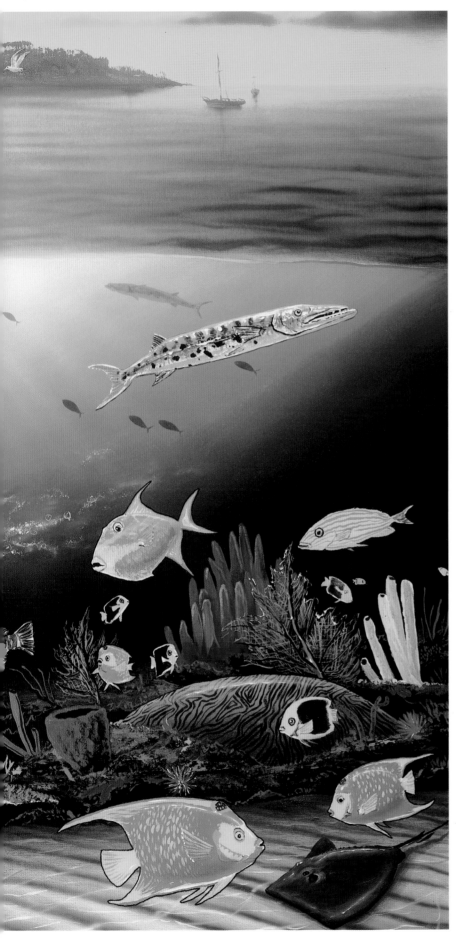

SUNSET CELEBRATION

*"When the day comes
that we can communicate
intelligently with dolphins,
they may introduce us
to the concept of
survival without aggression,
and the true joy of living,
which at present eludes us.
In that circumstance
what they have to teach us
would be infinitely more valuable
than anything we could
offer in exchange."*

—Horace Dobbs,
FOLLOW A WILD DOLPHIN

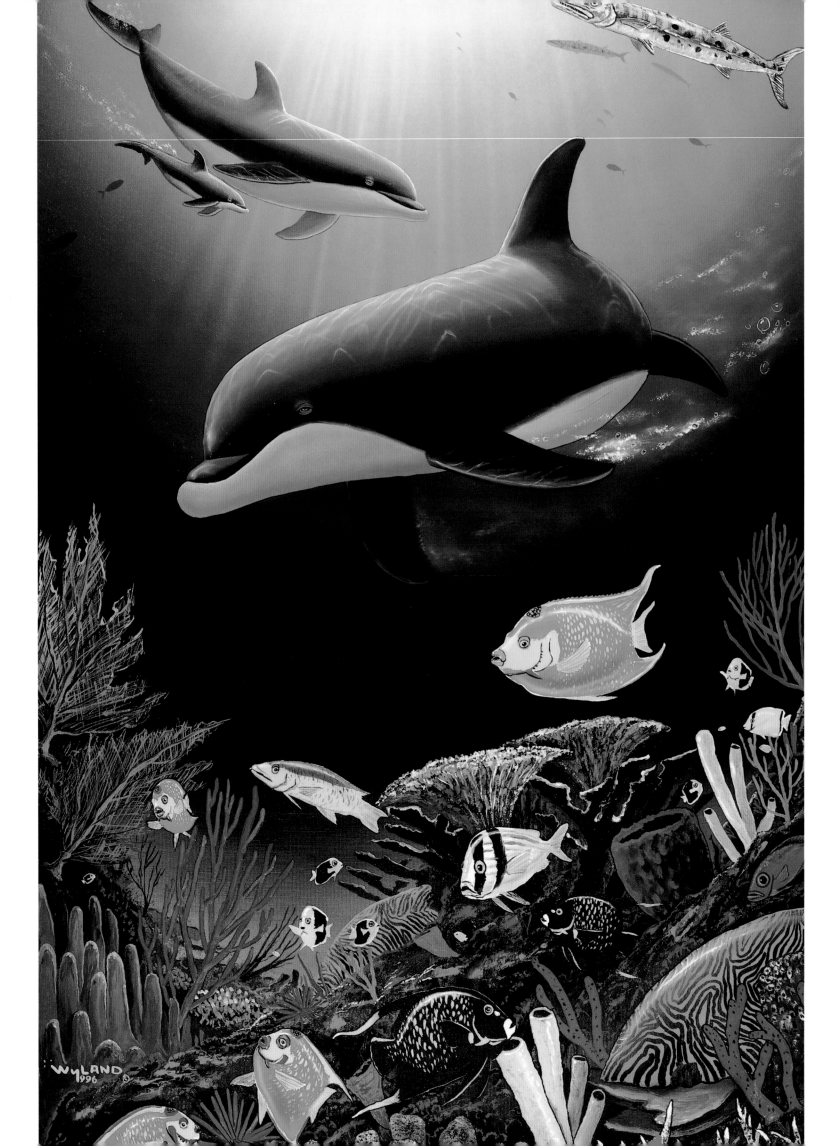

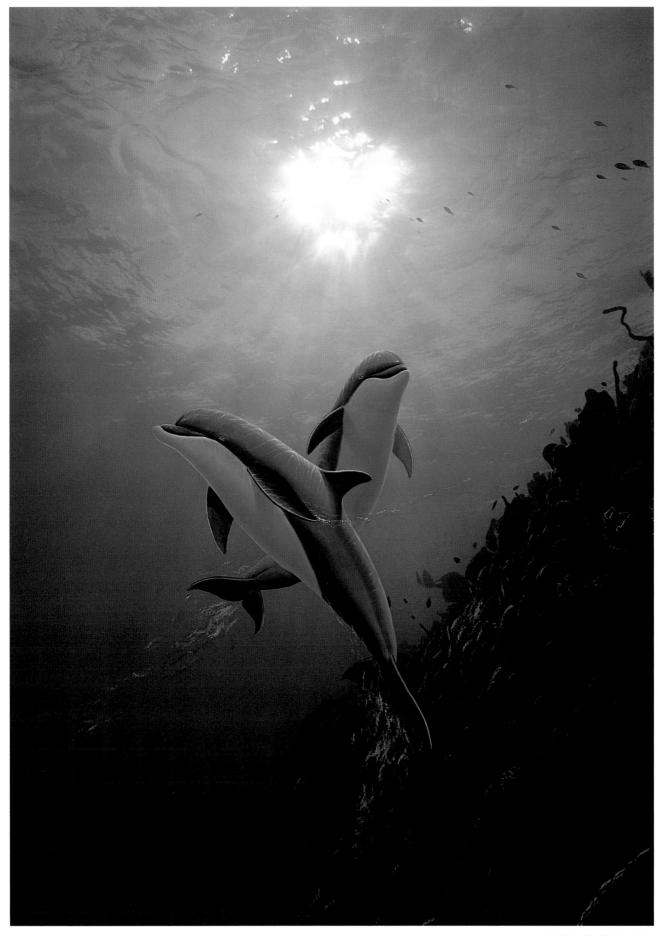

UNDERSEA TREASURES (*detail*)

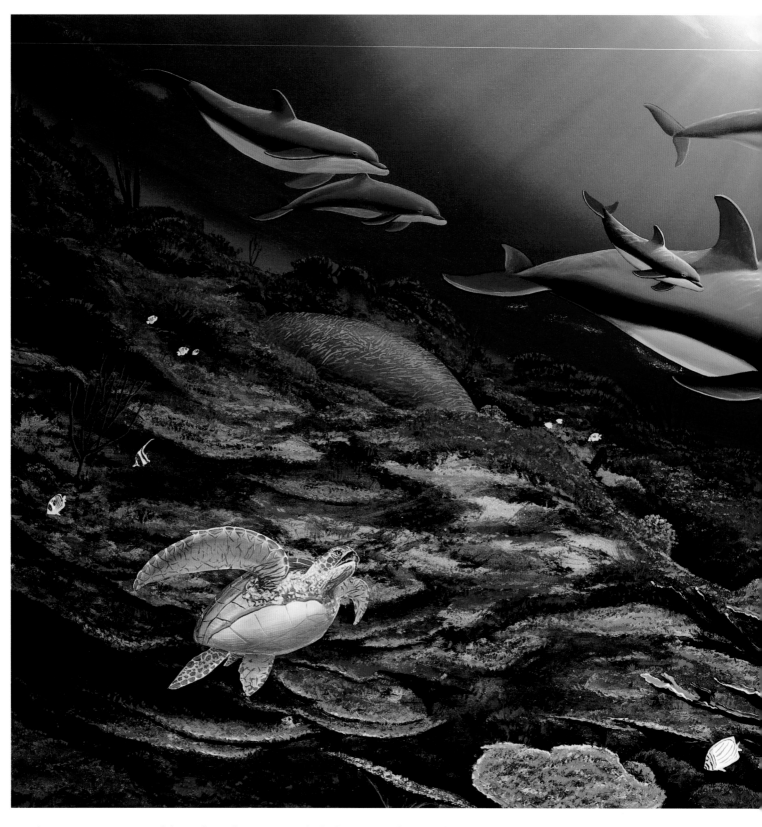

"*There is a sense of kinship between dolphins and people that goes back*

thousands of years.... A close encounter with a dolphin can be extremely emotional,

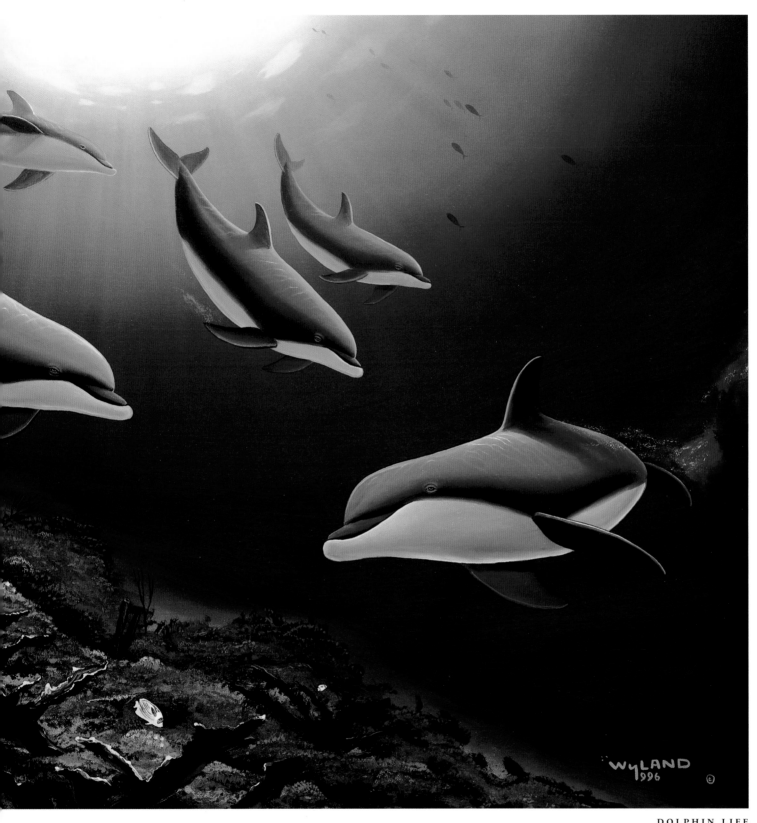

and may even trigger the healing process in people who are mentally or physically unwell."

—*Mark Carwardine,* THE BOOK OF DOLPHINS

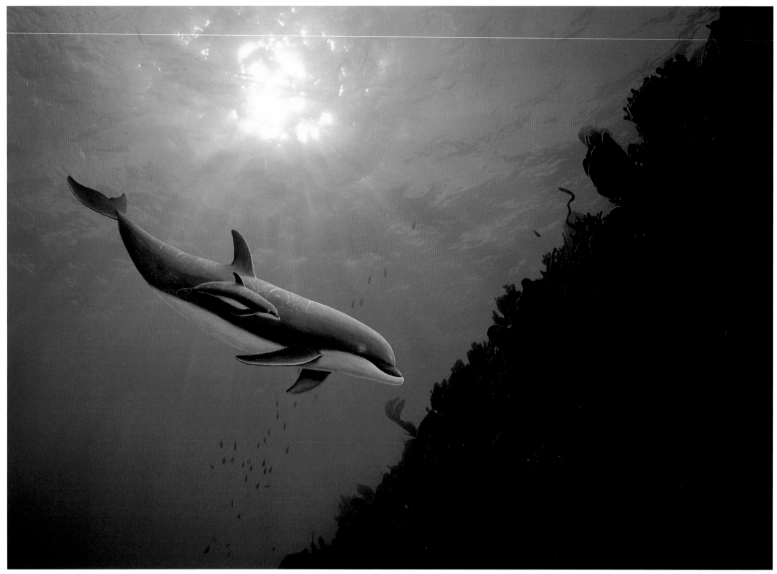

DOLPHIN VISION

"Dolphins seem to be one of the few animals on earth

that do things for fun, they spend their lives

in the pursuit of pleasure and happiness."

—*Wyland*

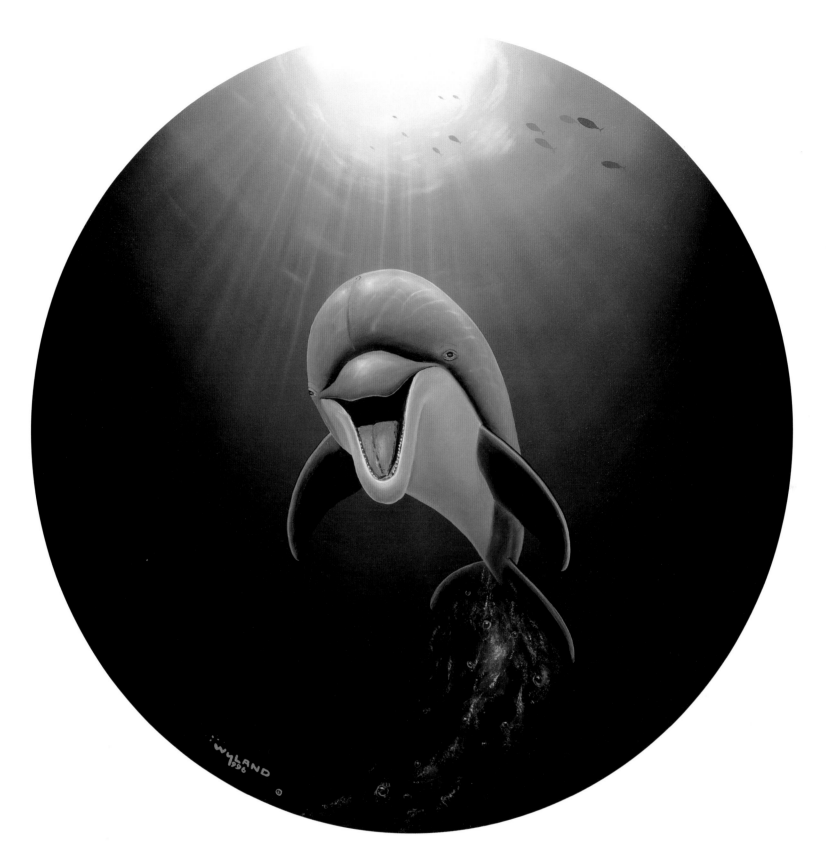

KING OF THE SEA

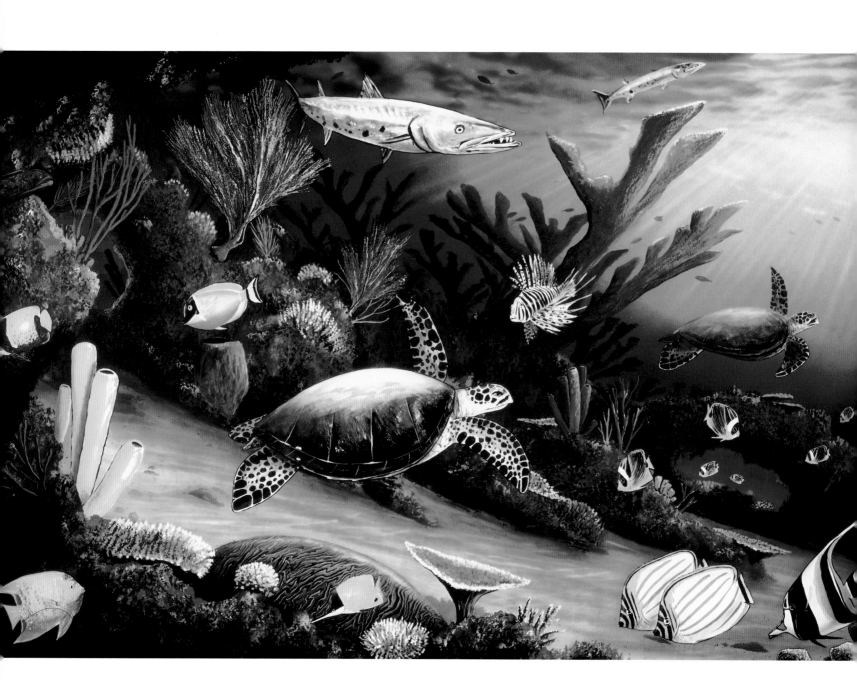

"In our lifetime we will face the most important decisions about the future of

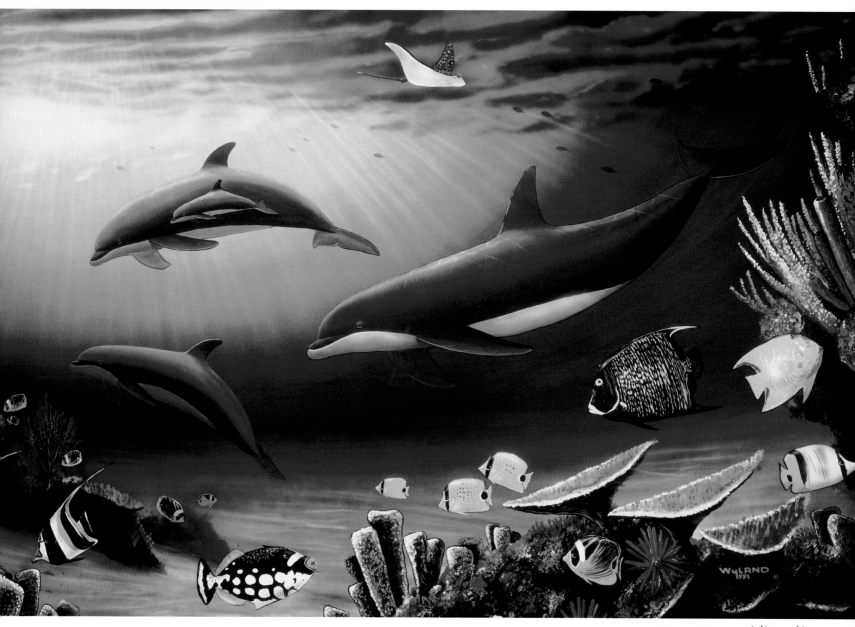

LIVING REEF (*diptych*)

life in the sea. Will we choose to keep it an Eden or witness a paradise lost?"

—*Sylvia A. Earle,* EXPLORING THE DEEP FRONTIER

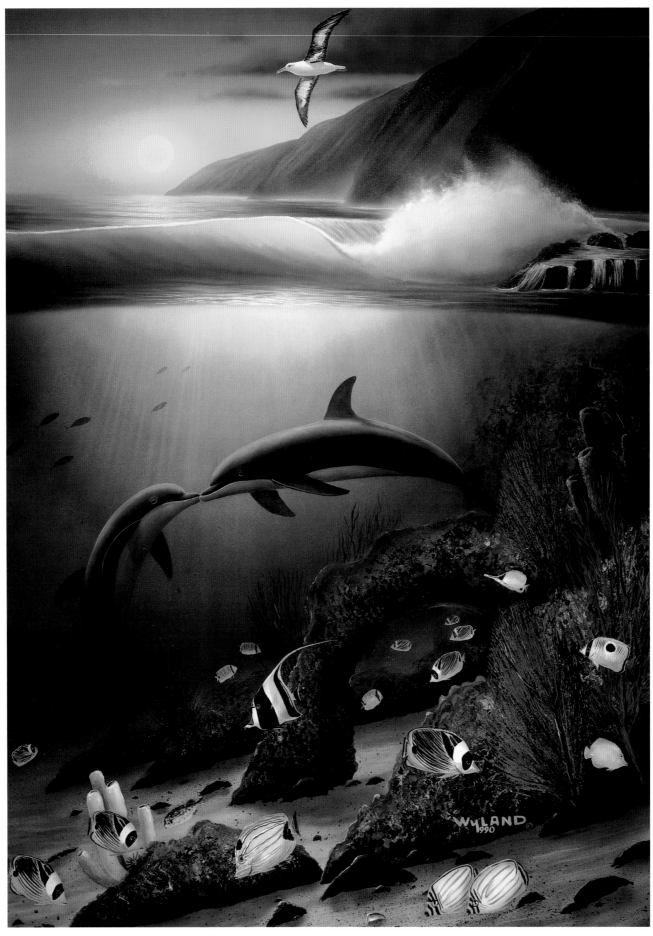

KISSING DOLPHINS

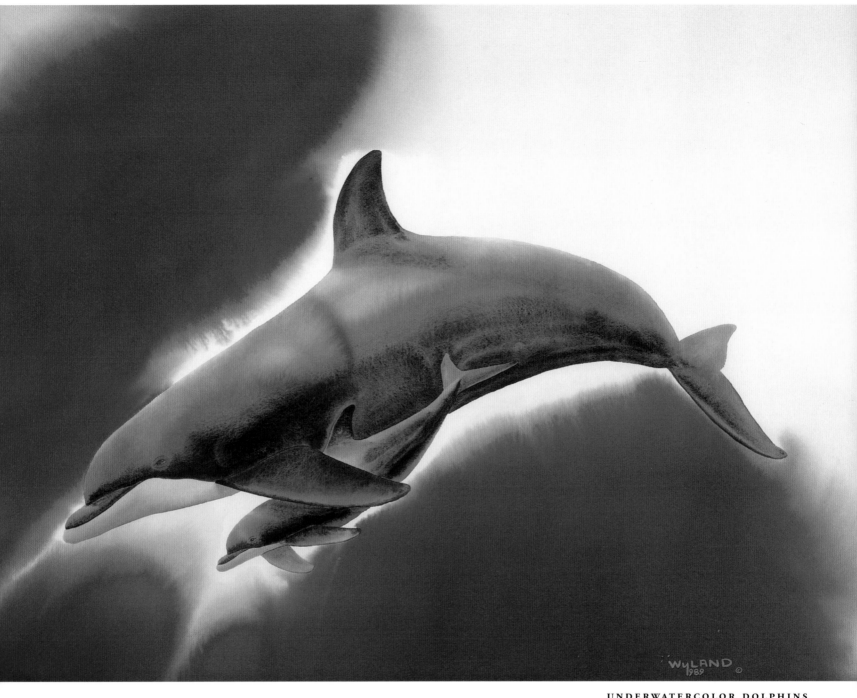

UNDERWATERCOLOR DOLPHINS

"They do not so much resemble us ... but when we look into their eyes and observe their actions, we recognize them as intelligent social mammals ... and we come to the conclusion that, despite their many obvious differences, they are one of us."

—*Bernard Wursig,* REALM OF THE DOLPHIN

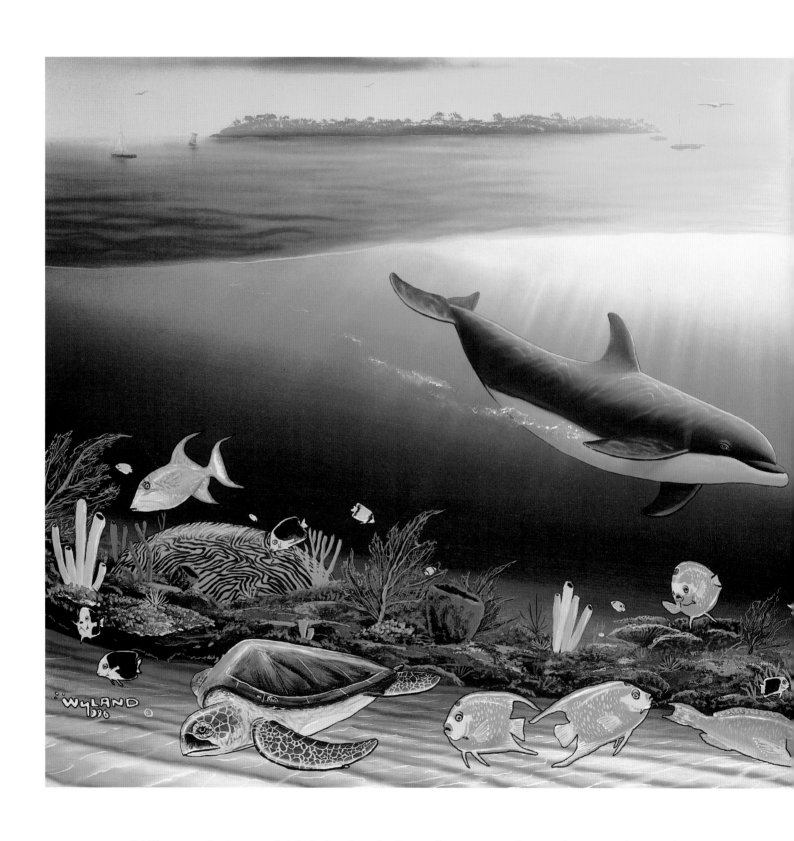

"The English word 'dolphin' is believed to come from the Greek word delphys,

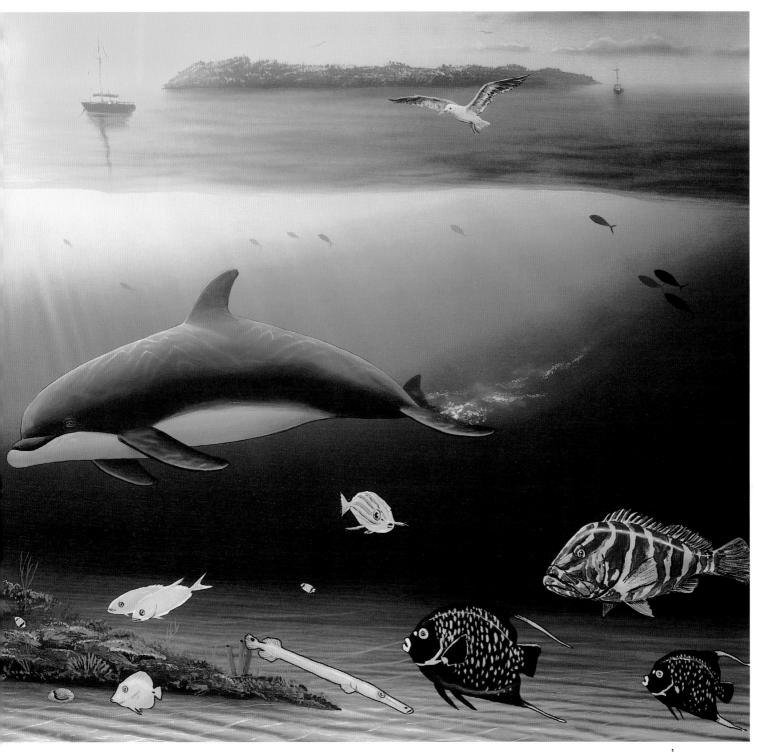

FLORIDA'S PARADISE

which means 'womb'; this is a symbol for the source of life...."

—*Mark Carwardine,* THE BOOK OF DOLPHINS

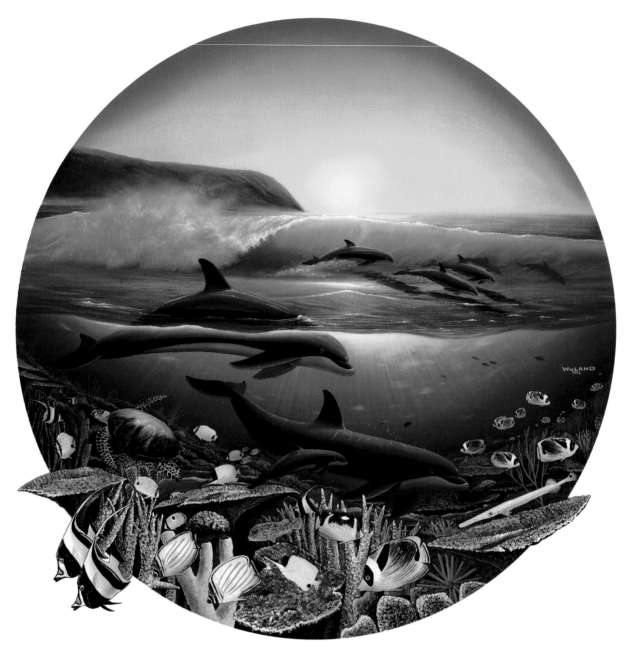

SURFING

"*The god Apollo saw the smallest whale, the dolphin, as the embodiment*

of peaceful virtue, undisguised joy, and as a guide to another world.

He sometimes exchanged his godlike status to assume dolphin form …

and founded the oracle at Delphi, named in the dolphin's honour."

—*Heathcote Williams,* WHALE NATION

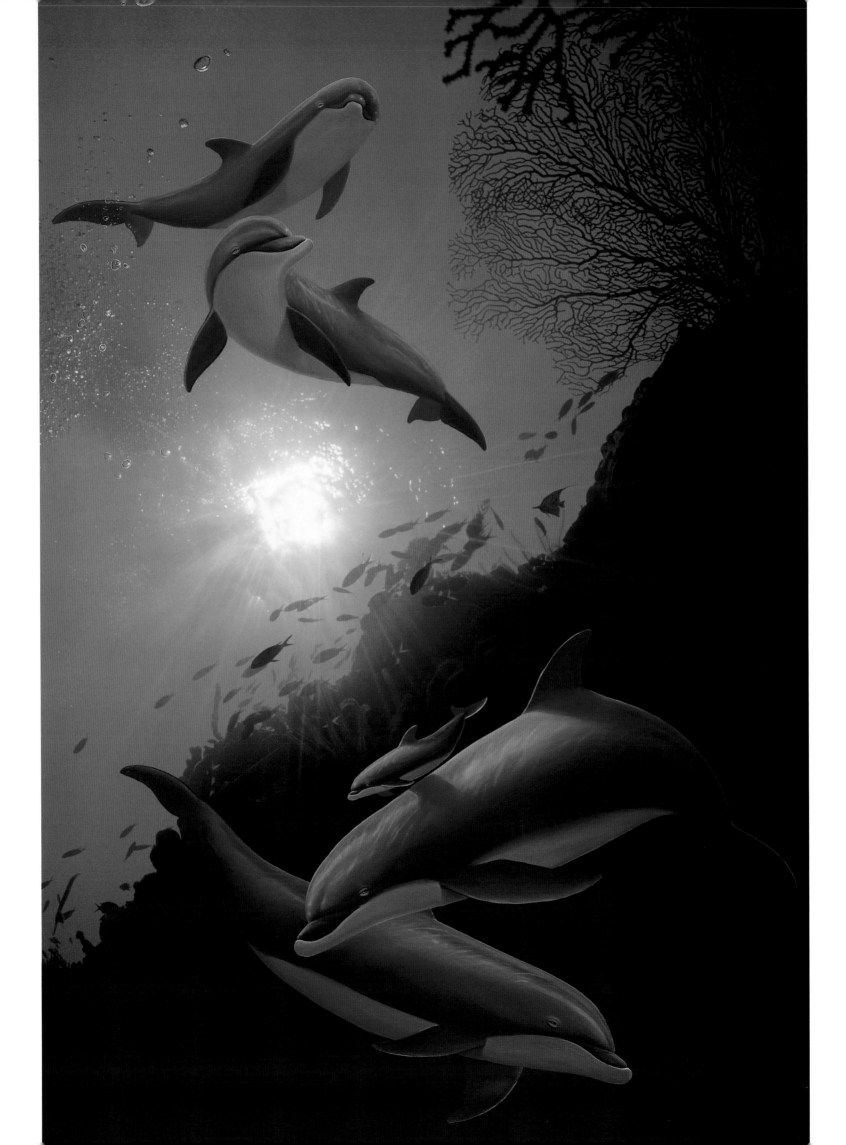

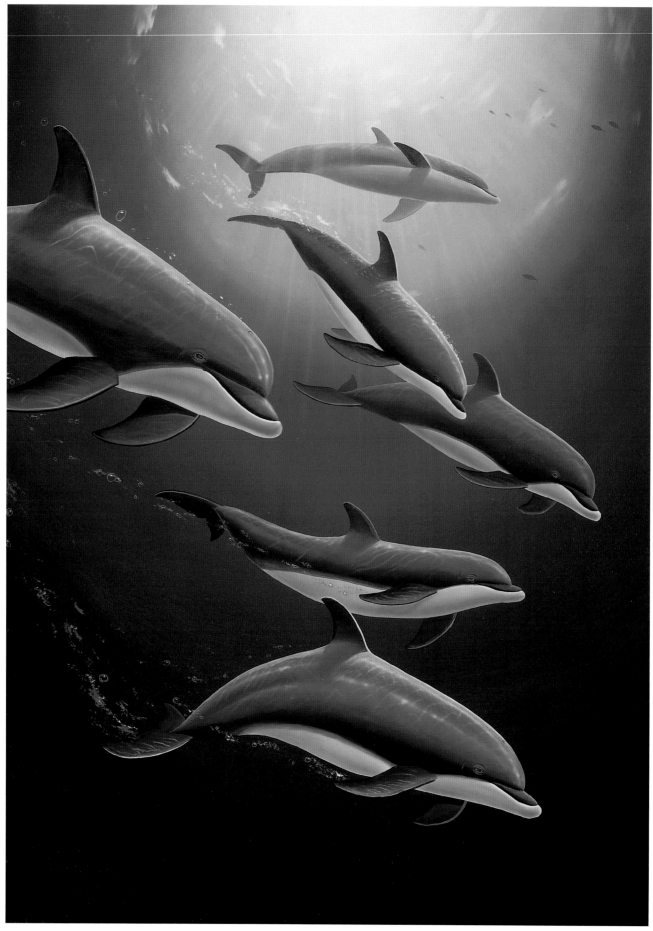

DOLPHIN TRIBE

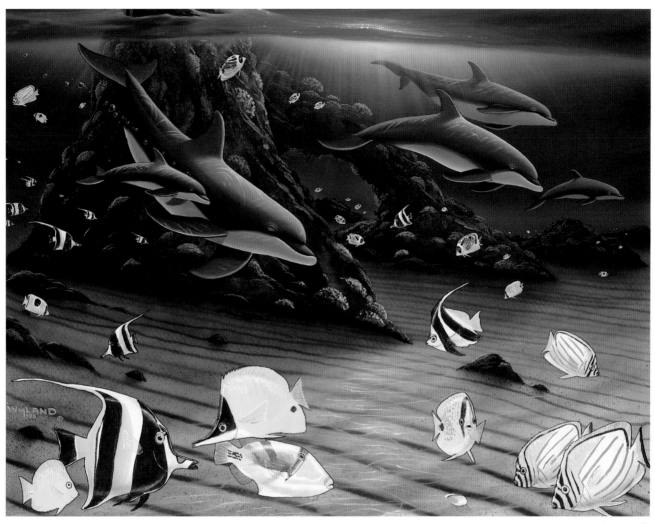

HANALEI BAY (*detail*)

"*Dolphins have a deep sense of family and you can sense their intimacy.*

It's possible to see several generations of the same

family living together over the years—

grandparents, parents, children."

—*Wyland*

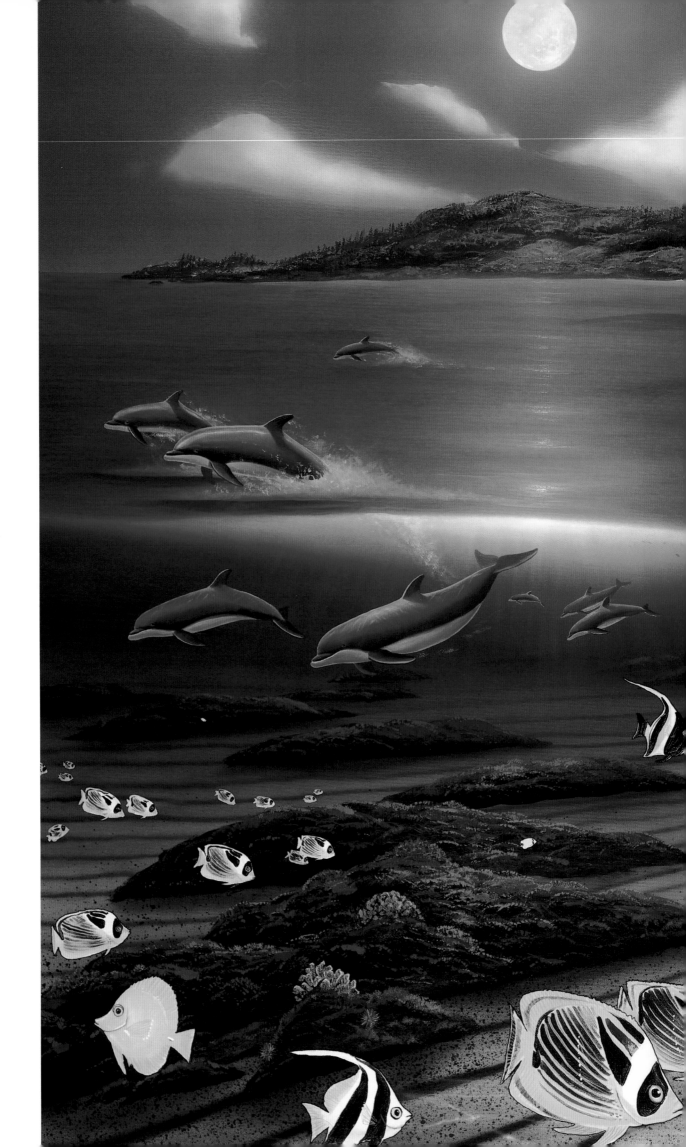

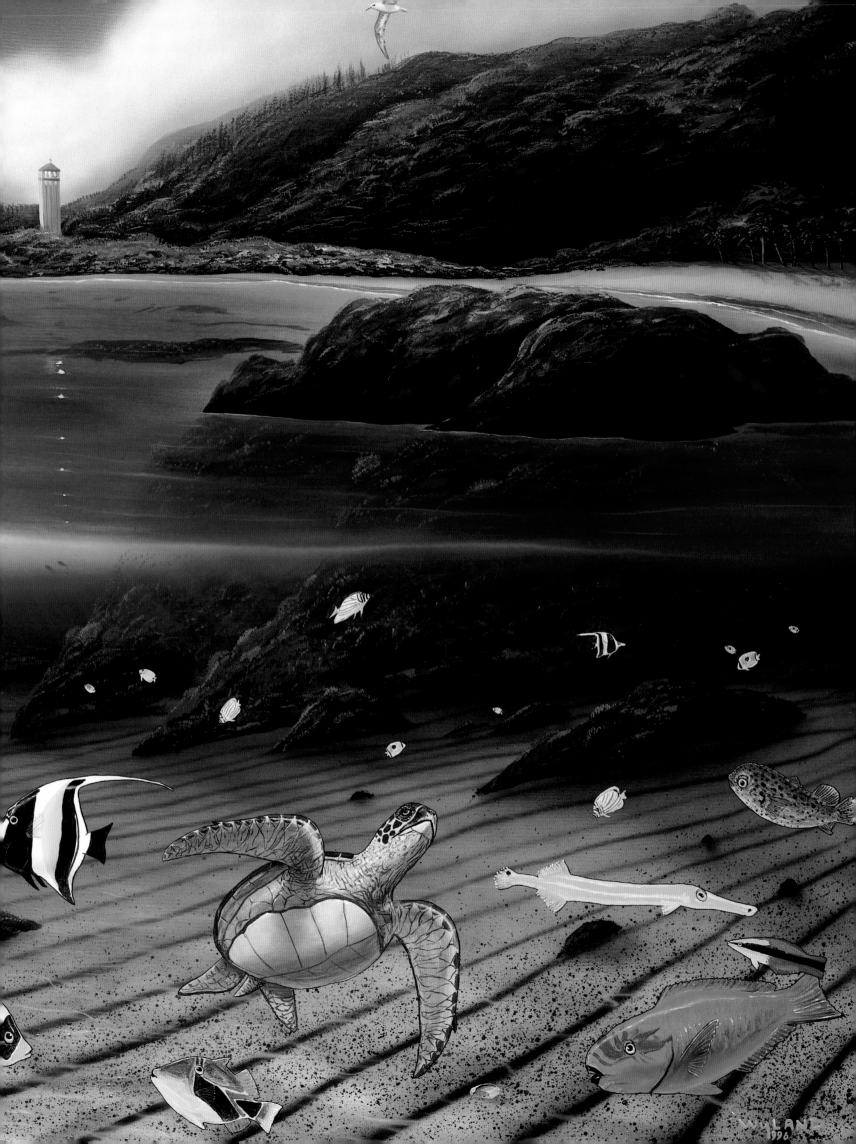

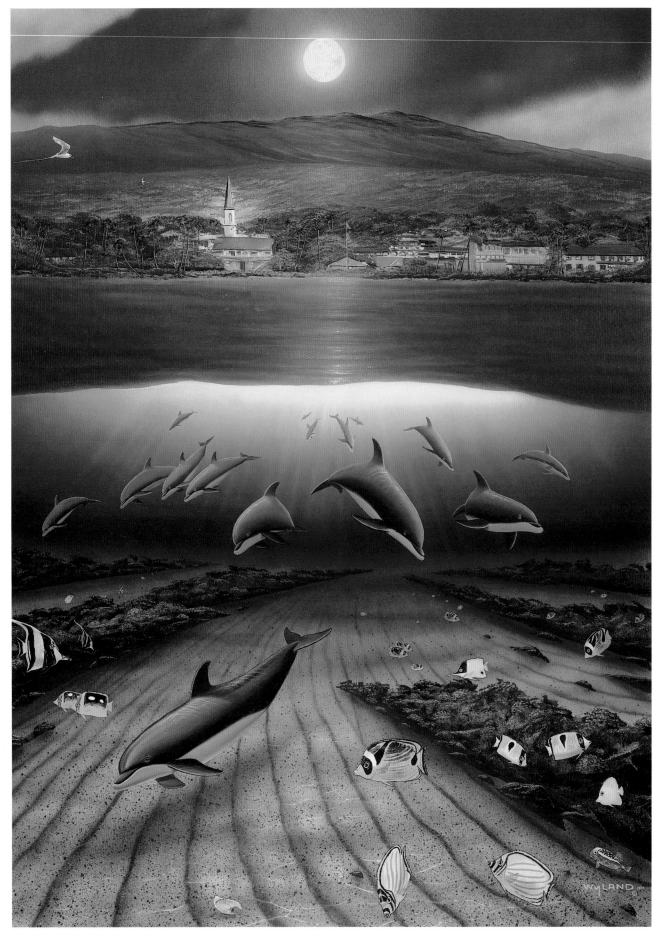

KONA MOON

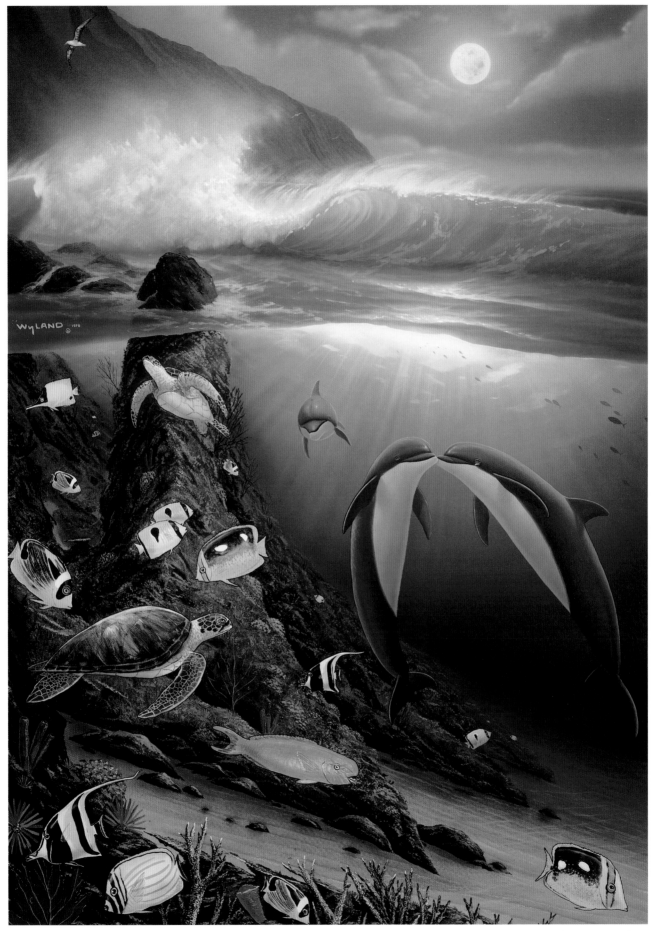

MYSTERIES OF THE SEA

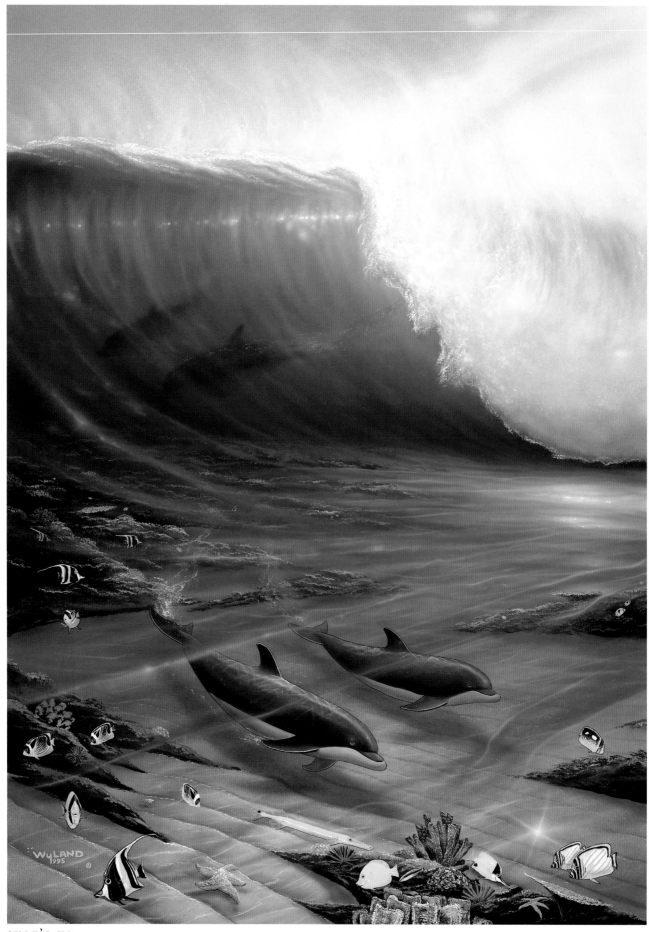

SURF'S UP

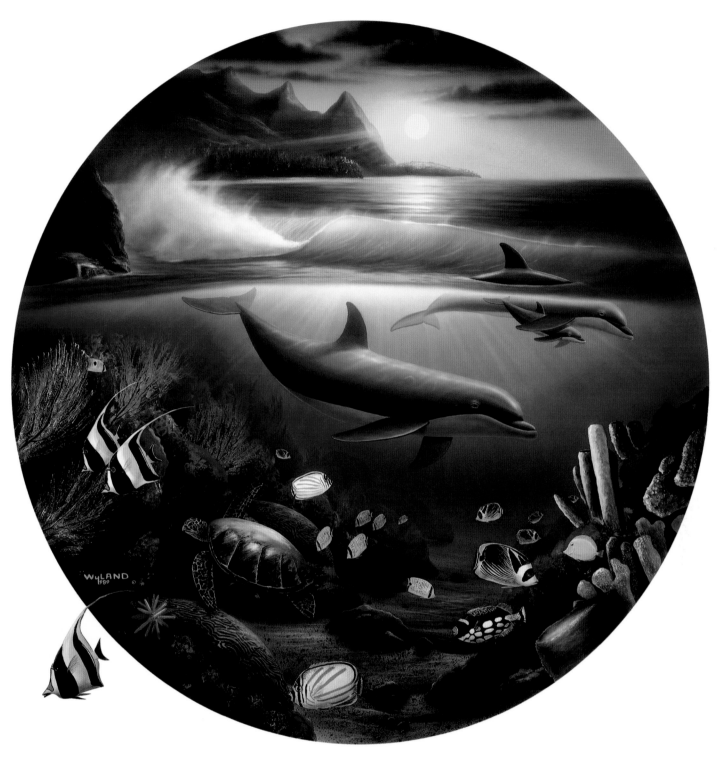

DOLPHIN PARADISE

"There's plenty of water in the universe without life,

but nowhere is there life without water."

—*Sylvia A. Earle,* SEA CHANGE

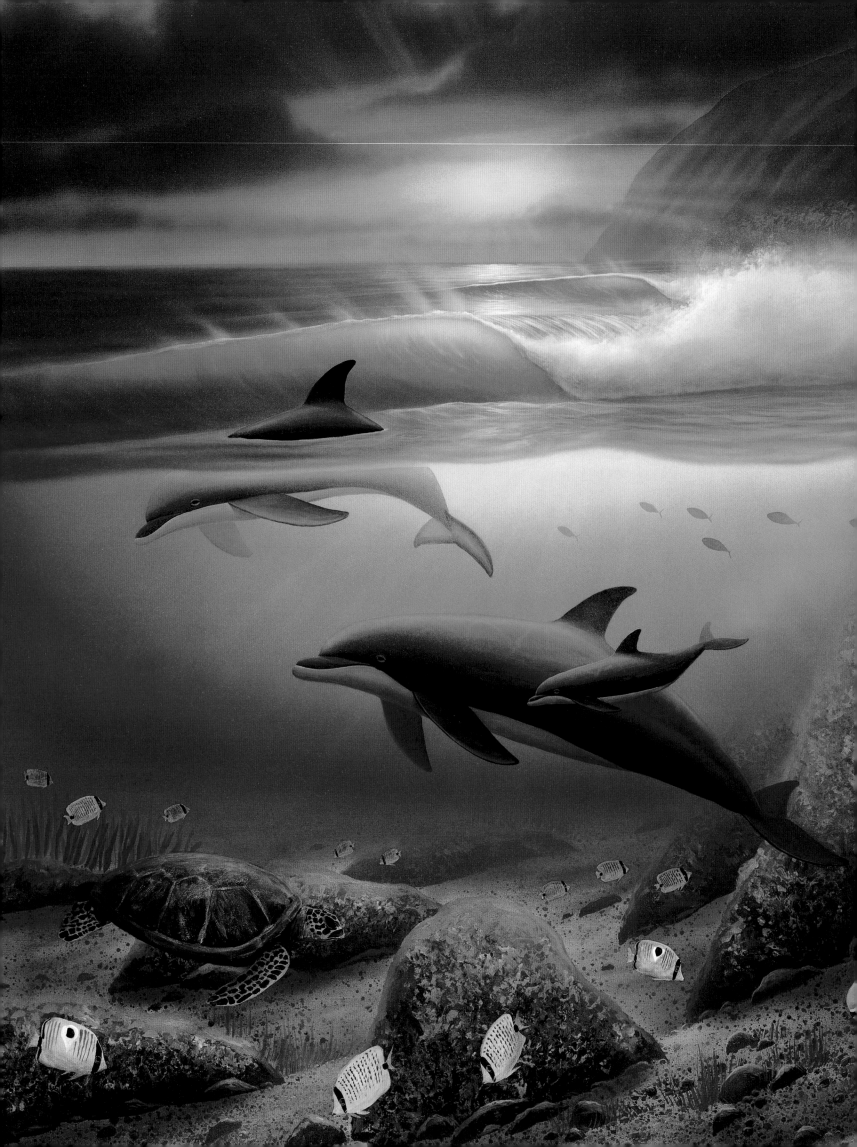

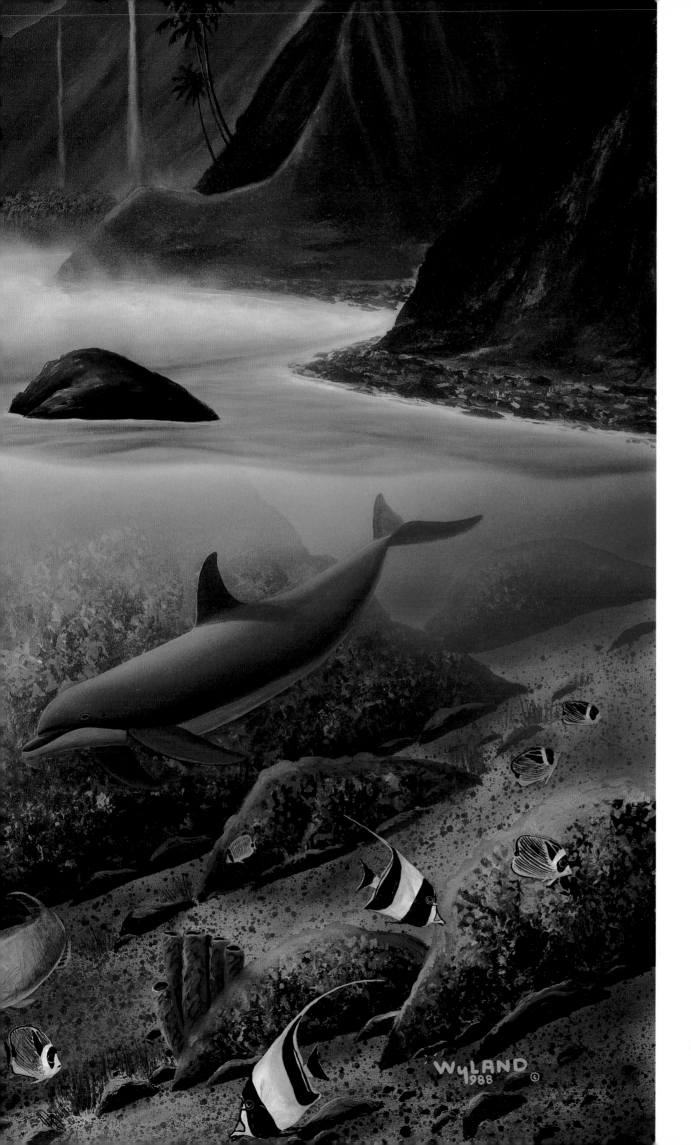

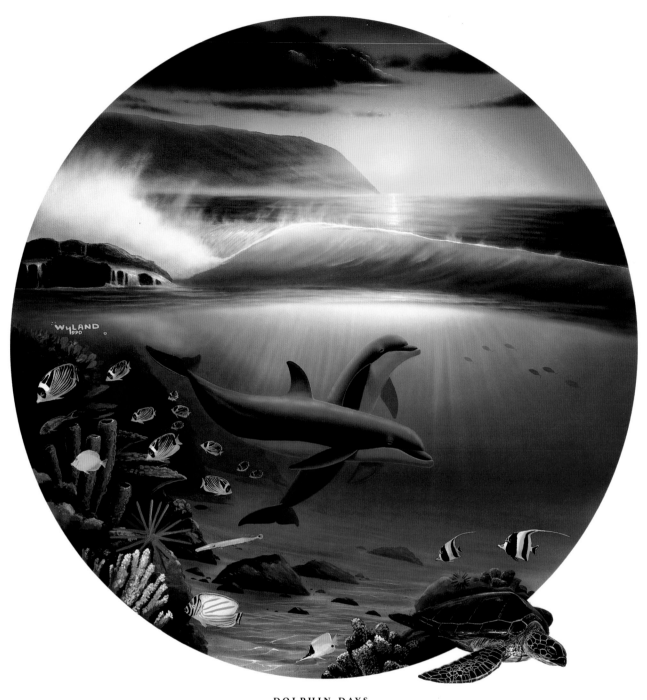

DOLPHIN DAYS

"When I hit a moment in playing the music when it really started working for me and I was

really in the groove, all of a sudden there was a crowd of dolphins in the window, just

completely hovering right there with their eyes locked on me. And what was interesting for

me was that if I got where I started to hesitate and hunt for chords, they'd split,

and as soon as the groove came back they'd be right back there."

—Kenny Loggins, EARTHTRUST *magazine*

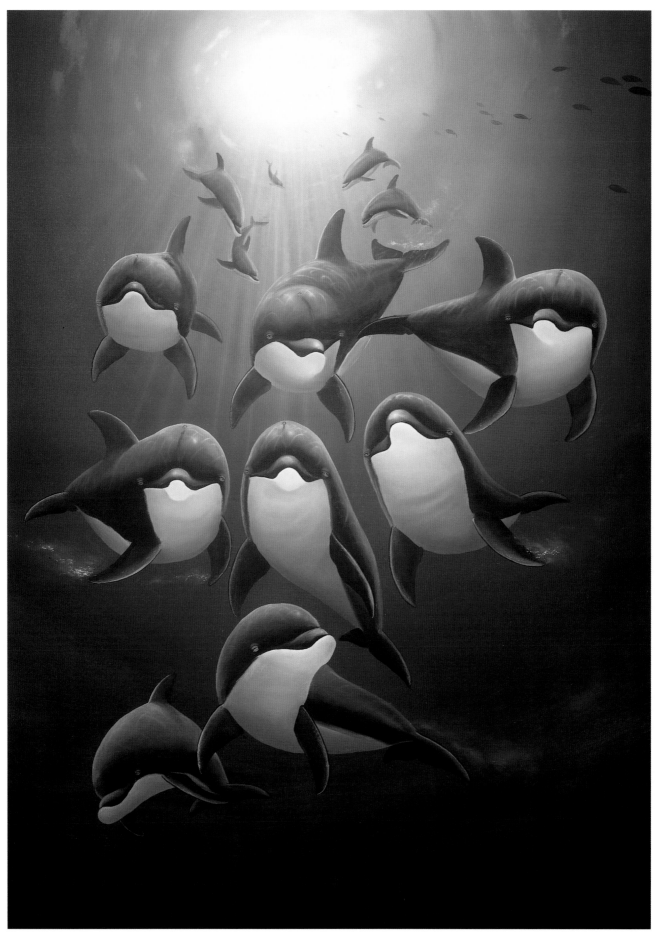

DOLPHIN PLAYGROUND

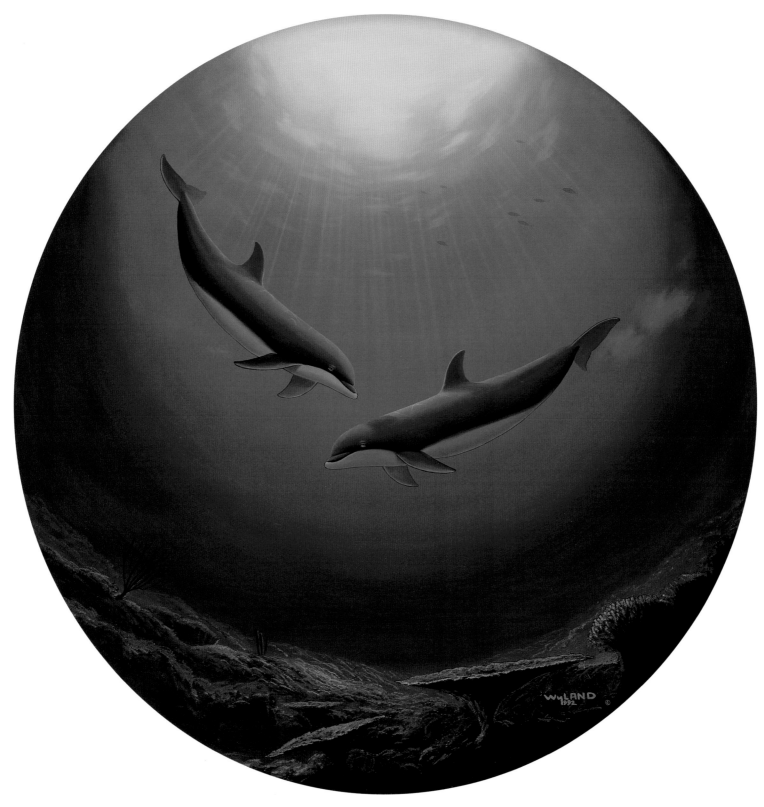

DOLPHIN SERENITY

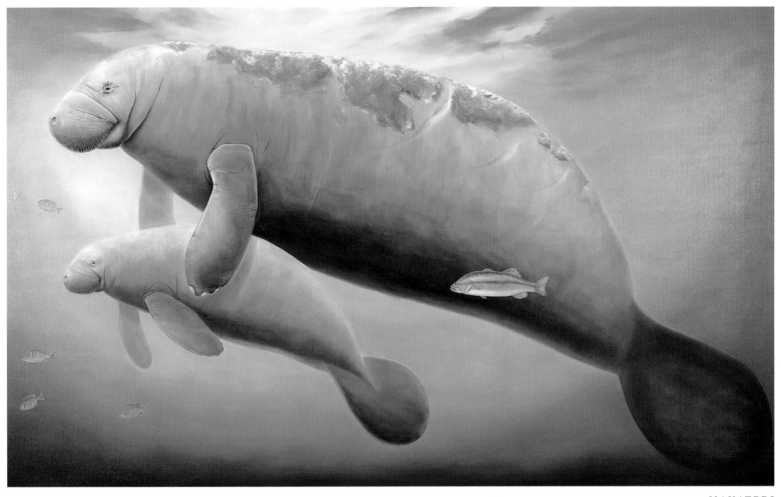

MANATEES

"The eyes of a manatee are like little black buttons, so ancient looking. They are

the most gentle creatures on earth. When I swam with them, the mother actually

let go of her calf and held me in her arms, in her flippers ... a twelve-foot

manatee and she was holding me. It changed my life."

—*Wyland*

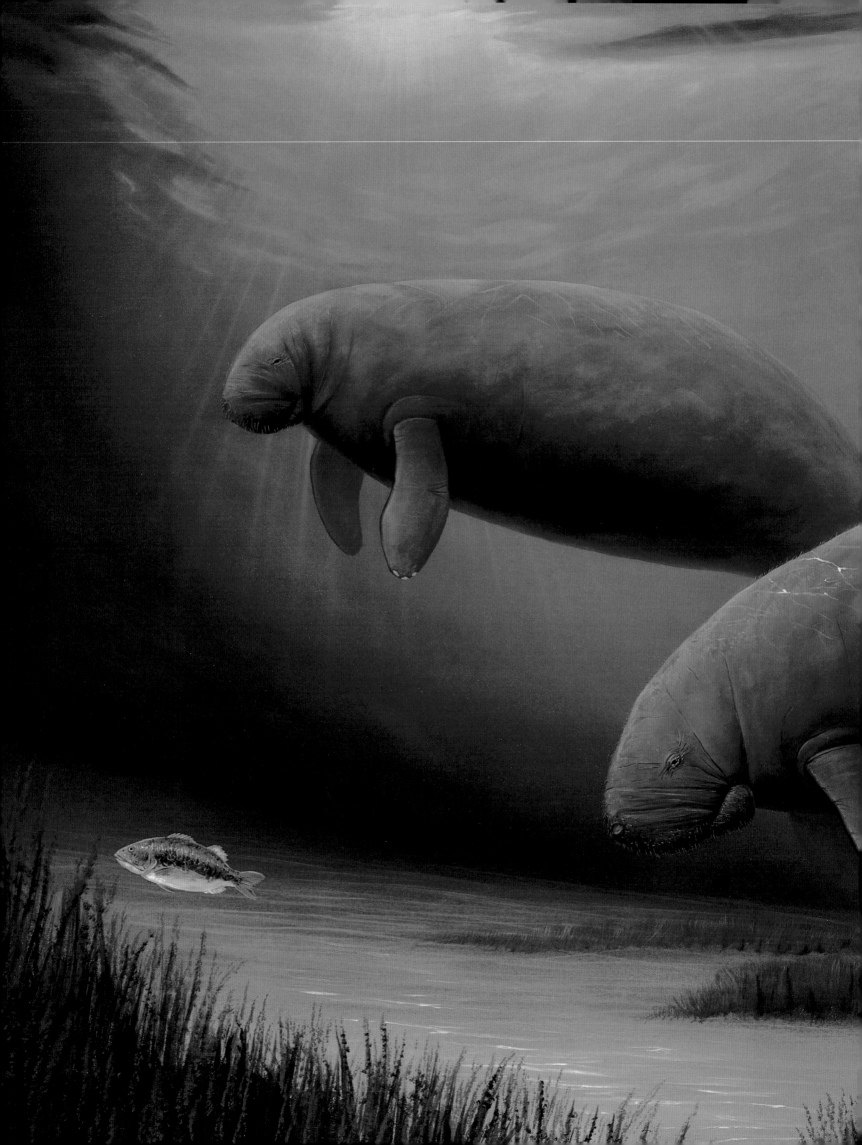

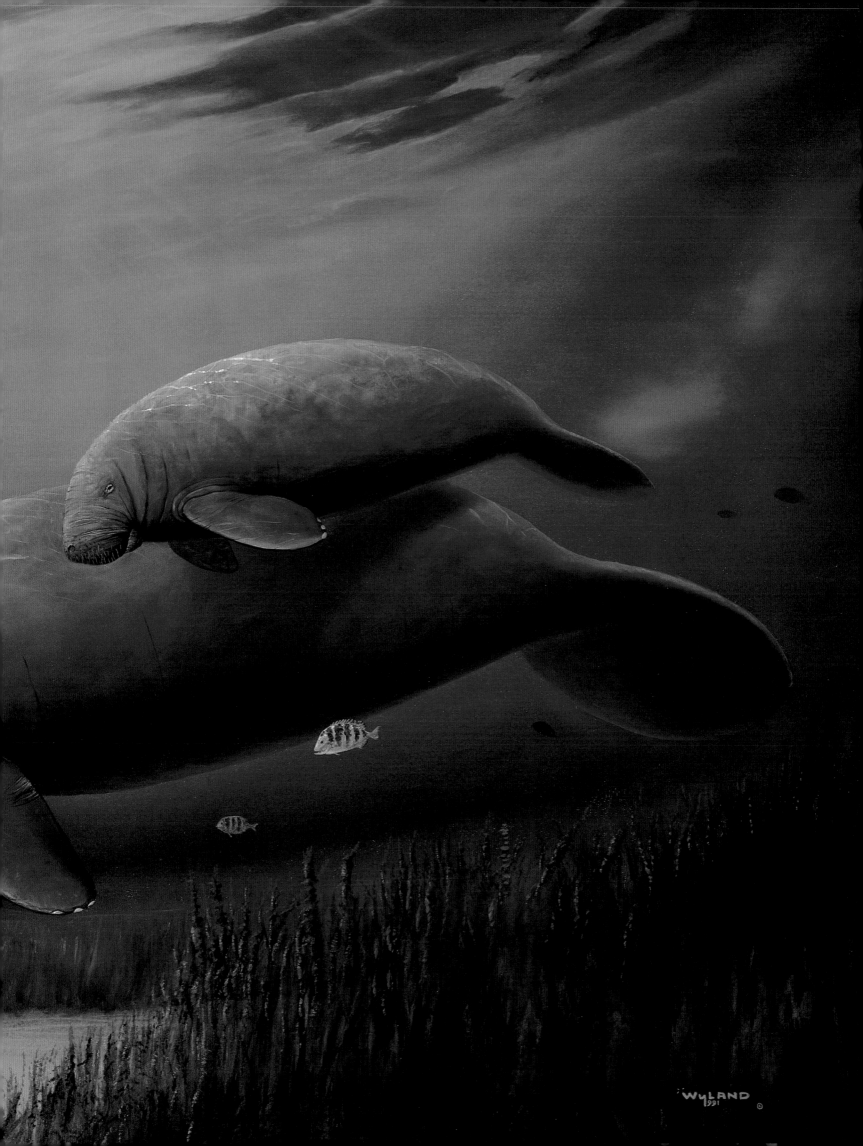

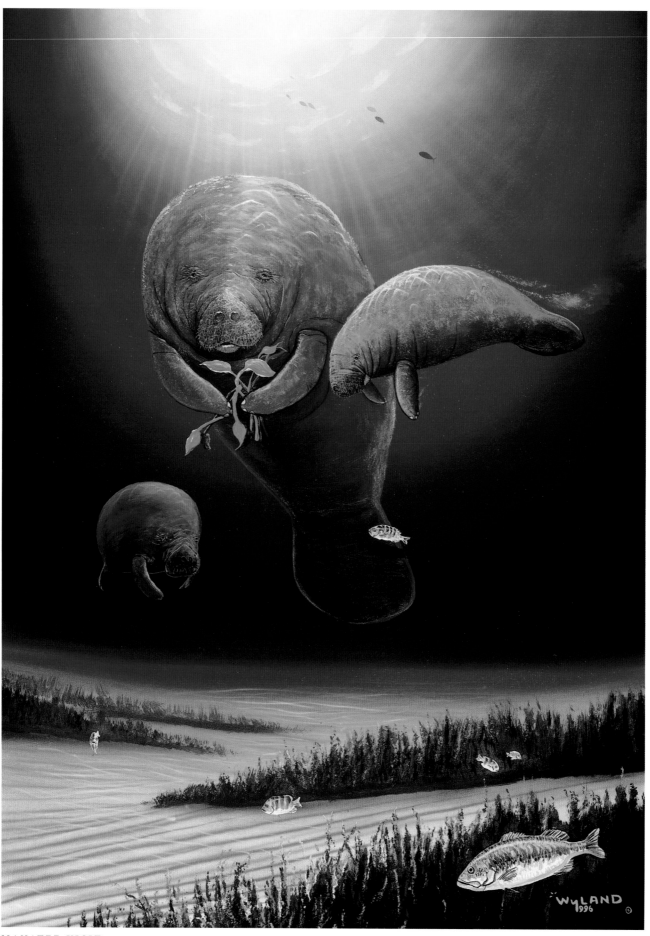

MANATEE VISIT

ENDANGERED MANATEES (*previous page*)

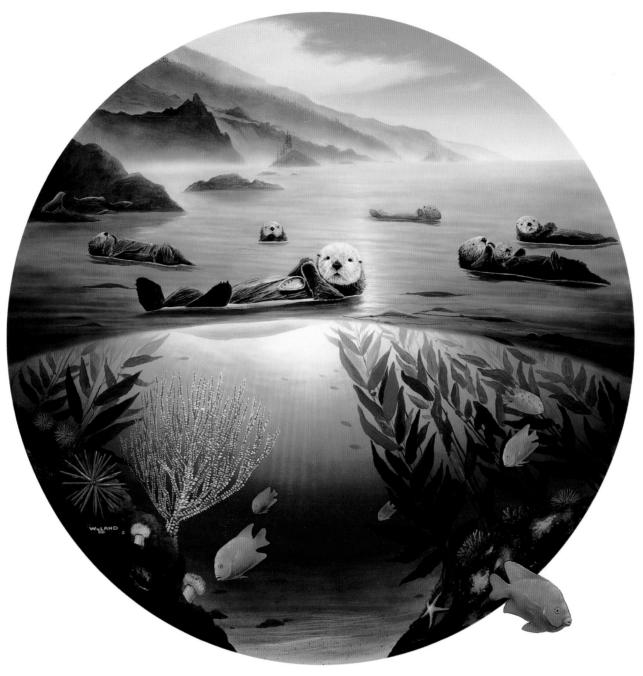

SEA OTTERS

"Hundreds of years ago, mariners believed that manatees and dugongs were indeed the mermaids of legend, and Christopher Columbus allegedly spotted some manatees ... he recorded in his log that the 'mermaids' were not quite as lovely as he had been led to believe."

—*Reynolds and Odell,* MANATEES AND DUGONGS

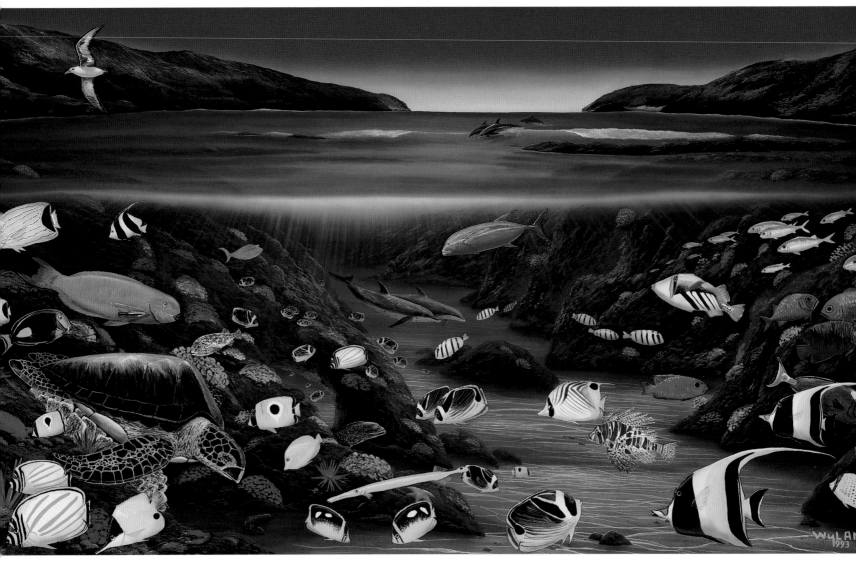

HANAUMA BAY

"If there is magic on this planet, it is contained in the water....

Its substance reaches everywhere; it touches the past and prepares the future;

it moves under the poles and wanders thinly in the heights of air. It can assume

forms of exquisite perfection in a snowflake, or strip the living

to a single shining bone cast upon the sea."

—*Loren Eiseley,* THE IMMENSE JOURNEY

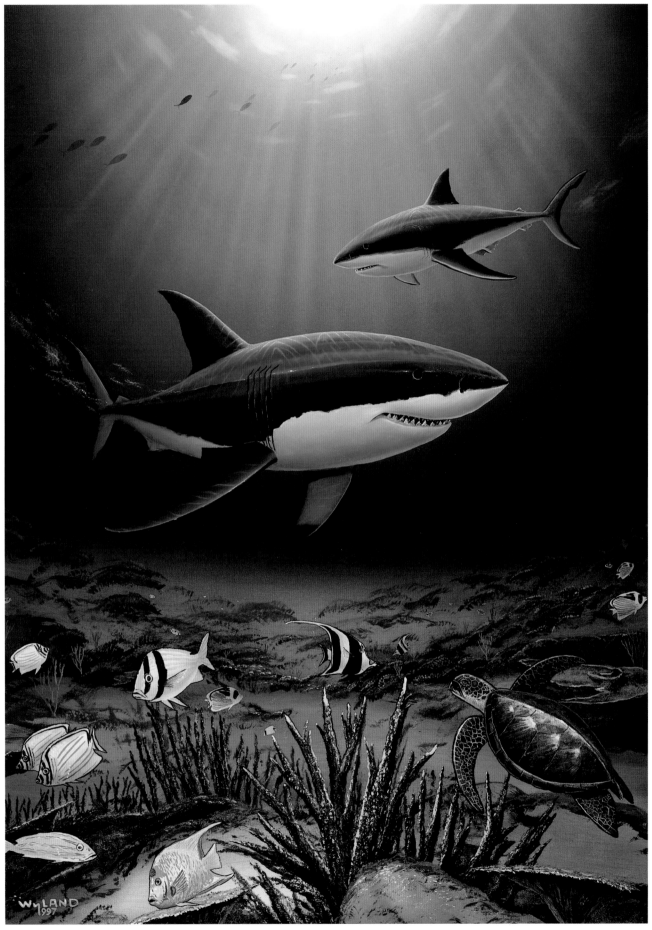

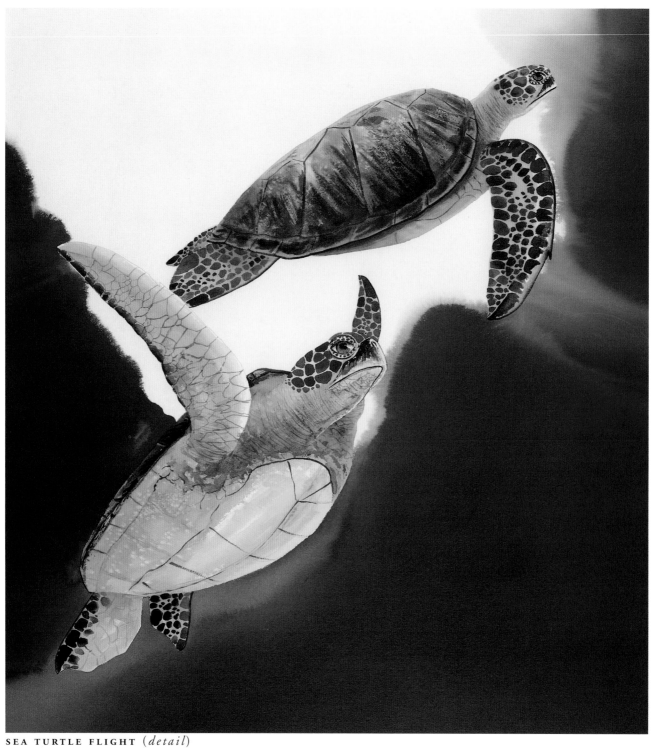

SEA TURTLE FLIGHT (*detail*)

"*Sea turtles are old souls, so peaceful....*

Some say they have been in the oceans

for 100 million years."

—*Wyland*

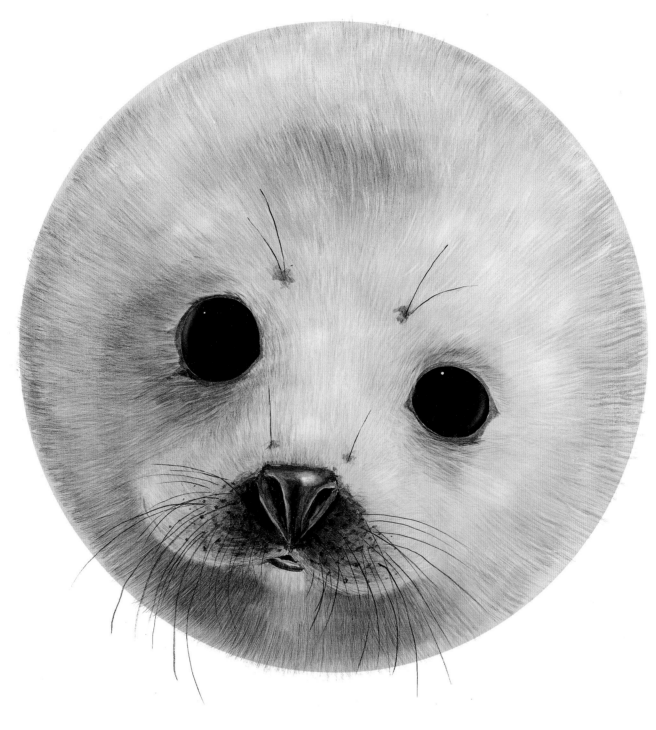

SNOW PUP

"Looking into the eyes of a baby harp seal we are reminded of our own children,

and the bond between mother and child which is equally strong."

—*Wyland*

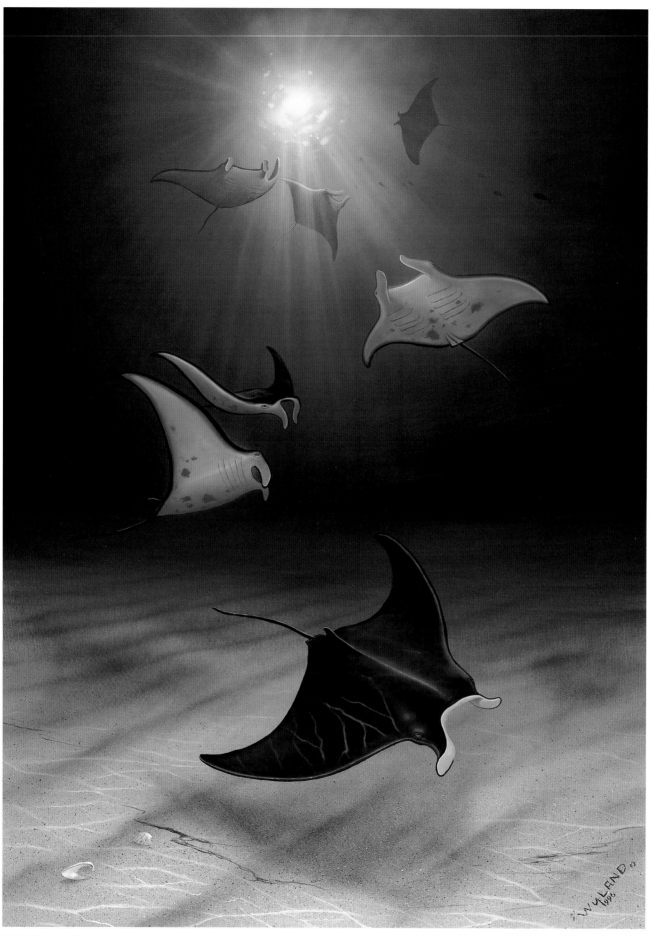

MANTA RAYS

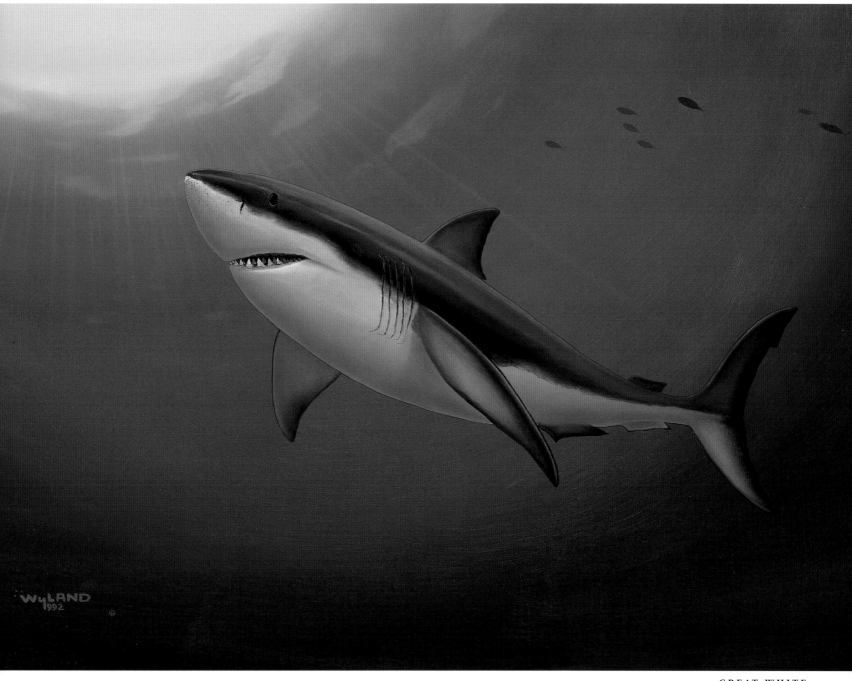

GREAT WHITE

"Man is separated from the shark by an abyss of time ... across the gulf of ages,

which evolved other marine creatures, the relentless, indestructible shark

has come without need of evolution, the oldest killer,

armed for the fray of existence in the beginning."

—*Jacques-Ives Cousteau,* THE SILENT WORLD

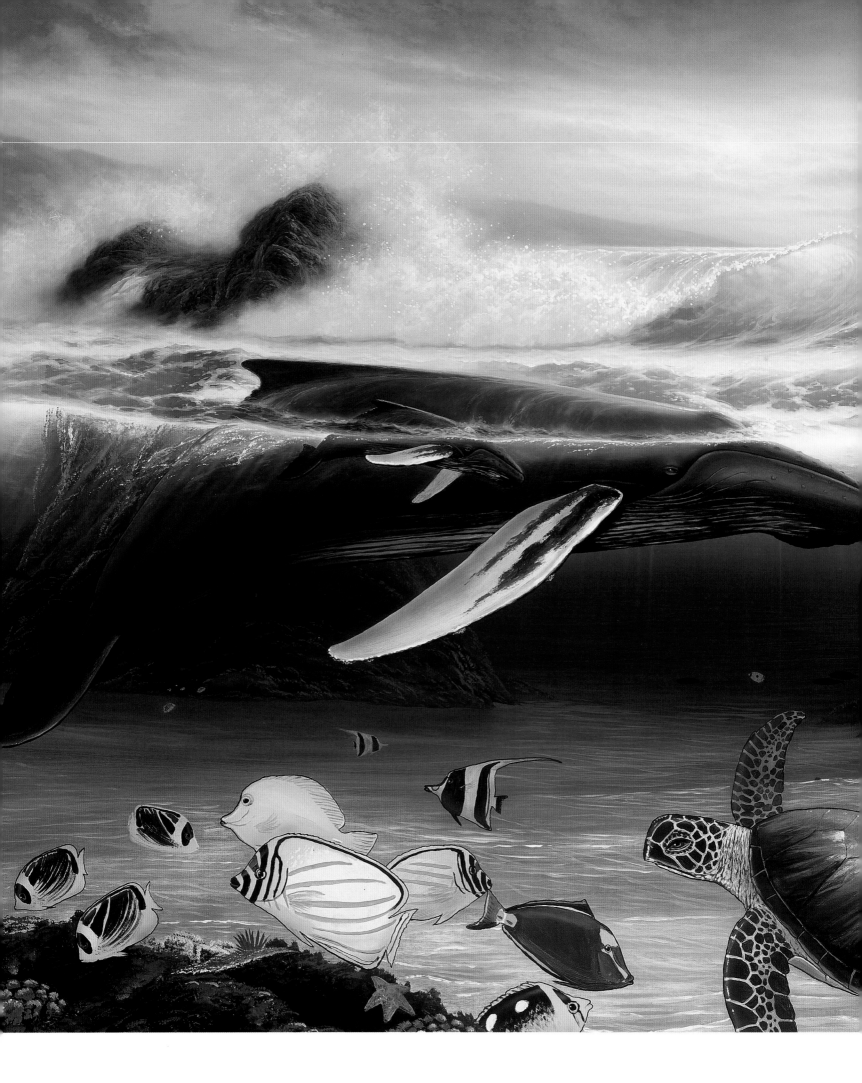

Collaborations

"All the arts are brothers;

each one is a light to all the others."

—*Voltaire,* NOTE TO ODE ON THE DEATH OF THE PRINCESS DE BAREITH

In 1985, at the dedication ceremony of Wyland's *Whaling Wall Thirteen* in Victoria, British Columbia, acclaimed wildlife artist Robert Bateman looked up at the American artist's lifesize mural depicting a pod of thirteen orca whales and stated, "I believe I see a bald eagle up there. I thought we had an agreement, you would paint below the ocean and I was supposed to do above." With this idea emerged the concept of two artists creating a single painting.

Several years later, Wyland mentioned the idea to a friend Roy Tabora, Hawaii's foremost seascape painter. Together Roy and Wyland pioneered the *Above and Below* series.

To date Wyland has collaborated with renowned artists Roy Gonzales Tabora, James Coleman, Walfrido Garcia, Tracy Taylor, Jim Warren, John Pitre, Janet Stewart, Al Hogue and William DeShazo.

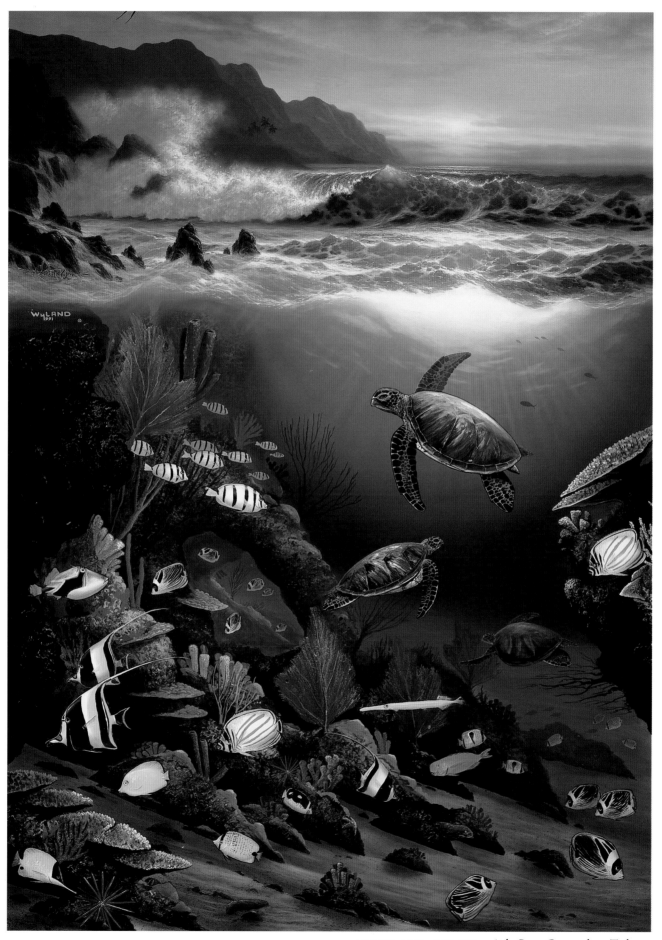

ABOVE AND BELOW *with Roy Gonzalez Tabora*

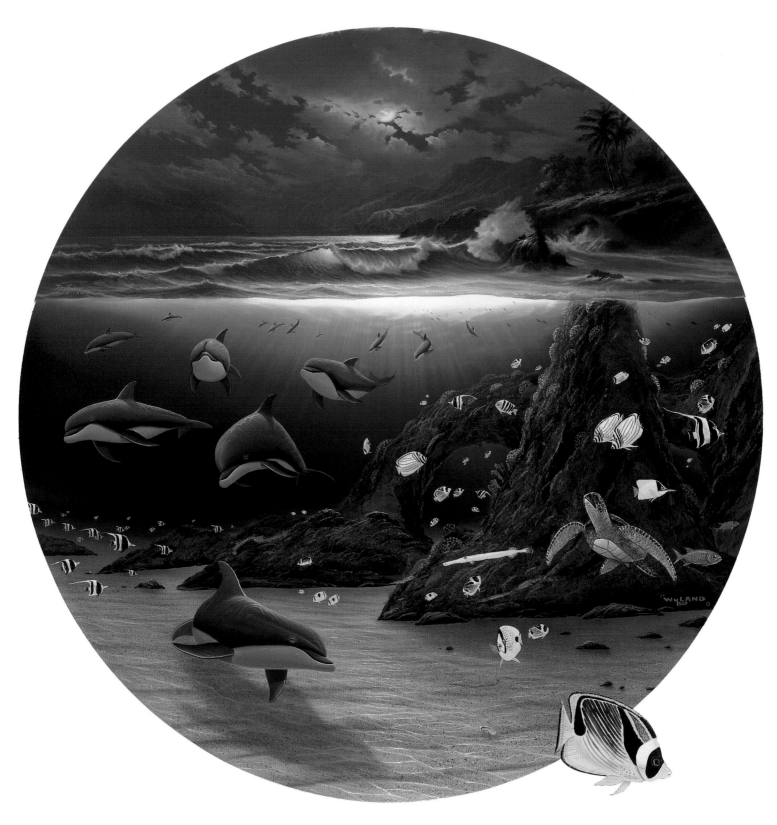

MOONLIT WATERS
with William DeShazo

TWO WORLDS OF PARADISE
with Walfrido Garcia

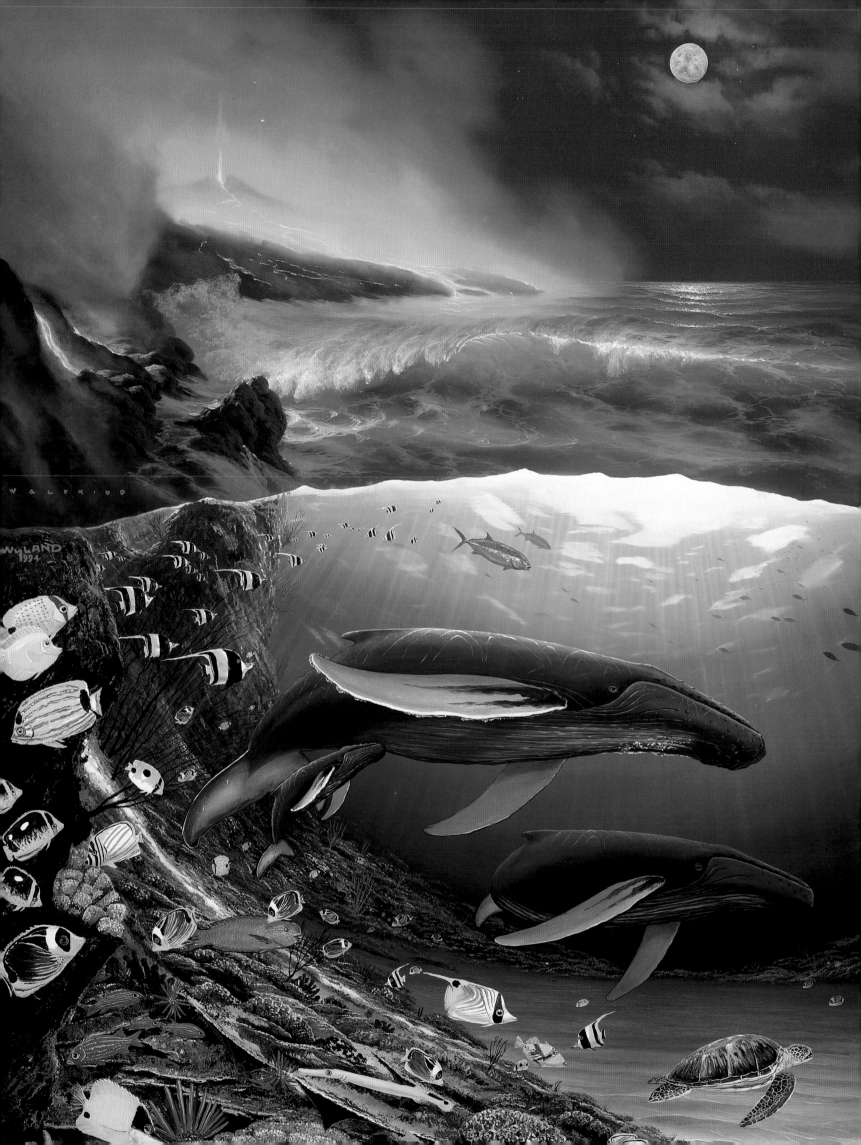

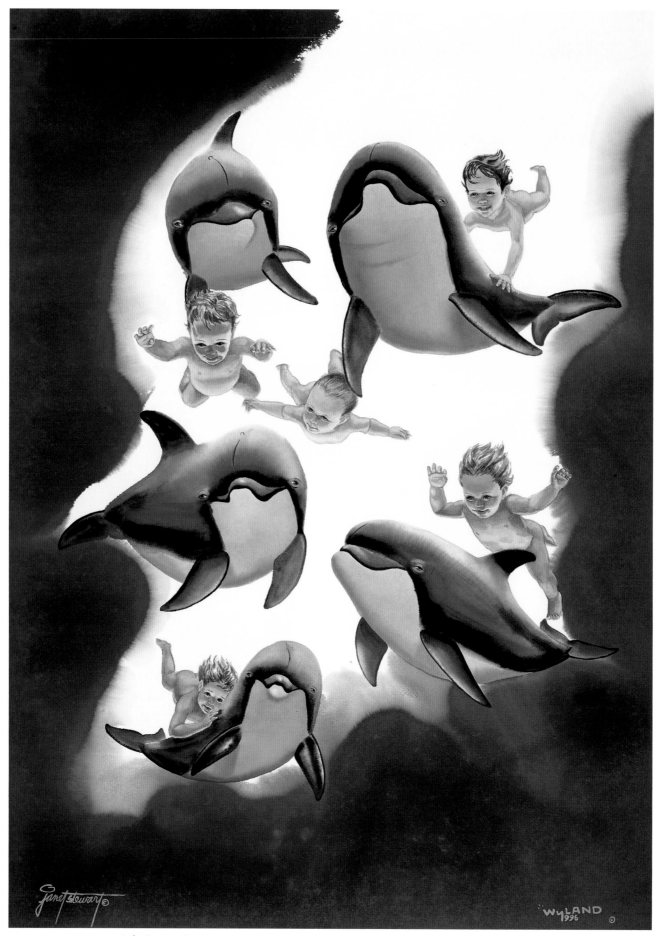

OCEAN BABIES *with Janet Stewart*

ARIEL'S DOLPHIN RIDE
with Walt Disney Studios

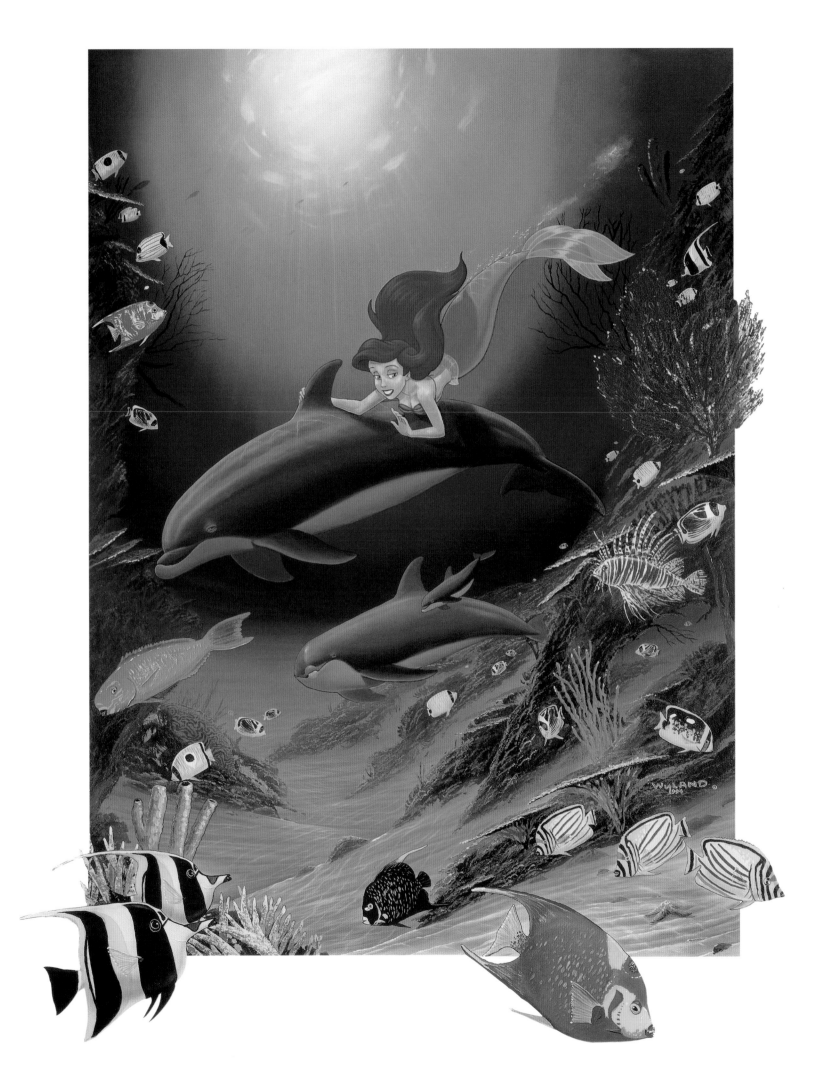

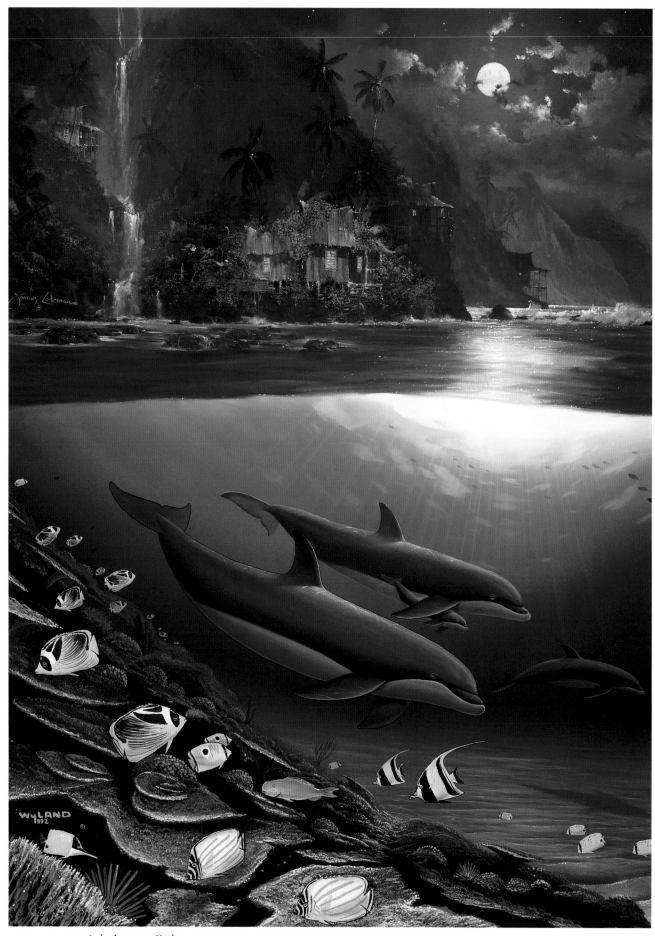

PARADISE *with James Coleman*

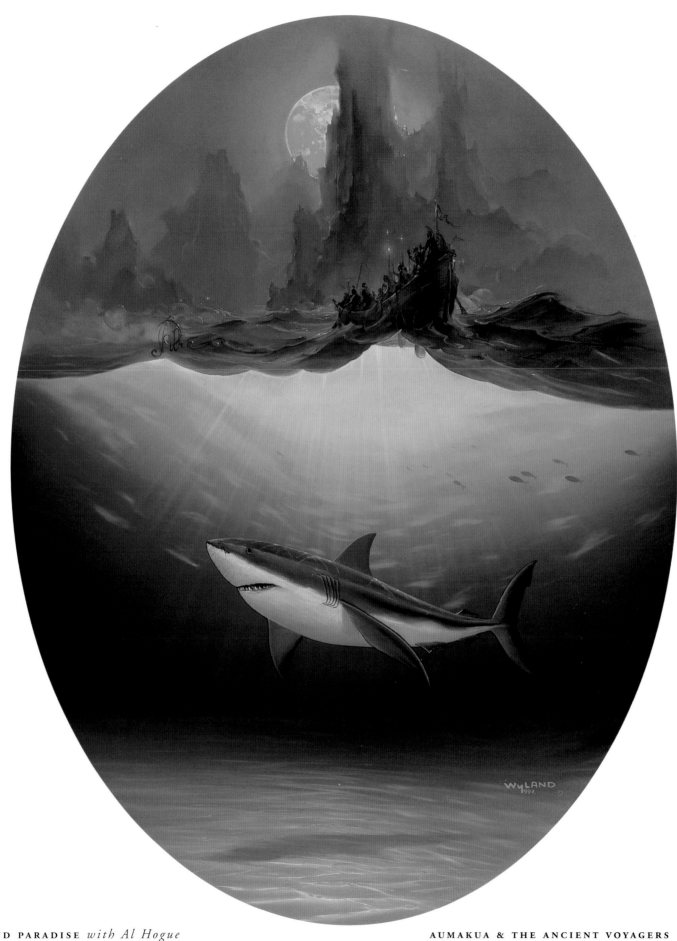

ISLAND PARADISE *with Al Hogue*

AUMAKUA & THE ANCIENT VOYAGERS
with John Pitre

121

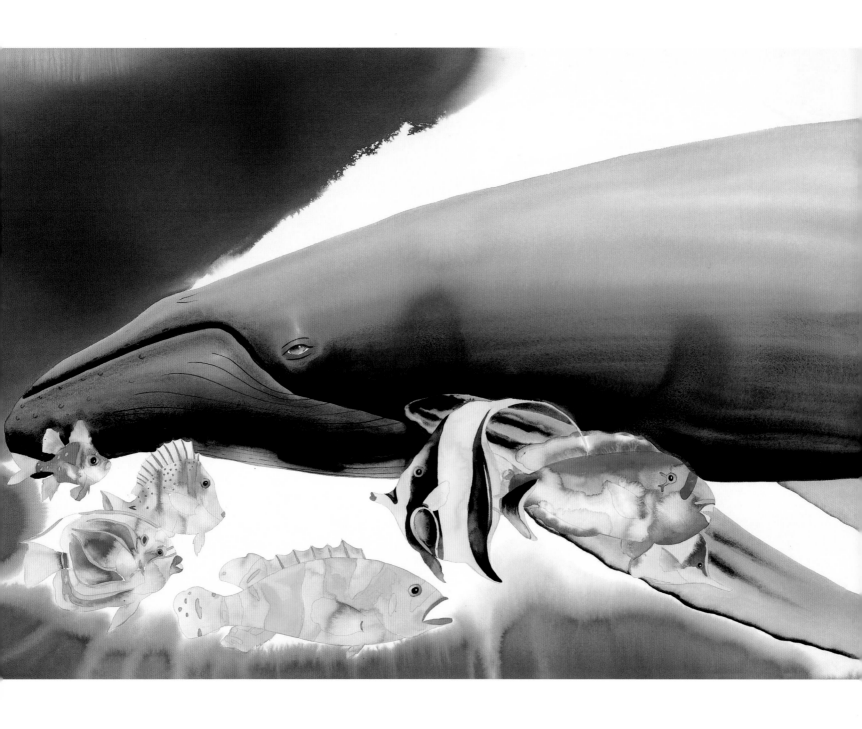

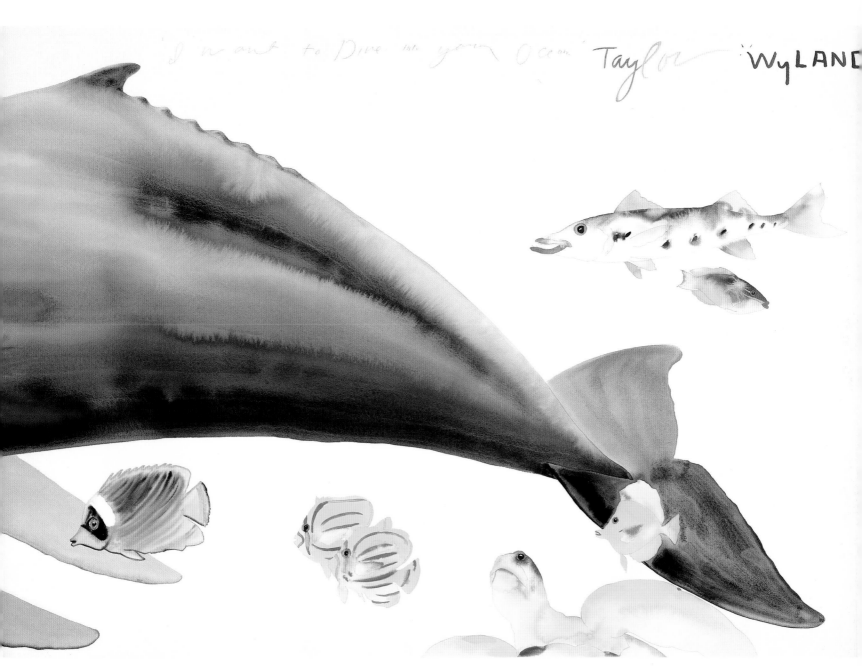

I WANT TO DIVE INTO YOUR OCEAN
(diptych) with Tracy Taylor

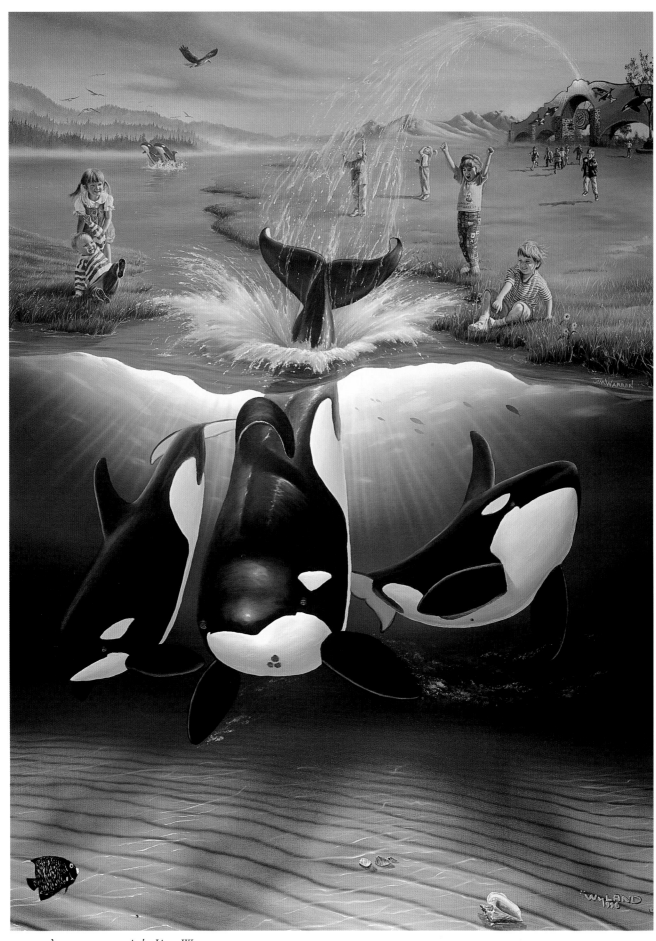

KEIKO'S DREAM *with Jim Warren*

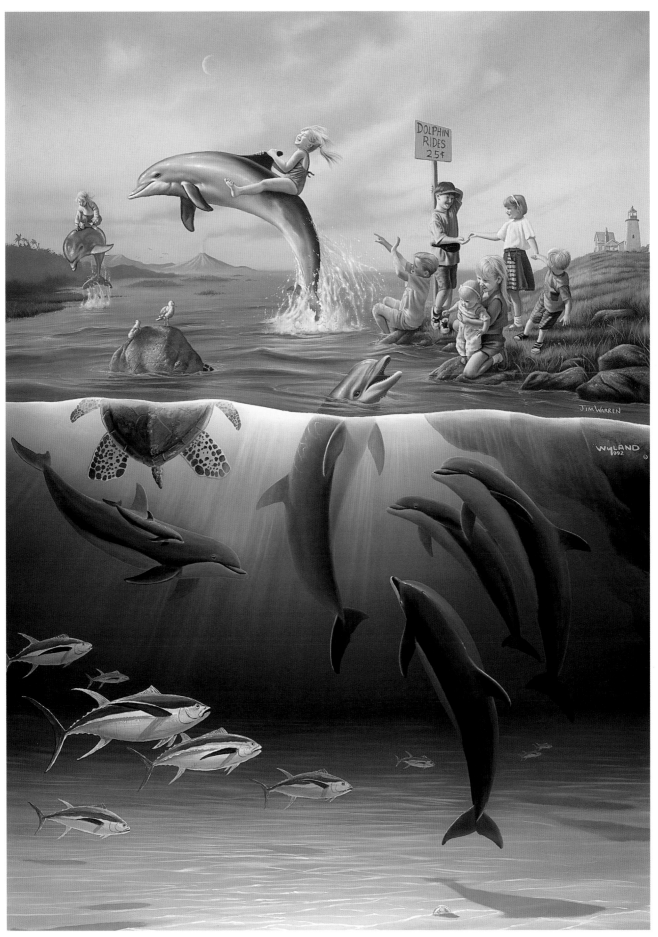

DOLPHIN RIDES *with Jim Warren*

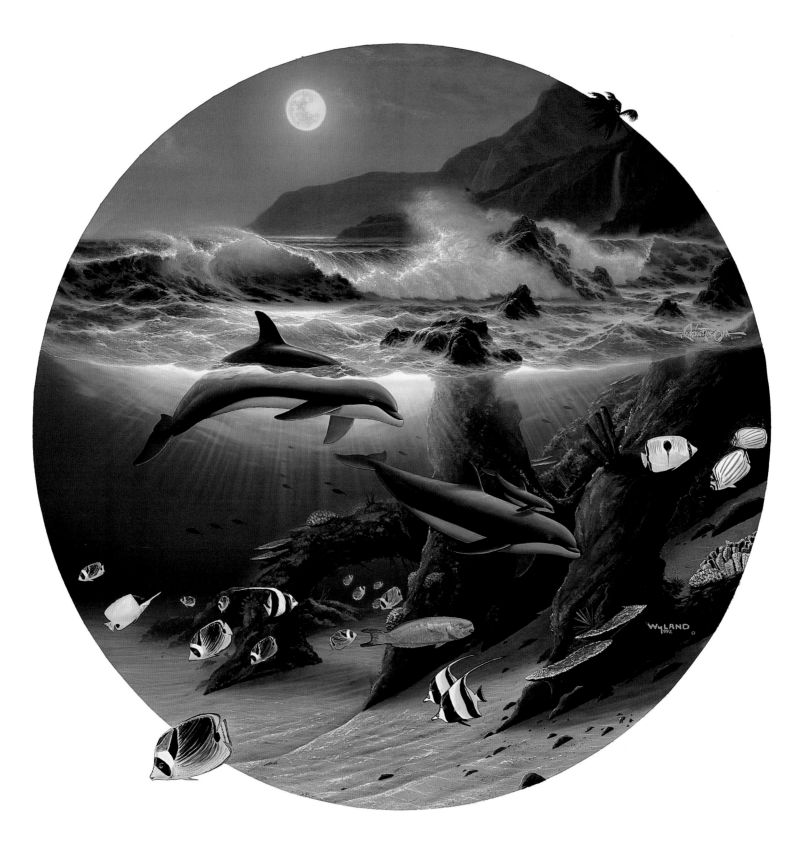

DOLPHIN MOON

with Roy Gonzalez Tabora

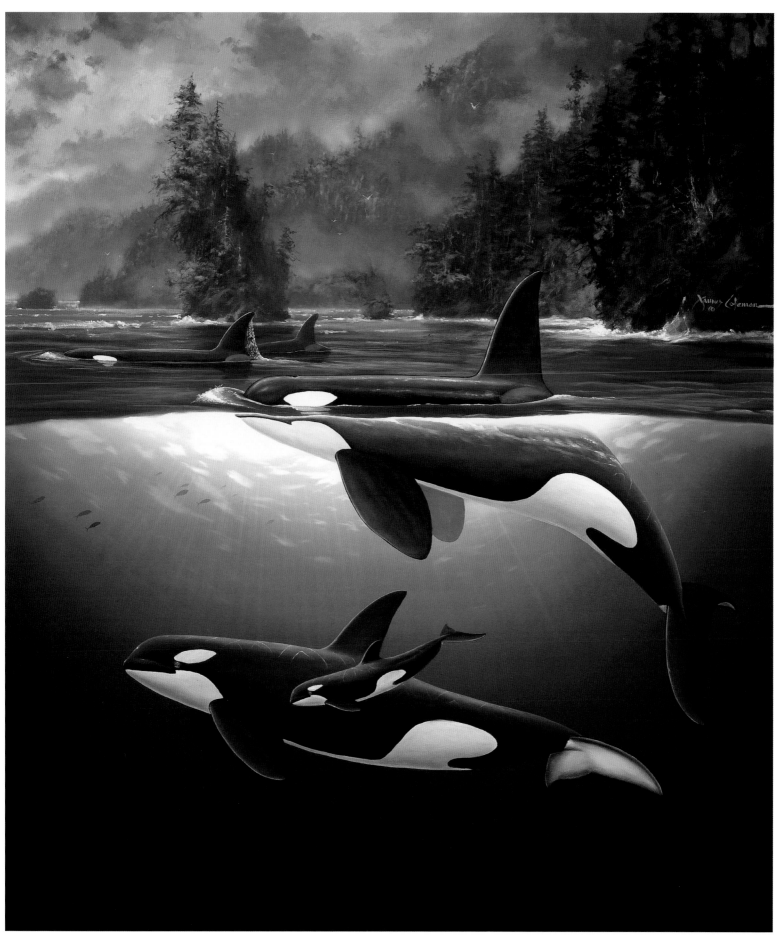

NORTHERN WATERS *with James Coleman*

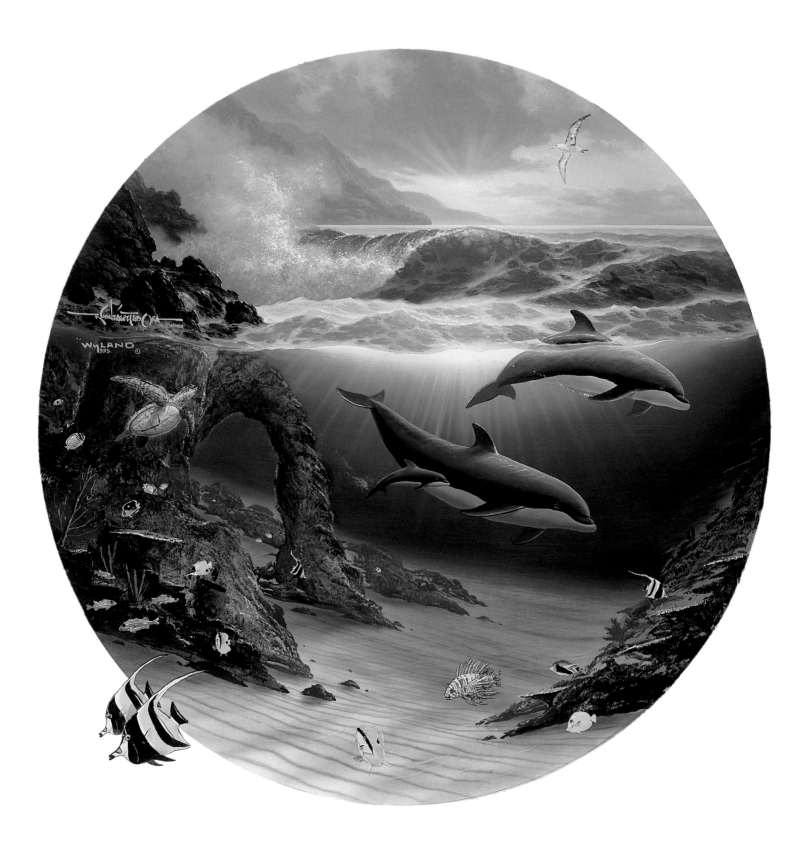

ENCHANTED OCEANS

with Roy Gonzalez Tabora

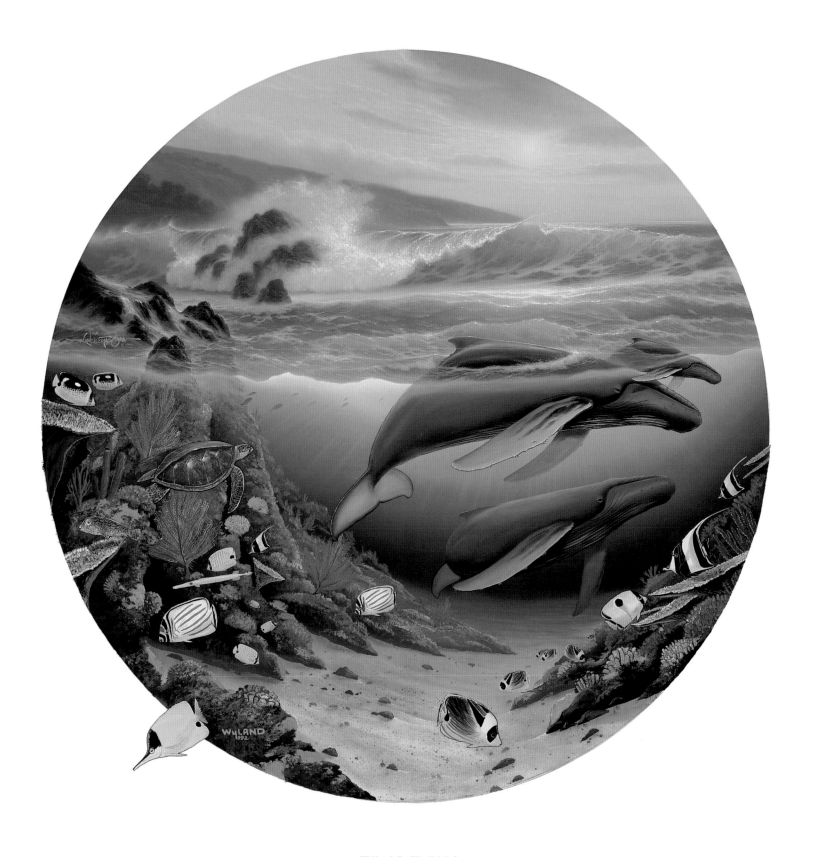

WHALE WATERS

with Roy Gonzalez Tabora

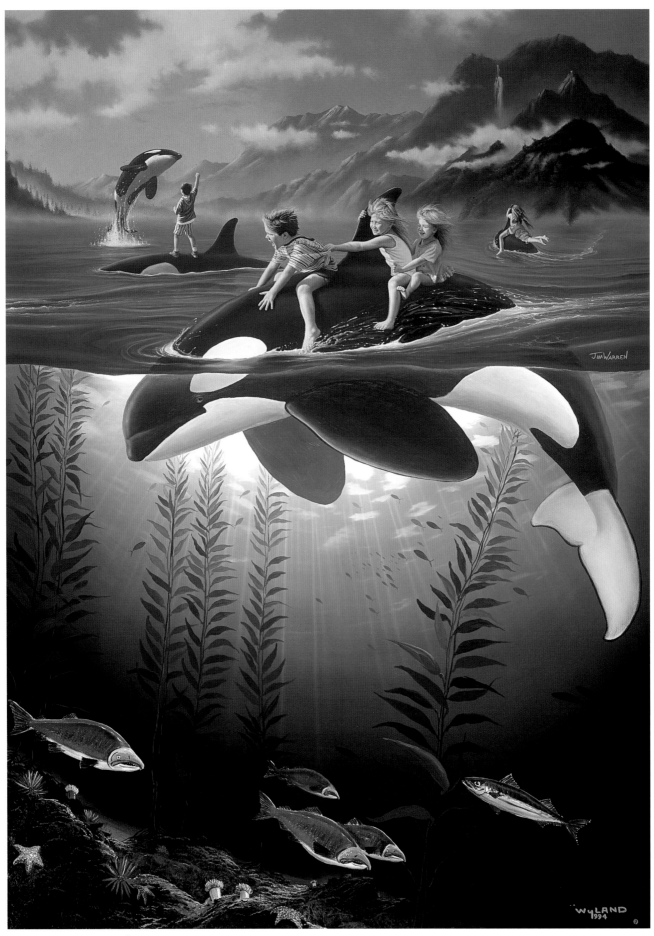

WHALE RIDES *with Jim Warren*

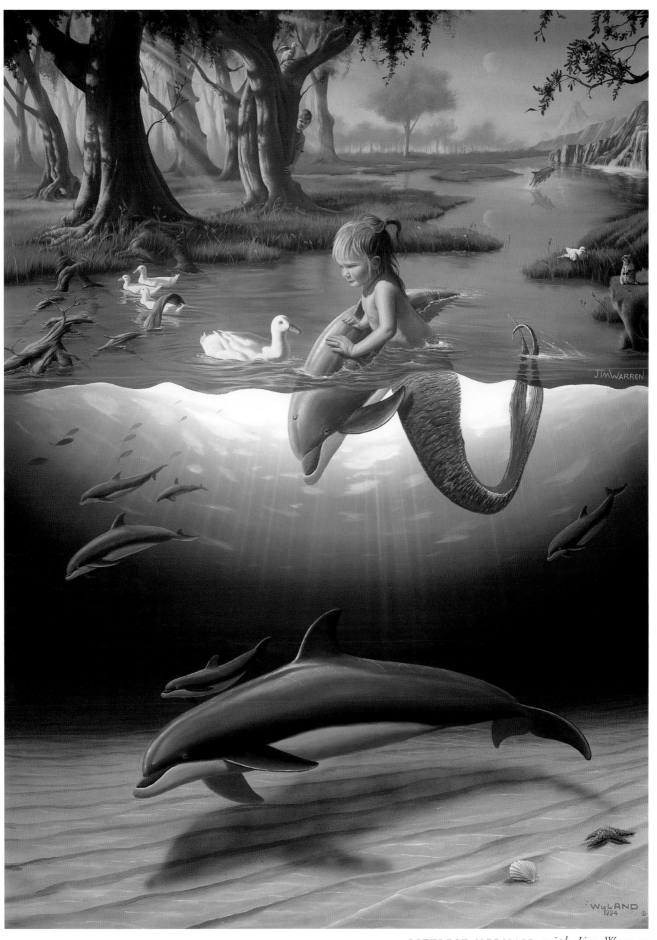

LITTLEST MERMAID *with Jim Warren*

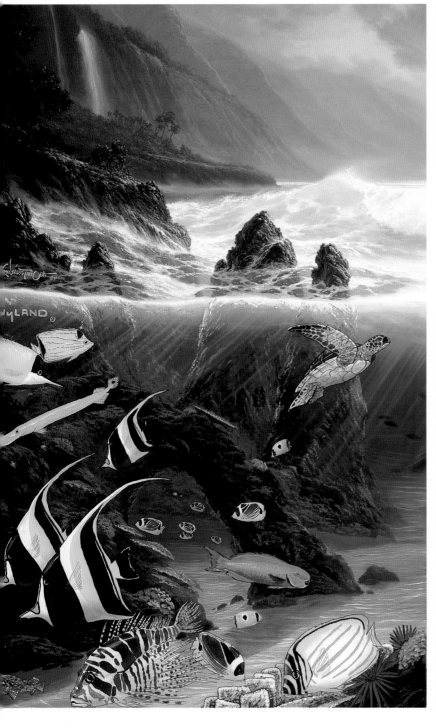
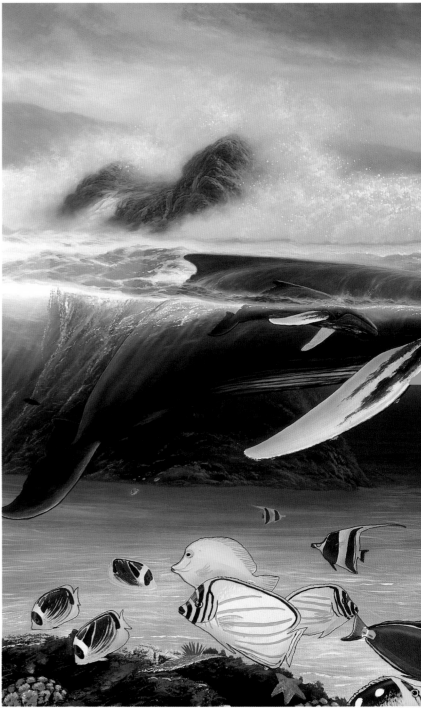

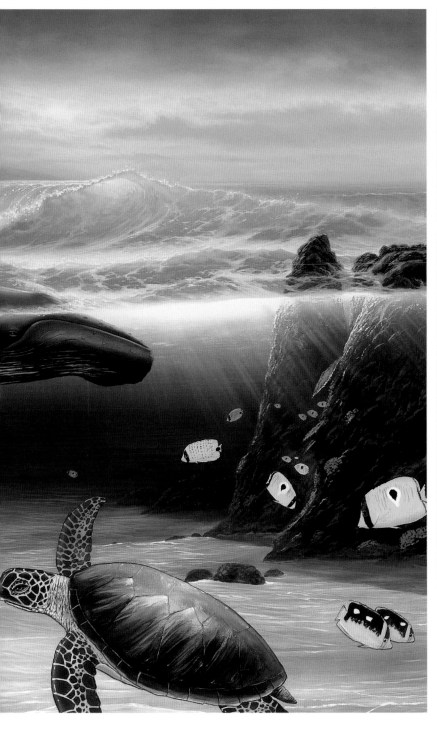
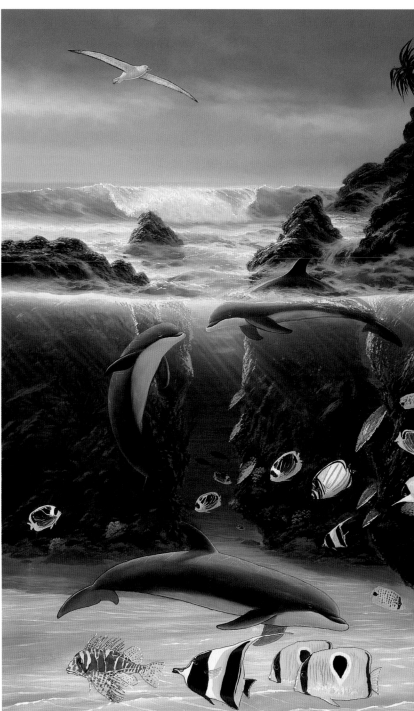

OCEAN TRILOGY *(triptych) with Roy Gonzalez Tabora*

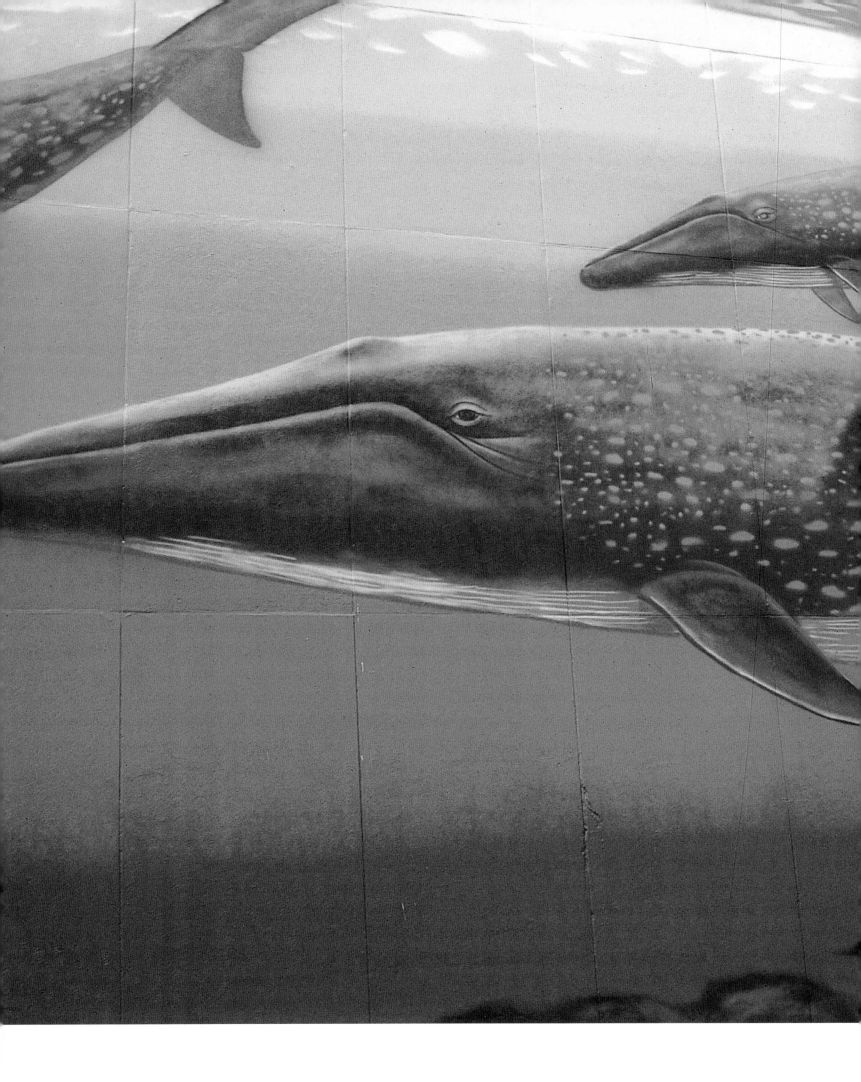

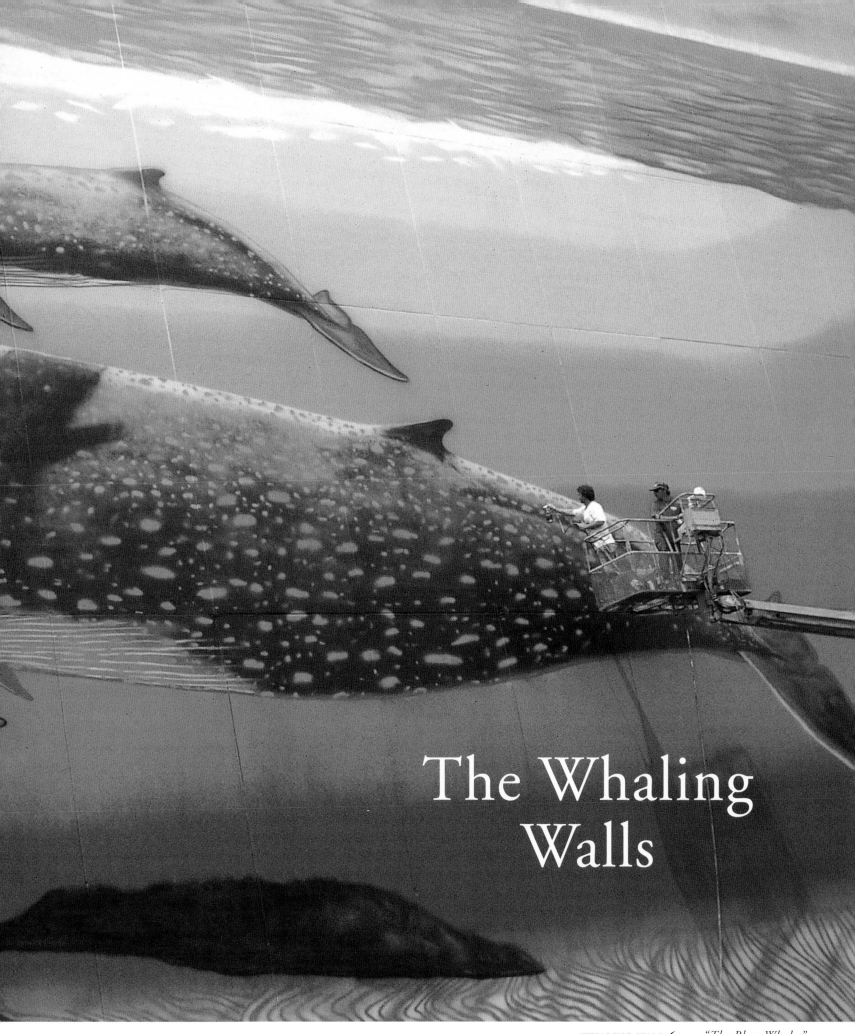

The Whaling Walls

WHALING WALL 69 — *"The Blues Whales"*
NEW ORLEANS, LA 1997—251 FEET LONG X 66 FEET HIGH

"I call what I do the art of saving whales."

—*Wyland*

Now, more than seventy-five Whaling Walls later, it's amazing to recall that my first wall took three years to complete. Not the actual painting, of course, but it took me three years of political wrangling—not to mention $20,000 of my own money, practically every cent I had—to get permission from the city of Laguna Beach to paint that first large-scale outdoor mural.

I guess it's one measure of how far we've come to consider not only how many walls we've completed in the fifteen years since then, but also how many cities, countries, and continents are standing in line, waiting to have their own Whaling Wall.

It's funny now to think how much I hated all that political resistance back then, because now I realize that it is truly part of the art. There's nothing like a good controversy, a good political battle, to help raise awareness. Now I realize that I want people to become political, to become advocates. After all, in the larger picture, this whole Whaling Wall project is not just about art; it's about people coming together—bringing people together for a single cause.

We launched our first big Whaling Wall tour in the summer of 1993—the East Coast Tour that took us from Portland, Maine, to Key West, seventeen walls in seventeen weeks. After surviving this incredibly brutal schedule of fourteen-hour days, usually seven days a week, I swore we would never try anything like that again. But the very next year we were off on another big tour, along the West Coast from Alaska to Mexico.

It was an amazing experience. Somehow we ended up painting thirteen murals in eight cities in eight weeks. A real highlight was that in Anchorage I painted the bowhead whale for the first time—one of the most endangered of all the great whales. The beauty of these tours, for me, is that I can create the marine life of each geographical area. Sometimes people don't realize what they have in their own backyard, and since these tours usually generate a lot of publicity, it's a great way to raise awareness.

Then, in 1997 we did a Midwest Tour—seven murals, seven cities, seven weeks, all around the Great Lakes. We saved the last stop for my hometown of Detroit, so for me it was really a great homecoming. This was an especially interesting tour for a number of reasons. First, people who live inland just don't expect to see whales, and when they do, it makes a tremendous impact. And second, a lot of people ask why I would paint ocean and marine life throughout the Midwest, which is, of course, the land of the Great Lakes.

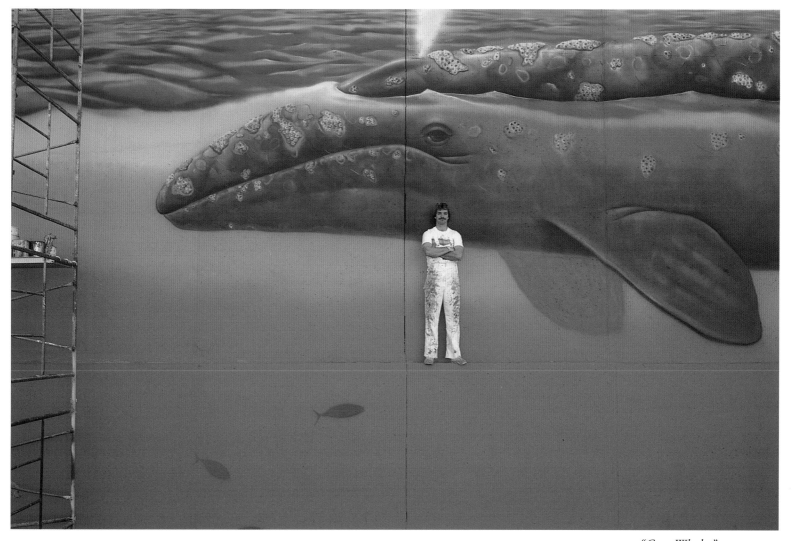

But it's very important for me to call attention to the fact that the oceans, the lakes, the rivers and streams are all connected. This is a crucial part of my message, and once I get that message out there, people really do rally around it. My hope is to complete murals in all fifty states.

Another thing I really enjoyed about this tour was that the wall we did in Toronto, which was the first stop, was dedicated by the co-founder of Greenpeace, Bob Hunter. I first met Bob a long time ago when I painted my fourth wall, in British Columbia, and it was wonderful to meet up with him again. His organization had really inspired me.

In the early '70s, it was Greenpeace that first made me think about how I could contribute to this important cause—how I could use my art to help save the whales.

It was just great for the whole thing to come full circle and have the person who founded that organization tell me how important my work was, in terms of creating awareness. Bob said it reminded him of Greenpeace in its early days—how I started out with a small dedicated group of people, Team Wyland, working together to make a difference.

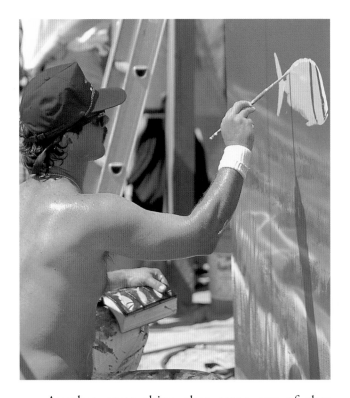

Another great thing that came out of that tour was that right after we finished the first mural in Toronto, the Royal Ontario Museum asked if I would do a mural for their permanent collection. I've always said that I paint for the people and not the critics, and that will always be true, but the idea of having a painting in this major museum was really exciting. So after we finished the tour in Detroit, we turned around and went back to Canada, and in a fourteen-hour marathon, we did a 70-foot-by-9-foot canvas of humpback whales. It really meant a lot to me when the director of the museum said how important my work was and that I would be one of the people responsible for saving life in the sea—what a great compliment.

At this point we've completed three major tours: the East Coast, the West Coast, and the Midwest. Now the timing is perfect to turn our attention to a tremendously exciting project that has grown directly out of the Whaling Walls. The year 1998 has been deemed the International Year of the Ocean, and I am choosing this opportune moment to initiate the Wyland Ocean Challenge of America.

I believe that my greatest mission is to inspire children, and the purpose of this Challenge is to get every school in the country involved in the effort to save the earth's waters. The goal is to get children across the country to paint more than 100,000 ocean murals during the course of 1998. And then we'll take the Challenge worldwide.

Everything in my life has happened for a reason, and it now seems like my whole life has led up to this project. The National Marine Fisheries in Hawaii asked me to do an ocean mural with the kids at a local high school in Honolulu. Of course I was happy to do it, but what was surprising was how the kids volunteered and worked together. The whole thing generated so much excitement that it occurred to me that we ought to go national and create the Wyland Ocean Challenge of America in 1998—the Year of the Ocean.

One of the real keys for me is that this is a way of building a bridge between science and art. Here are two schools of endeavor which have often been at odds, but I believe they need to work together, especially today when we need to be so concerned about conservation and the environment. The kids will understand it and get behind the effort. They'll be having fun and learning at the same time, and I hope they'll always remember having been a part of the Wyland Ocean Challenge.

The Challenge will involve about 67 million students in 120,000 public and private schools. And, I've already started talking to other countries—Japan, France, and others—and they all want to take this program into their schools. Everybody realizes that the kids are the future, and the conservation of the oceans is a global concern. So it's natural that this project would inspire interest worldwide.

I'm also now making plans for a United Kingdom Tour and an Asian Tour. In fact, we have nearly fifty countries that have asked me to do murals! It seems that people are really beginning to recognize the need for the conservation of the world's oceans.

So overall, we're on track to complete those one hundred Whaling Walls throughout the world by 2011. In fact, we're probably five minutes ahead of schedule. I guess it's a good thing they didn't all take three years, like that first one in Laguna Beach.

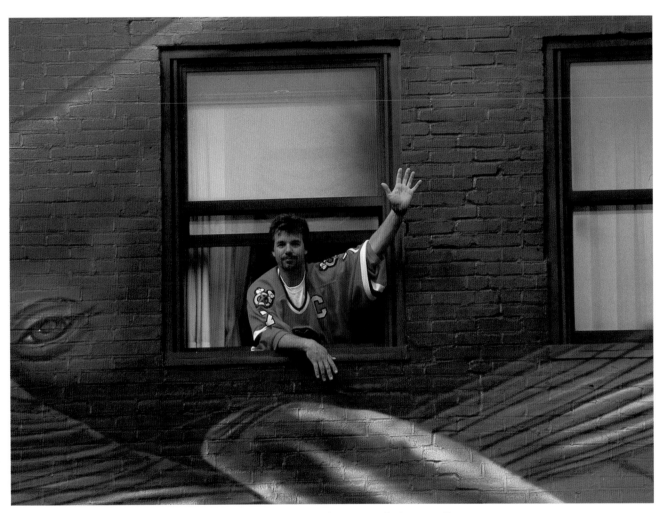

Wyland waves from Chicago, Whaling Wall 73.

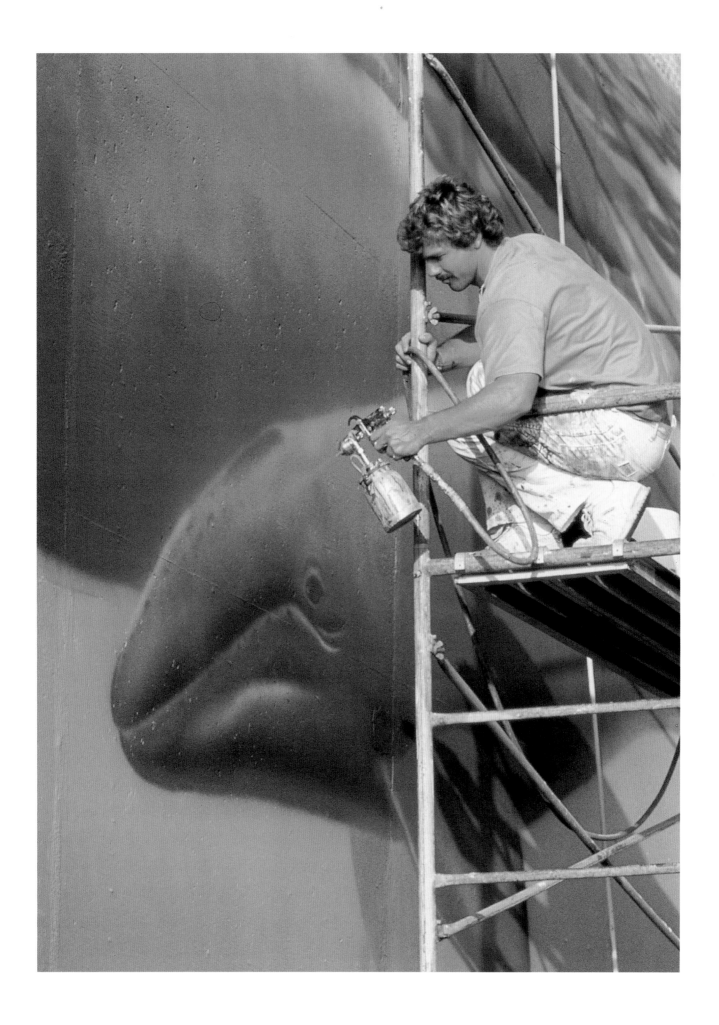

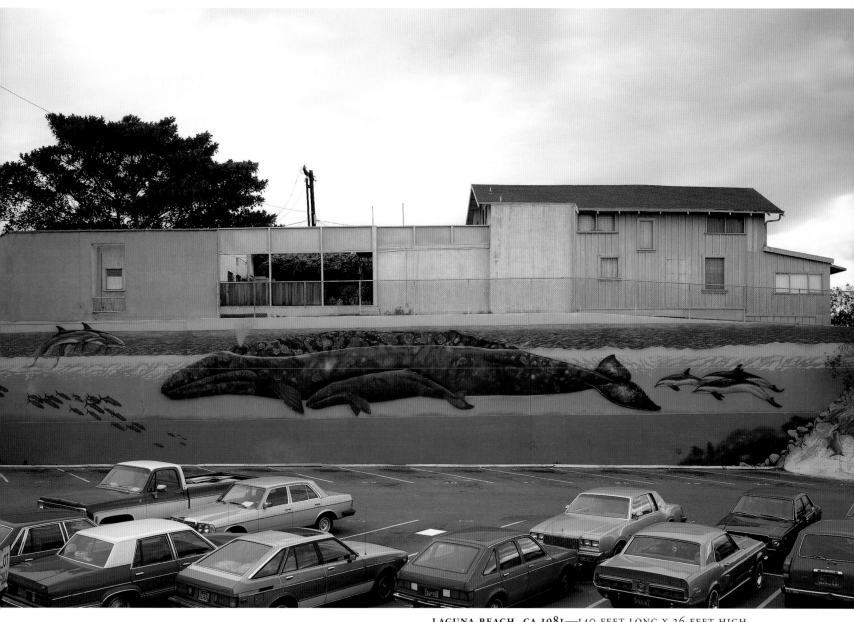

LAGUNA BEACH, CA 1981—140 FEET LONG X 26 FEET HIGH

WHALING WALL 1—*"Gray Whale and Calf"*

After three years of searching up and down the Pacific Coast Highway, Wyland finally found the "perfect wall" for his first life-size mural in the renowned artists' colony of Laguna Beach. The first Whaling Wall was dedicated on July 9, 1981, which happened also to be the artist's 25th birthday. The overwhelming response to the work inspired Wyland's decision to paint 100 such murals throughout the world.

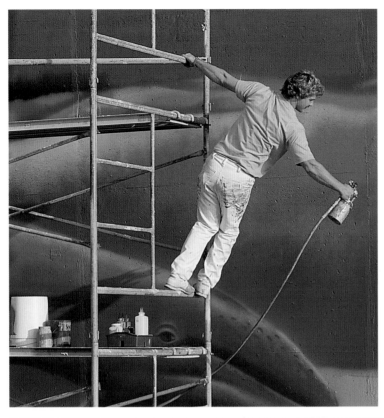

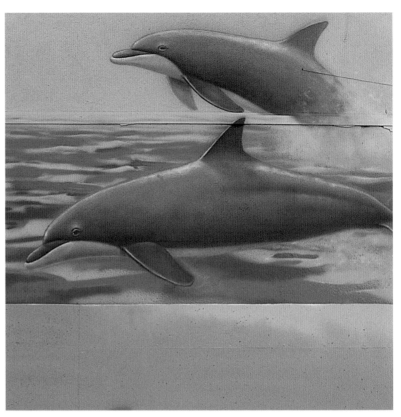

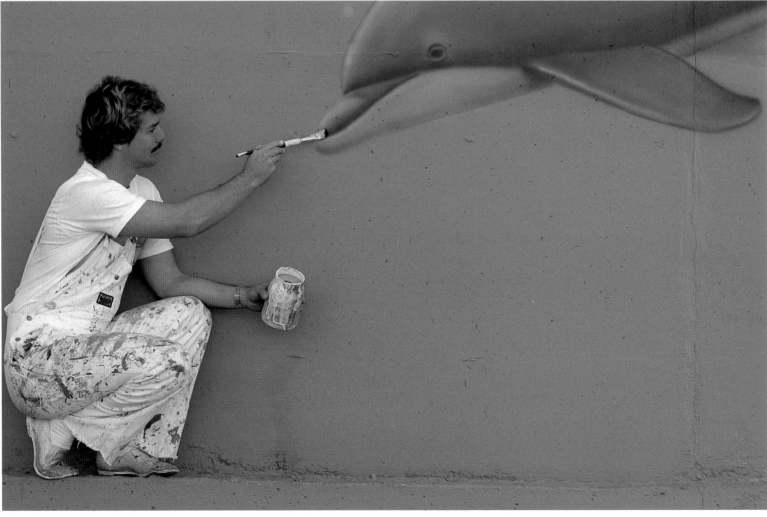

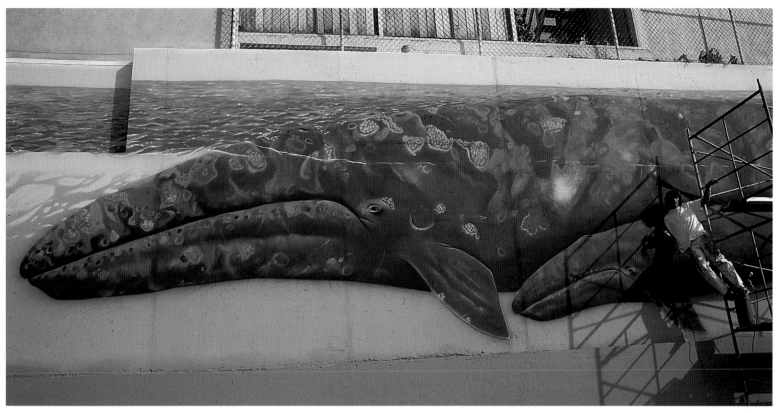

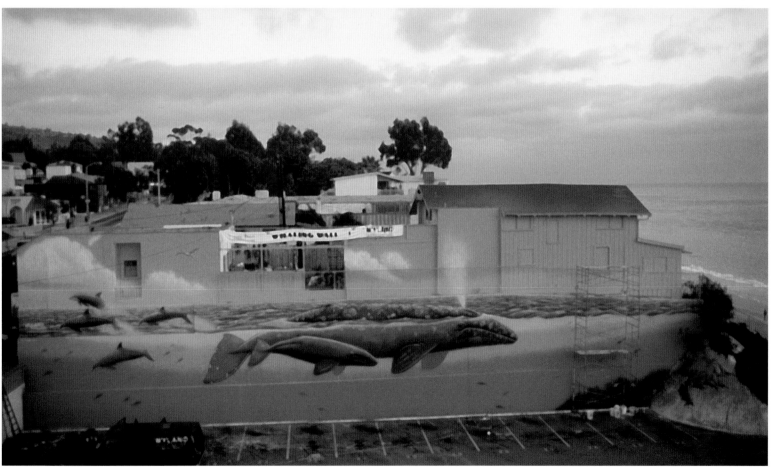

Whaling Wall 1 was repainted in 1996, and the direction of the whales was changed to have them swimming out to sea.

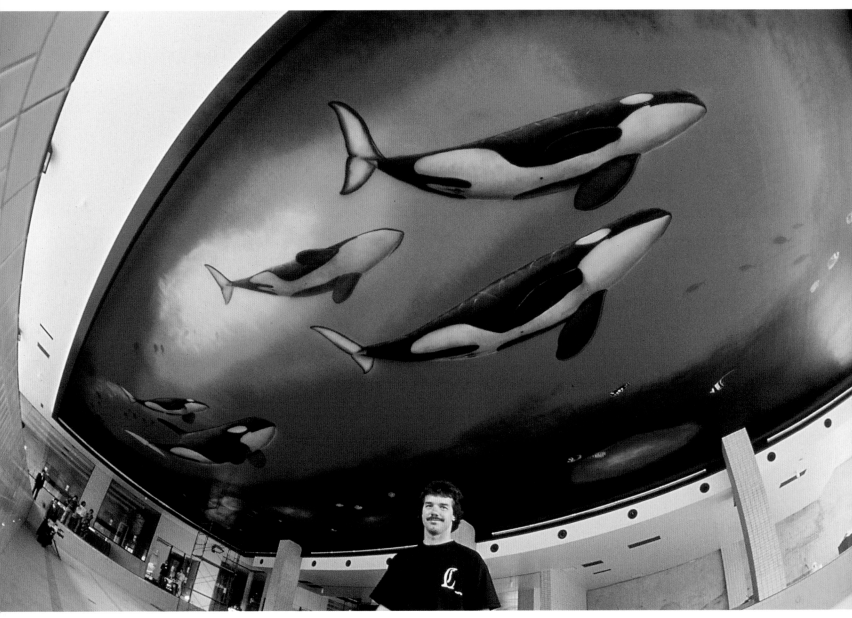

YAMAGATA, JAPAN 1990—145 FEET LONG X 45 FEET HIGH

WHALING WALL 22—*"Orca Heaven"*

In creating his first ceiling mural, Wyland wanted to create the illusion of being underwater and looking up at huge orcas swimming overhead. Initial difficulties with perspective were overcome when Wyland's brother, Bill, suggested that he tape a piece of chalk onto a yardstick and lie on his back to sketch in the whales.

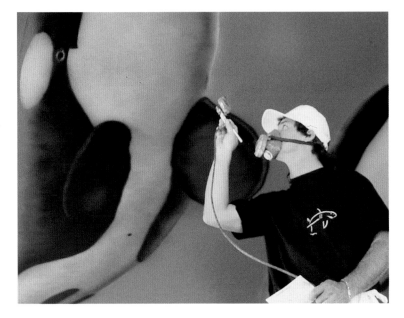

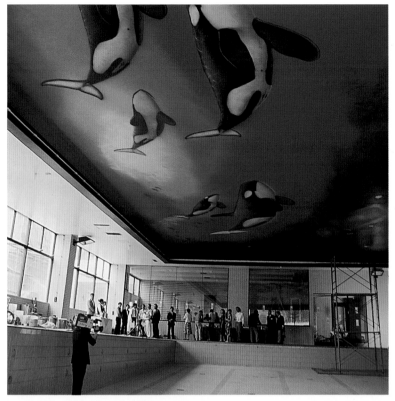
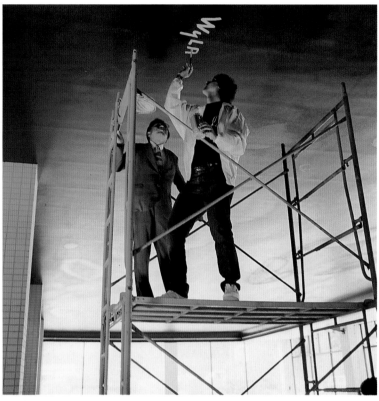
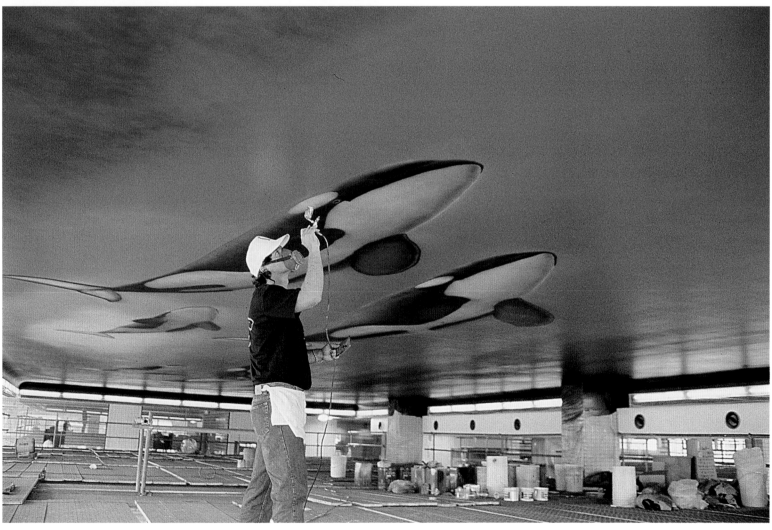

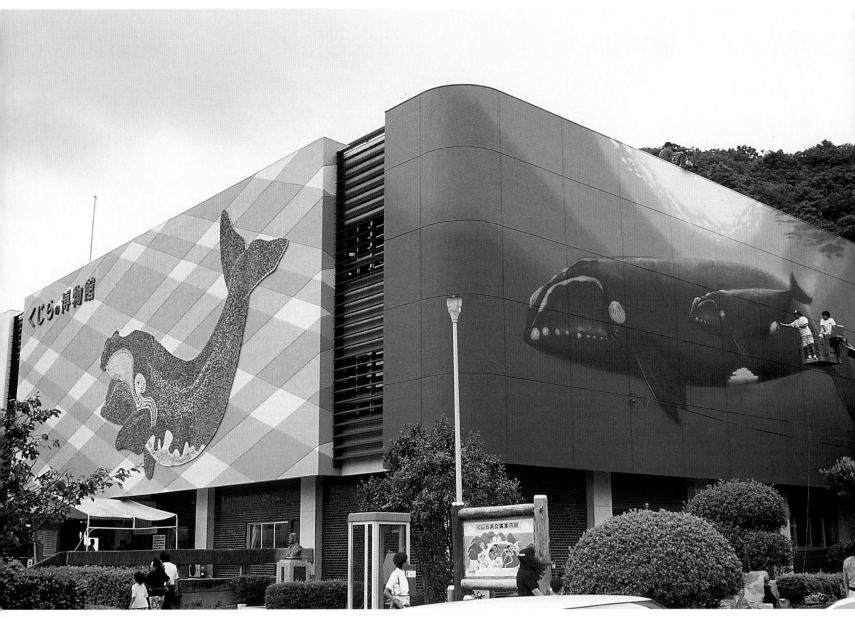

TAIJI, JAPAN 1991—100 FEET LONG X 35 FEET HIGH

WHALING WALL 32—*"Right Whales"*

This mural, on the exterior of the whaling museum in Taiji, Japan, holds particular significance for Wyland. It was in this coastal community, in 1606, with the harpooning of a right whale, that the Japanese whaling industry was initiated. To be invited to bring his message to the birthplace of Japanese whaling exemplifies the kind of cosmic justice that Wyland thrives on.

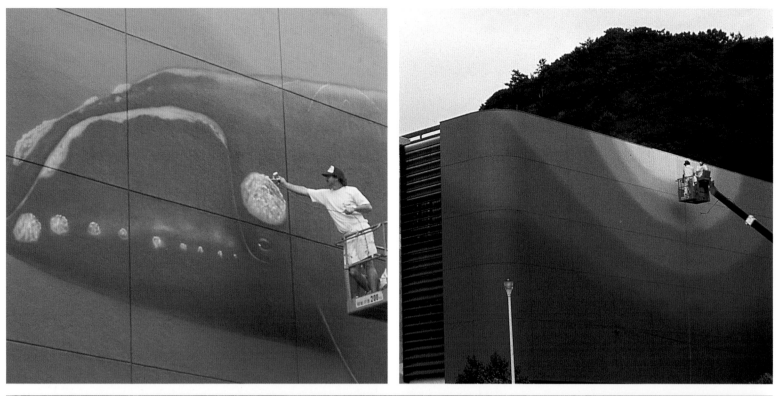

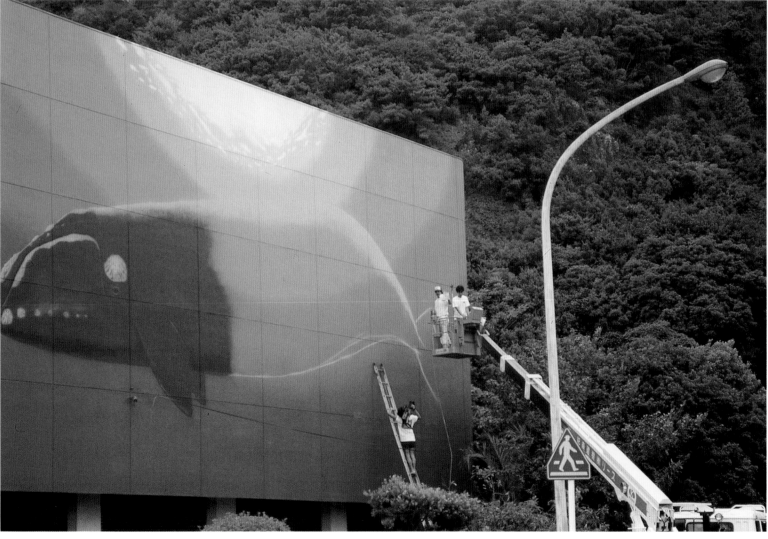

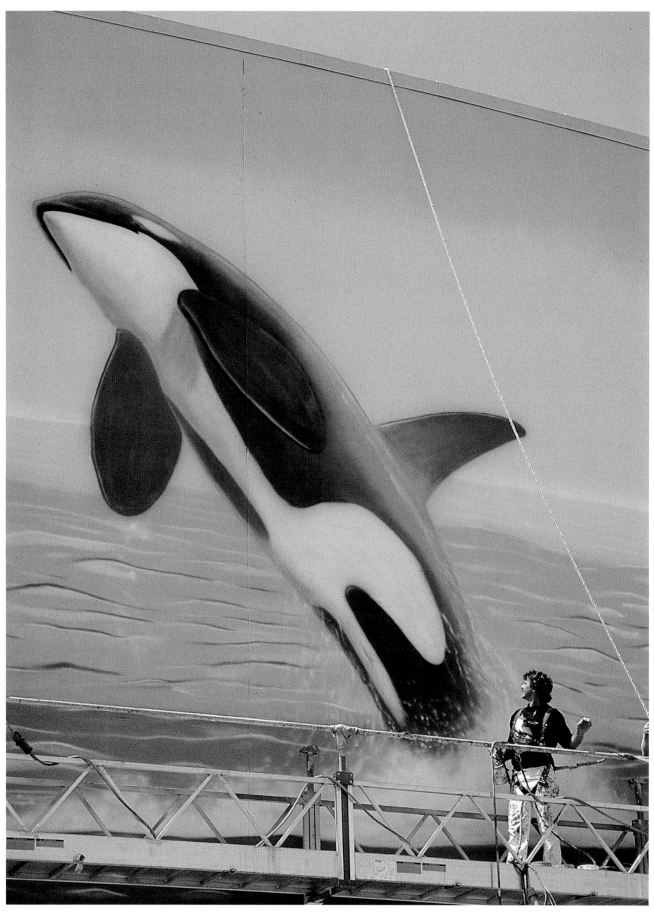

A life-size orca leaps above the artist.

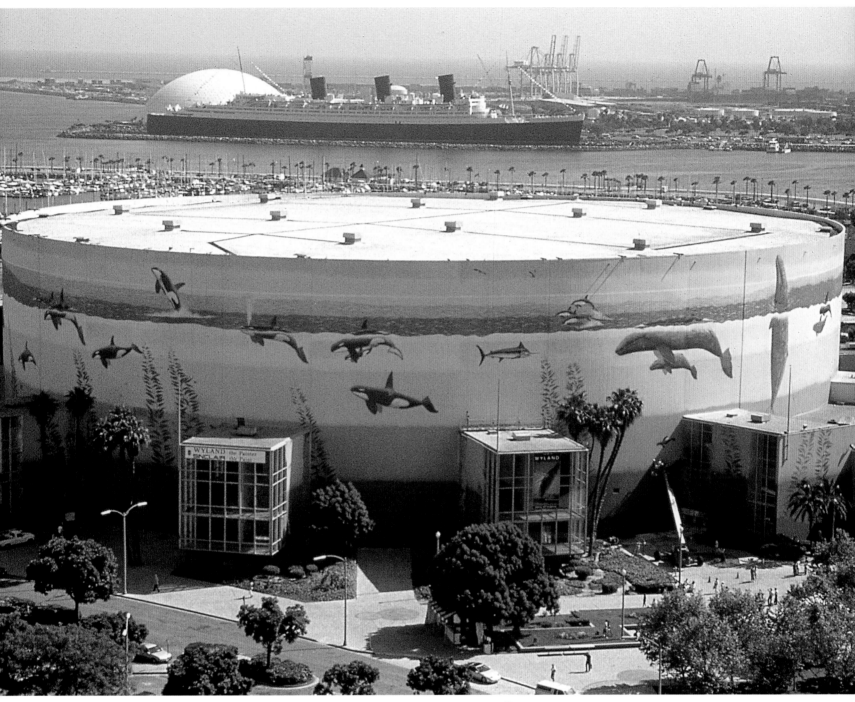

WHALING WALL 33—*"Planet Ocean"*

This spectacular painting, covering the circumference of the Long Beach Convention Center, has been certified by the *Guinness Book of World Records* as the largest mural ever created. Featuring marine life indigenous to Southern California, the mural includes gray whales, orcas, blue whales, pilot whales, Pacific bottlenose dolphins, California sea lions, sharks, and a variety of other fish—all painted life-size.

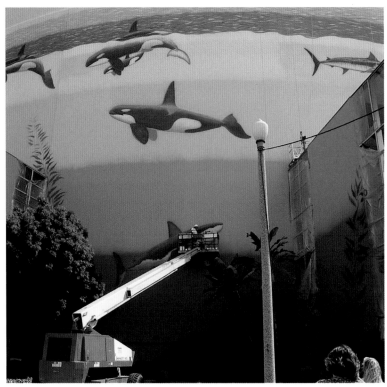

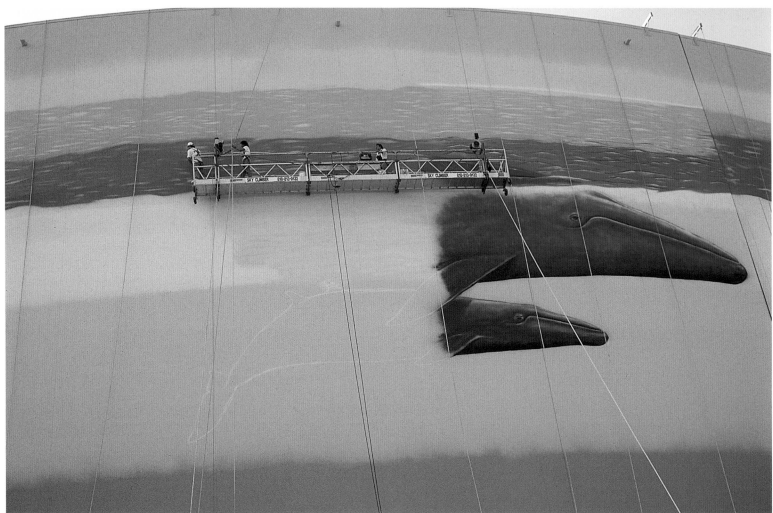

"Planet Ocean" covers nearly three acres and required 7,000 gallons of paint.

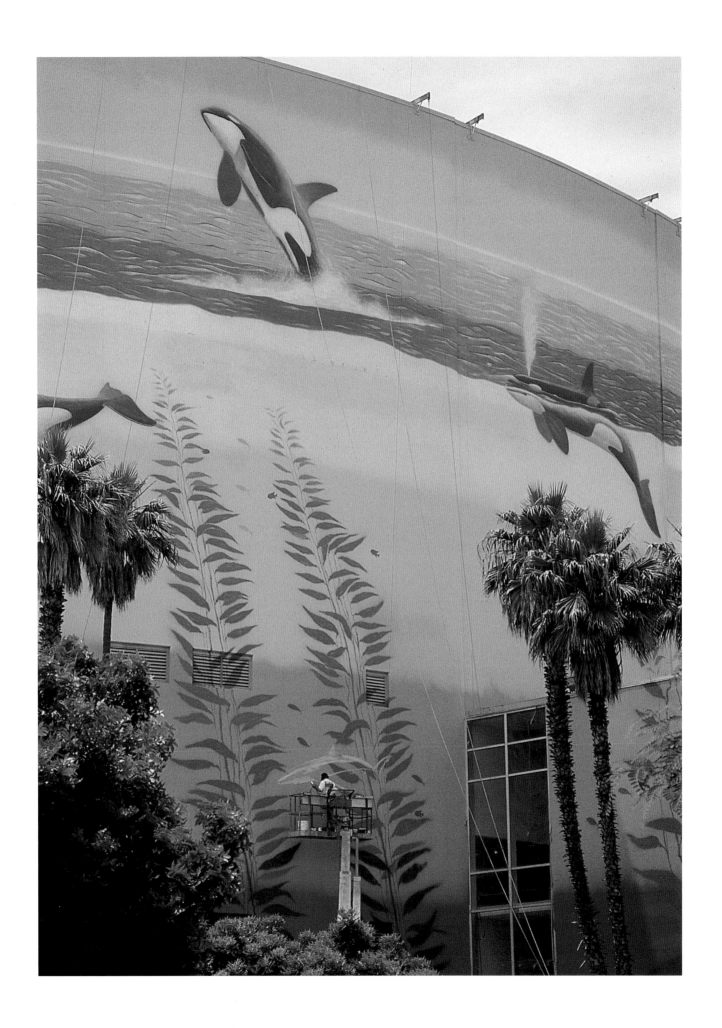

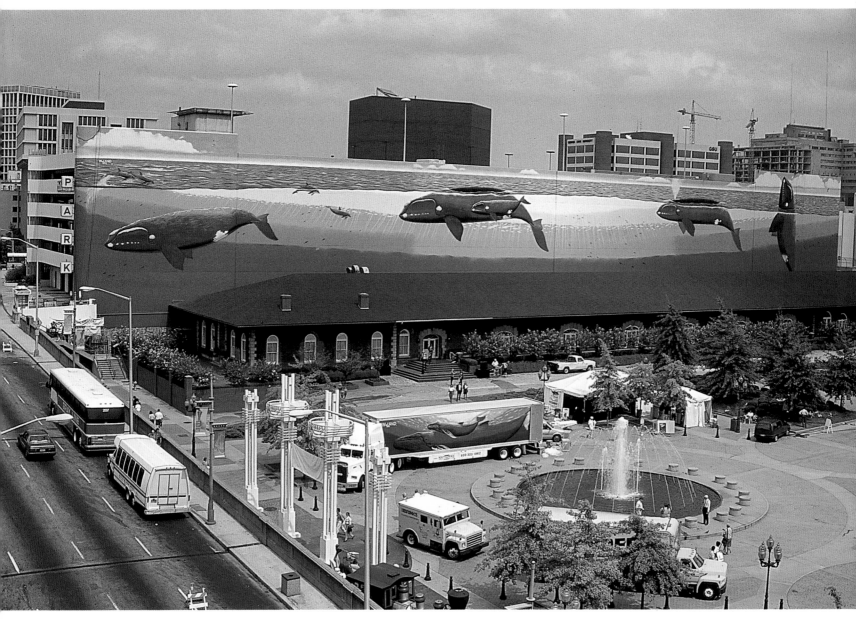

ATLANTA, GA 1993—450 FEET LONG X 50 FEET HIGH

WHALING WALL 50—*"Atlanta's Right Whales"*

This awe-inspiring painting of four right whales represented the half-way point in Wyland's quest to paint one hundred Whaling Walls worldwide by the year 2011. Dedicated during Atlanta's "countdown to the 1996 Olympics," the artist was particularly pleased by the potential of this mural to be seen by literally millions of people.

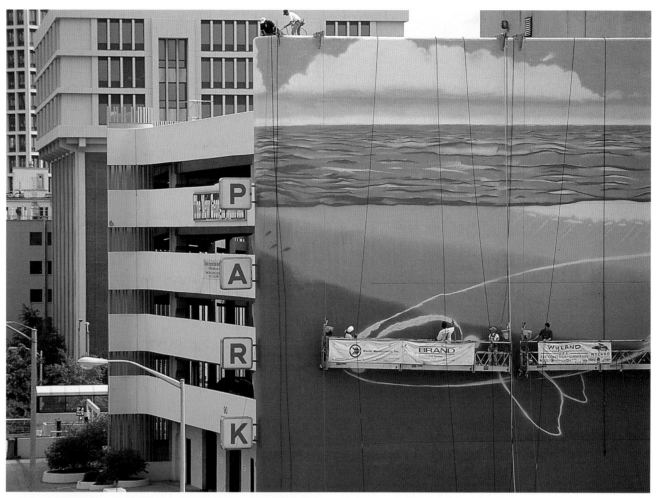

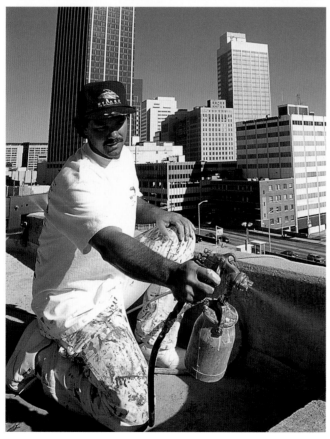

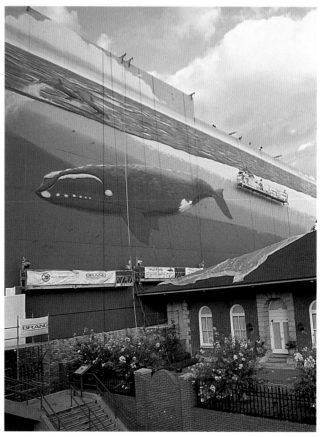

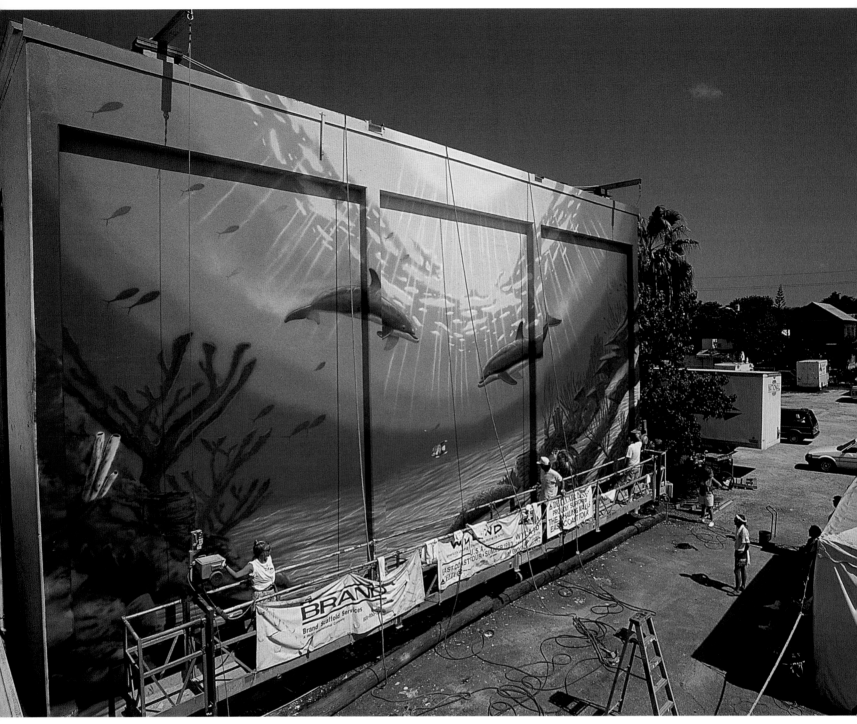

KEY WEST, FL 1993—52 FEET LONG X 45 FEET HIGH

WHALING WALL 52—*"Florida's Living Reef"*

This mural brought to an end the exhilarating but exhausting "17-Walls, 17-Cities, 17-Weeks" East Coast Tour that had begun in Portland, Maine, some four months earlier. Even at the end of this grueling trip, Wyland was excited about the prospect of painting Florida's living reef, the only living coral reef off the coast of the mainland United States.

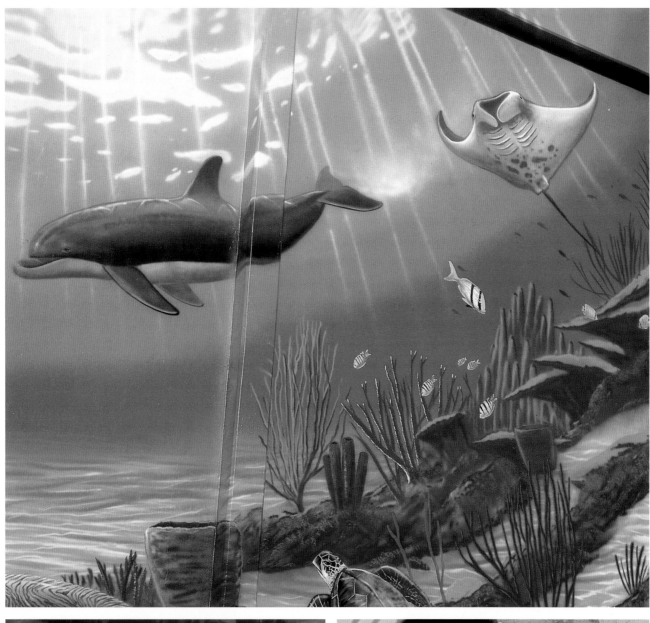

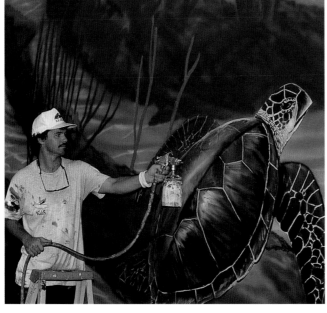

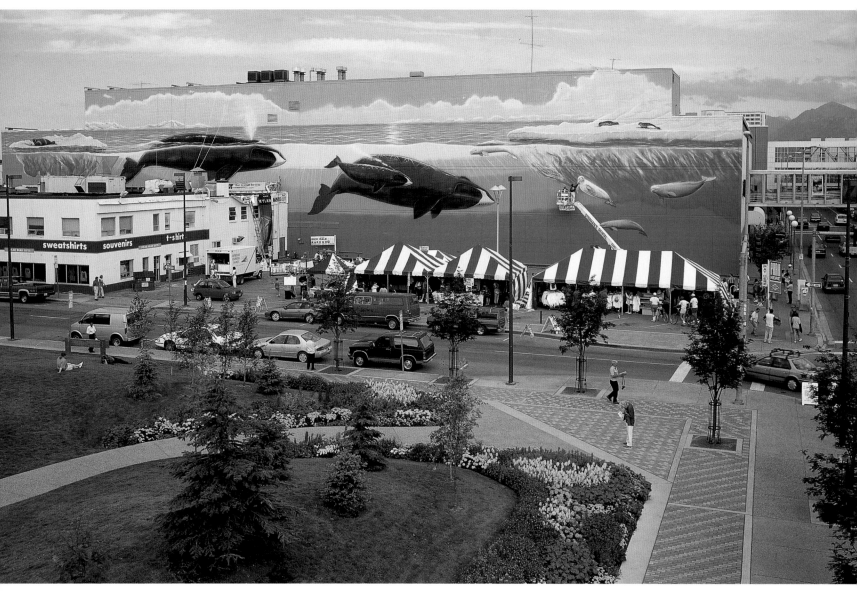

ANCHORAGE, AK 1994—400 FEET LONG X 55 FEET HIGH

WHALING WALL 54—*"Alaska's Marine Life"*

This huge mural in Anchorage kicked off Team Wyland's West Coast tour, which would produce thirteen walls in eight cities in eight weeks. This first-ever firsthand look at the marine life off the Alaska coast gave Wyland a welcome opportunity to work with new subjects—the beautiful bowhead whales and belugas indigenous to the area.

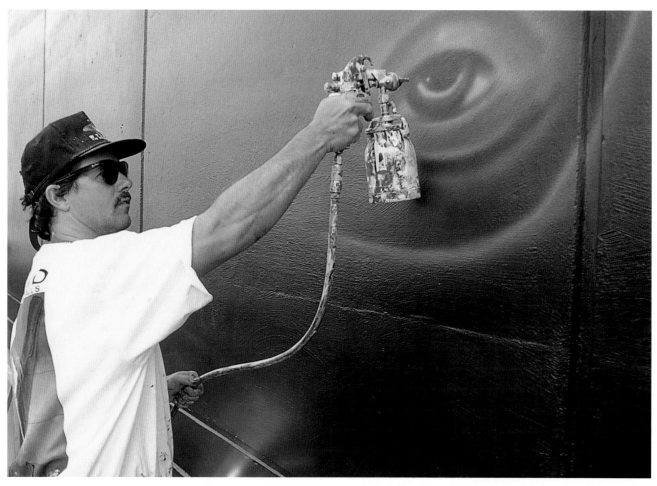

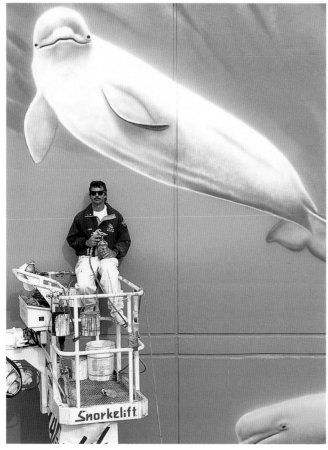

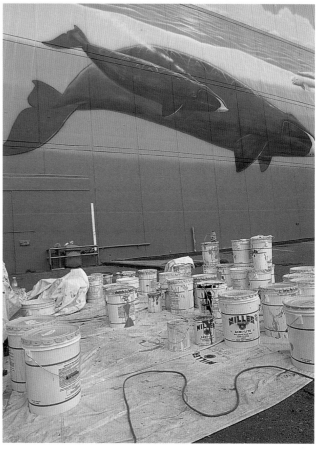

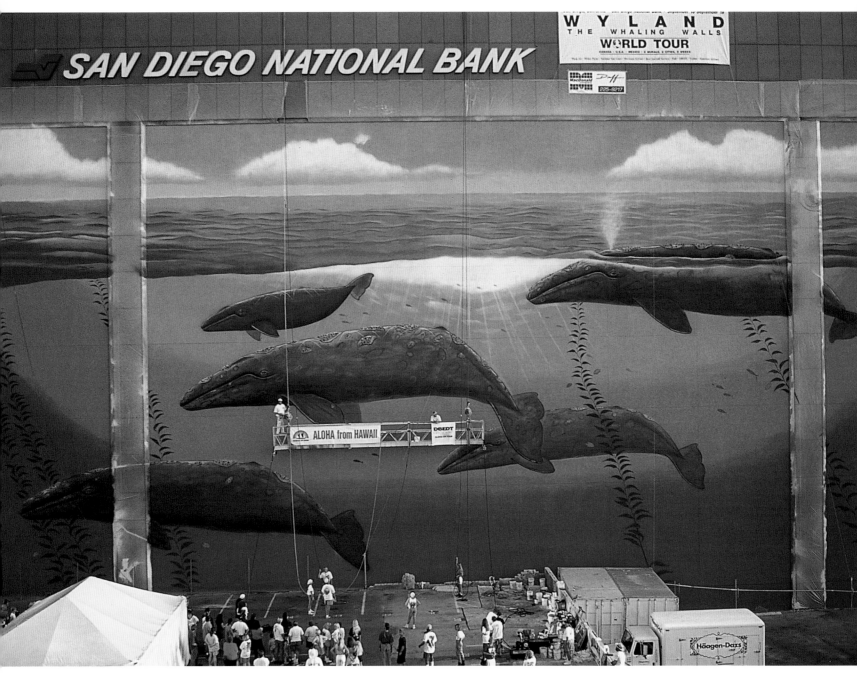

SAN DIEGO, CA 1994—164 FEET LONG X 80 FEET HIGH

WHALING WALL 64—*"San Diego Migration"*

This large mural, painted on the side of the San Diego National Bank building, is one of Wyland's most beautiful and most visible—an arresting sight both from the freeway and from the airplanes flying in and out of San Diego International Airport. By depicting gray whales migrating down the coast of California, Wyland celebrates the removal of this magnificent animal from the endangered species list.

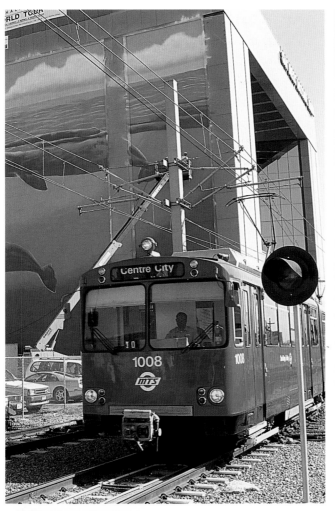

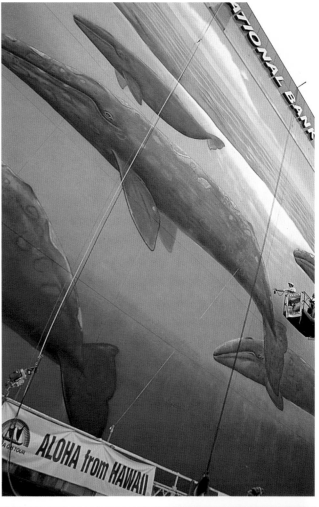

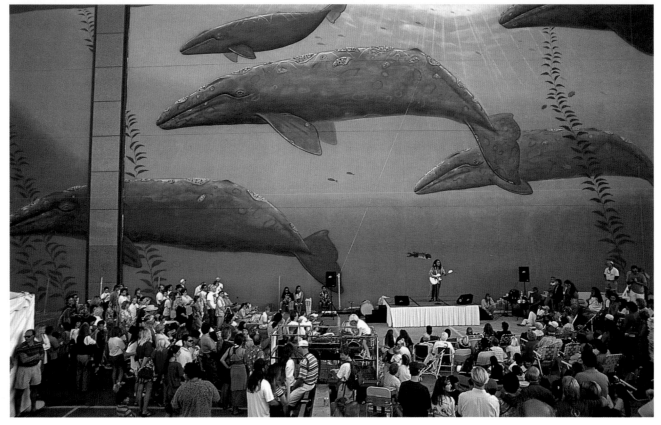

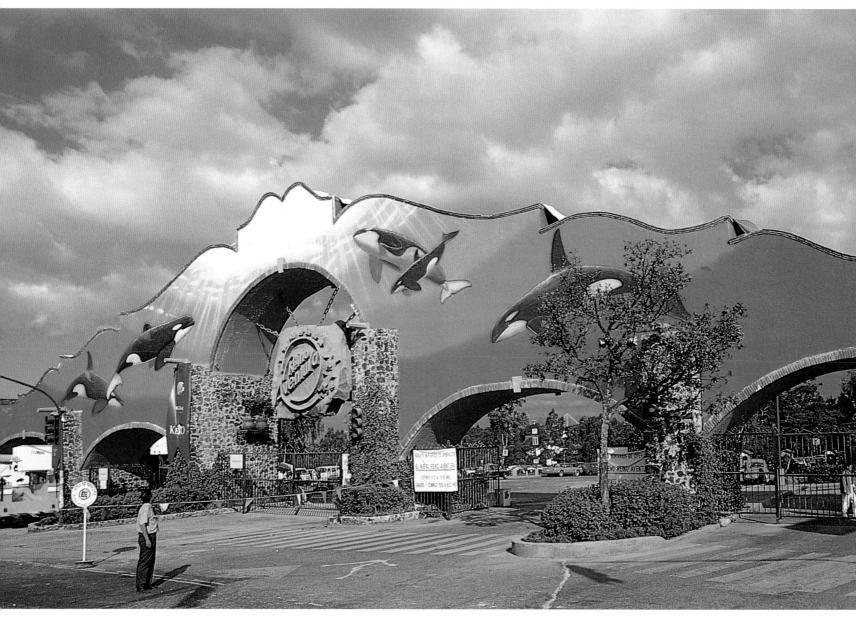

MEXICO CITY, MEXICO 1994—200 FEET LONG X 45 FEET HIGH

WHALING WALL 66—*"Free Keiko"*

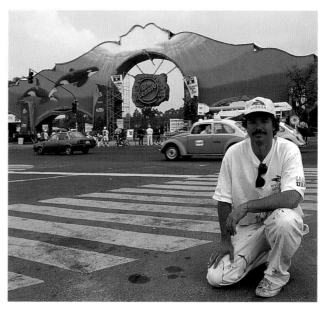

This last stop on the West Coast Tour proved the most special for the artist. The Reino Aventura Park in Mexico City agreed to release Keiko (the orca featured in the motion picture, *Free Willy*) in conjunction with the painting of the historic Whaling Wall at the park's entrance. Keiko would be admitted to a whale rehabilitation facility and, ultimately, would swim free again.

160

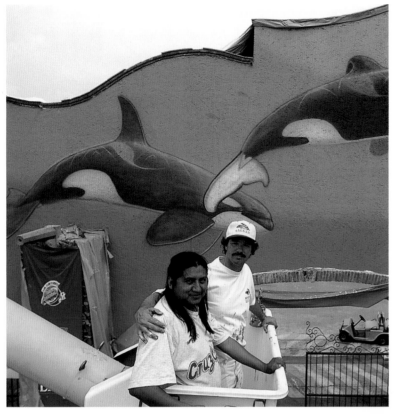

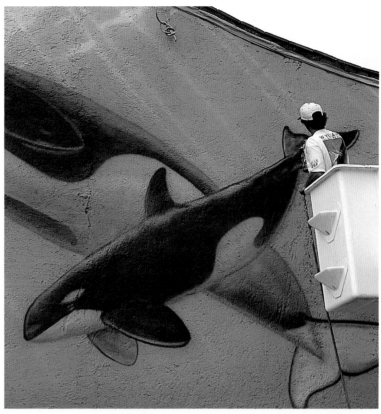

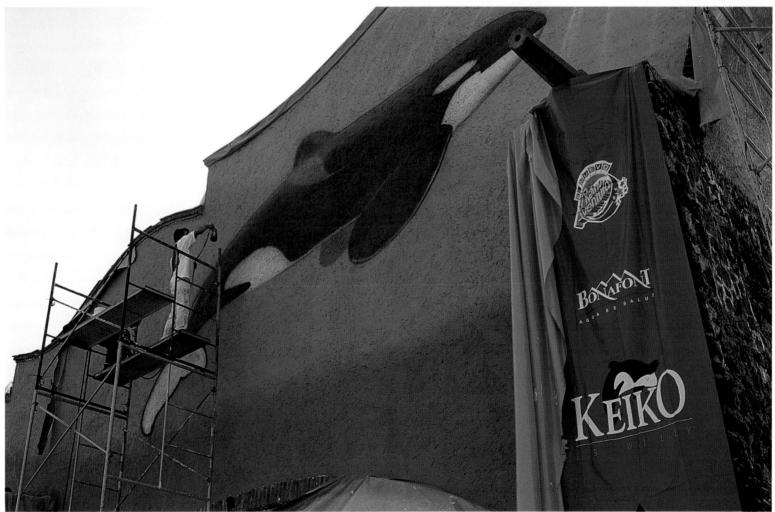

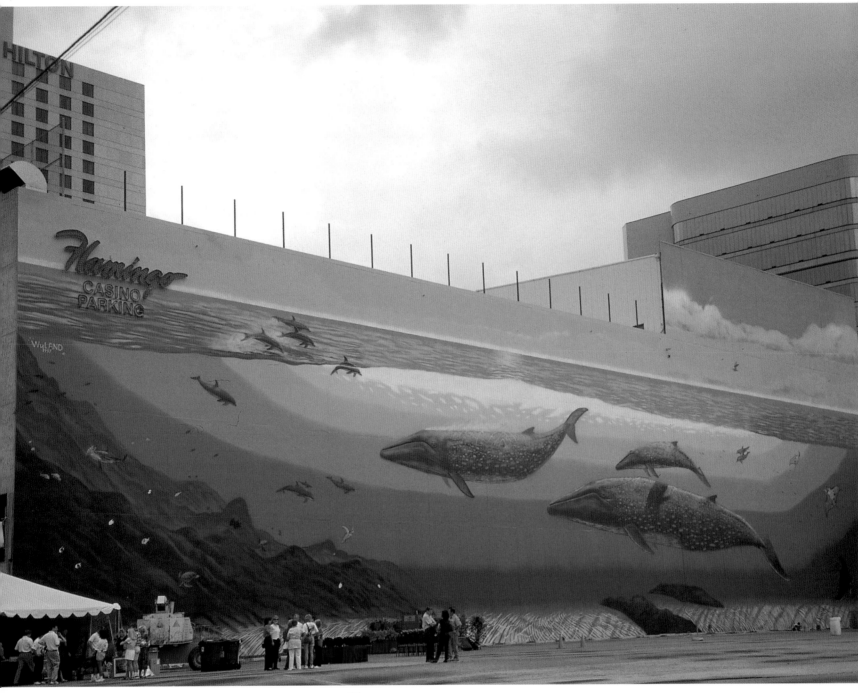

NEW ORLEANS, LA 1997—251 FEET LONG X 66 FEET HIGH

WHALING WALL 69—*"The Blues Whales"*

Created during the annual New Orleans Jazz Festival, this mural was "a gift to the city of New Orleans," according to the artist, "in celebration of the International Year of the Ocean." Wyland intended to share the unique marine life native to the Gulf of Mexico with all the people who live in or come to visit New Orleans. The title, "The Blues Whales," pays homage to blues legend Luther Kent, a participant at the wall's dedication.

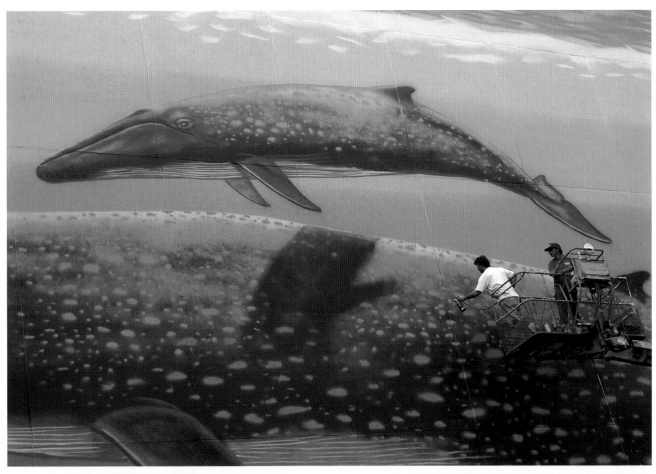

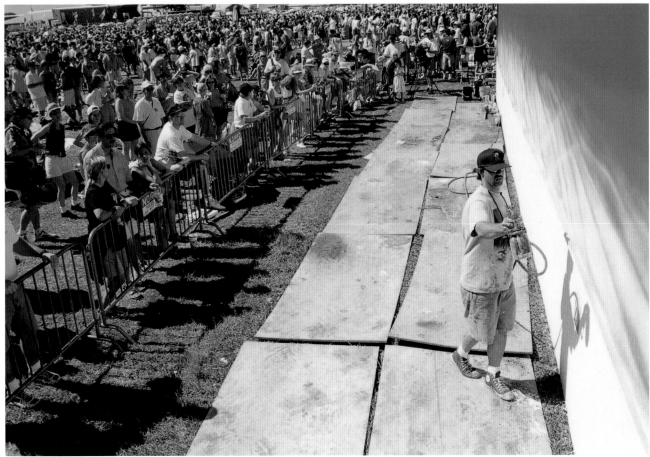

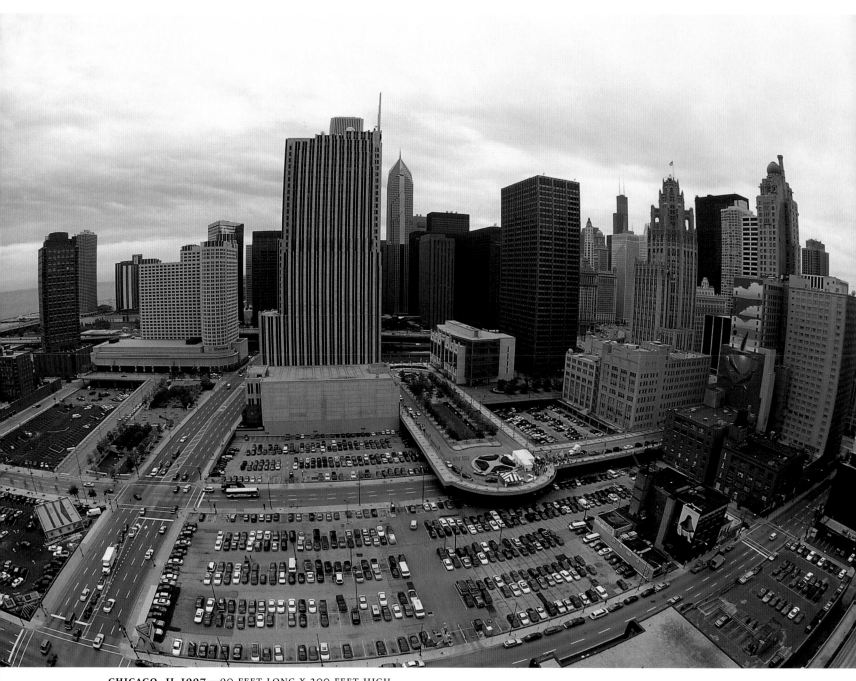

CHICAGO, IL 1997—90 FEET LONG X 200 FEET HIGH

WHALING WALL 73— *"The Windy Whales"*

Chicago was the midpoint of Team Wyland's seven-city Midwest Tour, which began in Toronto and concluded in the artist's hometown of Detroit. In this mural, the east wall of Chicago's Hotel Inter-Continental, clearly visible along Lake Shore Drive, offered the perfect location for Wyland to bring his message inland—and to emphasize the interconnectedness of oceans, lakes, rivers, and streams.

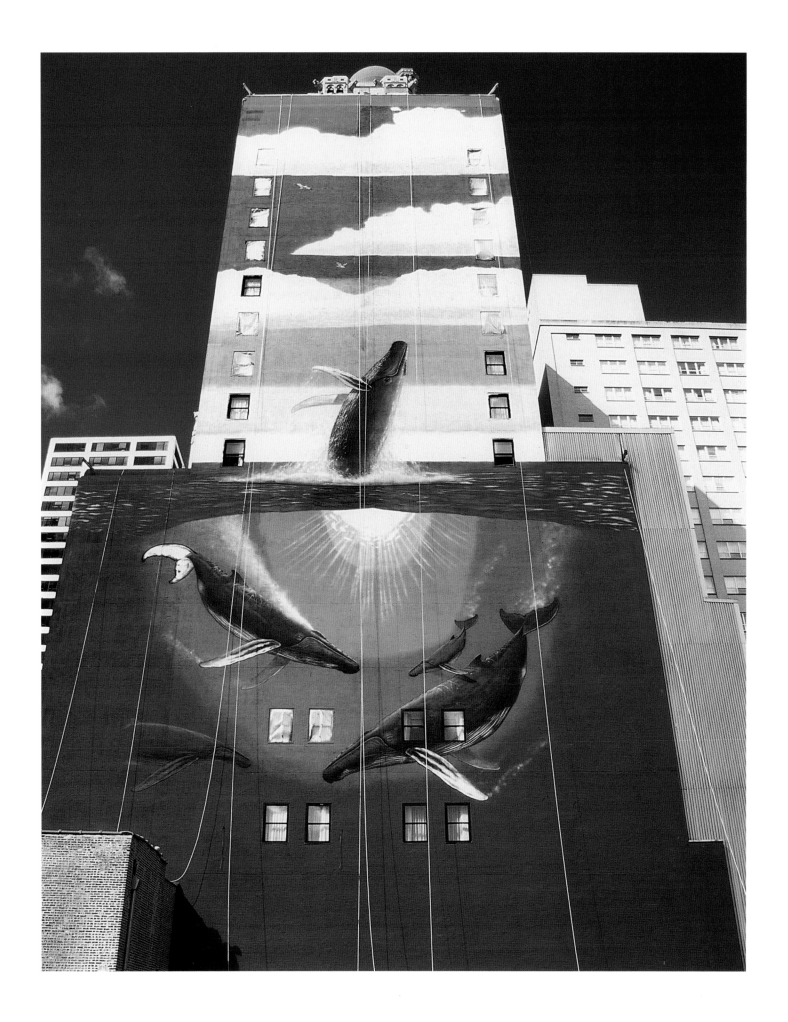

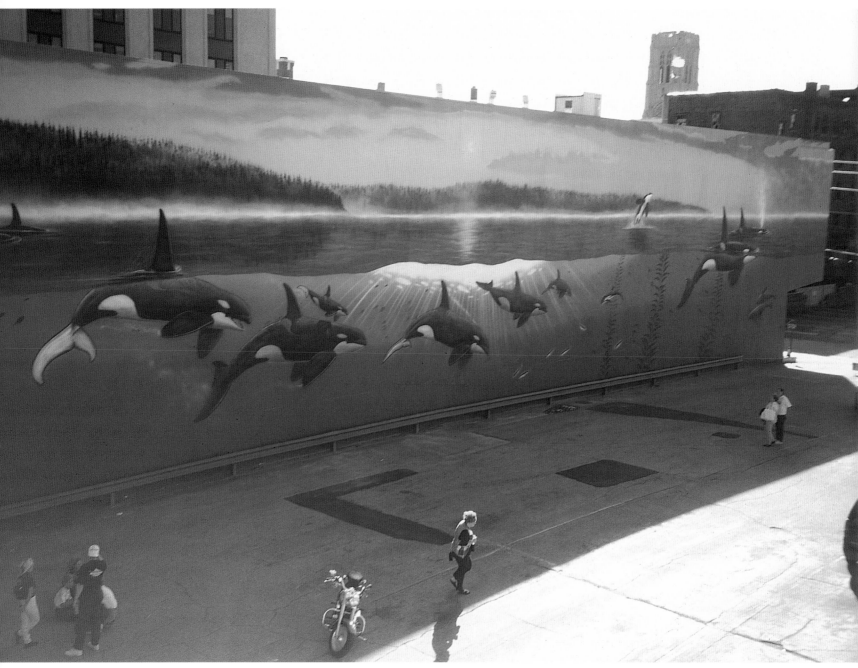

INDIANAPOLIS, IN 1997—153 FEET LONG X 35 FEET HIGH

WHALING WALL 74—*"Orcas' Passage"*

In creating this mural on the Indianapolis Public Schools Building, Wyland got to work in front of his favorite audience: Children. During the course of the project thousands of school children were bused to the location to meet the artist and to study the art of saving whales. The children's enthusiasm was especially gratifying, considering that Wyland's ambitious new project, the Wyland Ocean Challenge of America, will go into every school in the country.

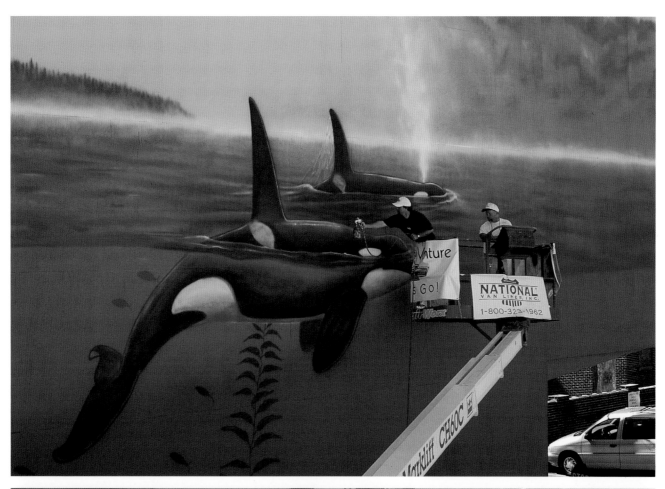

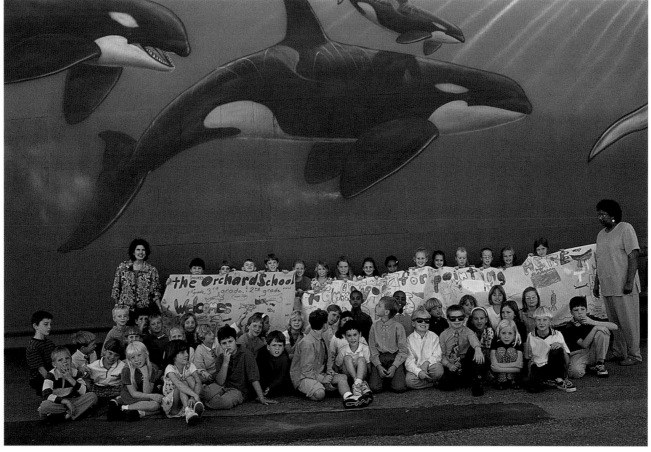

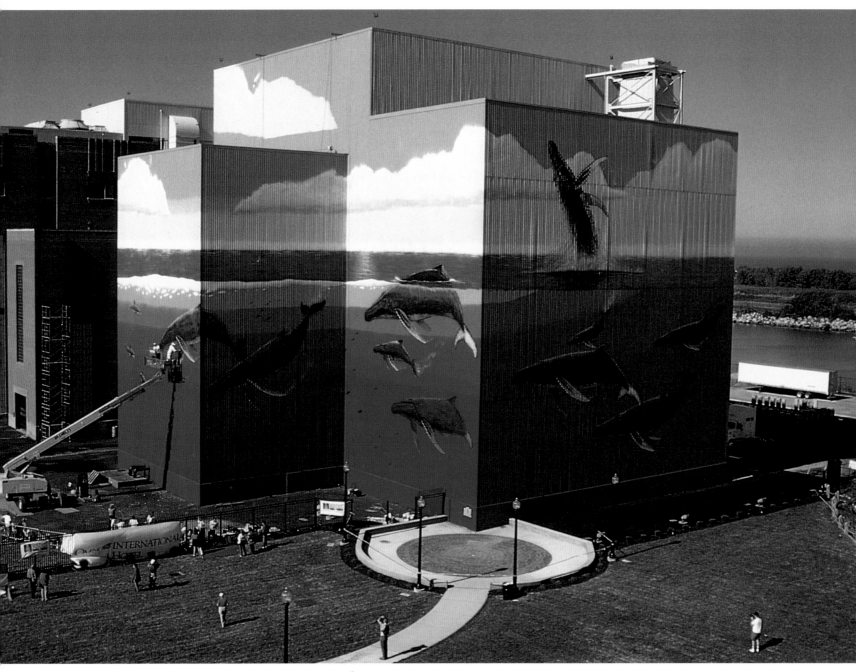

CLEVELAND, OH 1997—300 FEET LONG X 108 FEET HIGH

WHALING WALL 75— *"Song of the Whales"*

The next-to-last stop on the Midwest Tour, Cleveland, offered special logistical challenges. Not only did 30-mile-per-hour winds create havoc for the airless guns, but the wall itself was corrugated, requiring twice as much paint as a normal flat wall would. Nevertheless, Wyland was able to create a landmark mural, topped with beautiful cumulonimbus clouds that literally blend in with Cleveland's own skyline overlooking Lake Erie.

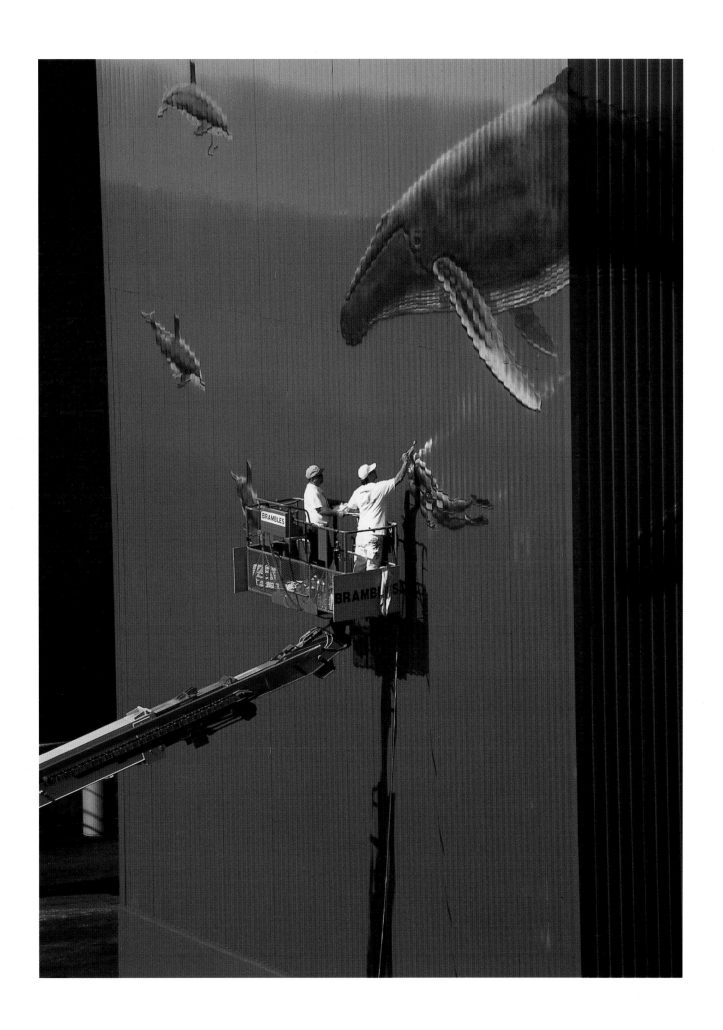

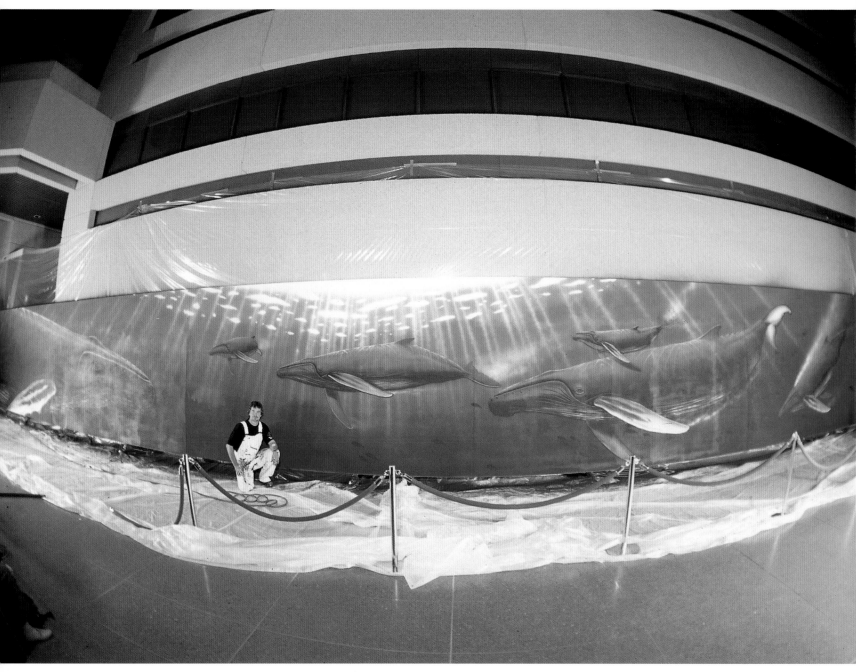

TORONTO, ONTARIO, CANADA 1997—70 FEET LONG X 9 FEET HIGH

WHALING WALL 77—*"Eye of the Whale"*

At the special invitation of the Royal Ontario Museum, Wyland dazzled museum visitors and staff by creating a gigantic whale pod portrait—a 70-foot-long canvas of brilliant blue water alive with humpback whales—all in a 12-hour painting marathon. The throng of schoolchildren in attendance were encouraged to create their own whale art alongside the artist. "If I can reach at least a tenth of the children in the world with my message to protect our precious waters," says Wyland, "well, then, my work here has been worthwhile."

The Whaling Walls

FIRST WHALING WALL—*1981 in Laguna Beach, California*
TOTAL WHALING WALLS TO DATE—*77 Life-size Murals*
CITIES—*66 Cities*
COUNTRIES—*United States, Canada, Japan, Australia, France, and Mexico*
LARGEST—*Whaling Wall 33, "Planet Ocean"; Largest Mural in the World—May 4, 1992,*
Guinness Book of World Records; 1,280 Feet in Circumference and 105 Feet High

TOTAL LENGTH	77 Walls	12,469 Ft.	2.36 Miles
TOTAL HEIGHT	77 Walls	3,927 Ft.	393 Stories
TOTAL SQ. FOOTAGE	77 Walls	720,570 Sq. Ft.	16.5 Acres
TOTAL GAL. OF PAINT	77 Walls		86,513+ Gallons
ESTIMATE OF PEOPLE TO VIEW WHALING WALLS DAILY			7,232,280
ESTIMATE OF PEOPLE TO VIEW WHALING WALLS ANNUALLY			Over 1 Billion

TYPES OF MARINE LIFE PAINTED LIFE-SIZE

Gray Whales	40–52 Ft.	Atlantic Bottlenose Dolphins	10–13 Ft.
Minke Whales	25–35 Ft.	Pacific Bottlenose Dolphins	10–13 Ft.
Fin Whales	65–88 Ft.	Spotted Dolphins	8 Ft.
Blue Whales	75–100 Ft.	Atlantic White-sided Dolphins	6–9 Ft.
Humpback Whales	45–53 Ft.	Common Dolphins	8 Ft.
Right Whales	40–60 Ft.	Harbor Porpoises	5–6 Ft.
Sperm Whales	37–60 Ft.	Vaquita Porpoises	4–5 Ft.
Killer Whales	23–32 Ft.	Whale Sharks	40–50 Ft.
False Killer Whales	16–18 Ft.	Great White Sharks	18–26 Ft.
Long-Fin Pilot Whales	13–20 Ft.	Blue Sharks	5–7 Ft.
Short-Fin Pilot Whales	13–18 Ft.	Octopi	1–6 Ft.
Beluga Whales	14–16 Ft.	Sea Lions	6–7 Ft.
		Harbor Seals	4–5 Ft.

Other marine life included: Green Sea Turtles, Loggerhead Turtles, Hawksbill Turtles, Ridley's Turtles, Manta Rays, Sting Rays, Bat Rays, Marlin, Reef Fish, Bill Fish, Yellow Fin Tuna, Macarole, Geribaldi, etc.

OTHER COUNTRIES AND CONTINENTS PROPOSED:
Russia, Germany, China, Spain, Italy, Ireland, Scotland, Poland, India, Africa, Korea, Switzerland, Egypt, Israel, South America, England and Norway.
CURRENTLY THE LARGEST ART PROJECT IN THE WORLD
TOTAL WHALING WALLS—*100 Worldwide*
TIME—*30-Year Project (1981–2011)*

Color Plates

PAGE NO.	MEDIUM	TITLE	SIZE	YEAR	COLLABORATOR
6	oil	Annual Migration	18" x 59" *(diptych)*	1995	
12	oil	Dolphin Life II	46" x 49"	1997	
18	oil	Ocean Realm (Ancient Travelers)	36" x 48"	1996	
20	oil	Whale Protection	36" x 72"	1996	
21	oil	Whales	36" x 48"	1995	
22	oil	Art of Saving Whales	48" x 60"	1989	
23	oil	Orca Journey	48" *Round*	1990	
24	oil	Two Worlds of Whales	28" x 72" *(triptych)*	1997	
26	oil	Gray Whales	30" x 40"	1983	
27	oil	Sounding	36" x 48"	1984	
28	oil	Maui Moon	36" x 60"	1980	
30	WC	Whale	30" x 40"	1996	
31	WC	Big Breach	30" x 40"	1996	
32	oil	The Great Sperm Whales	36" x 48"	1998	
34	oil	Innocent Age	48" *Round*	1992	
35	oil	First Breath	48" x 72"	1993	
36	oil	Blue Whales Forever	50" x 30"	1998	
38	WC	Water World	30" x 40"	1996	
39	WC	Humpbacks Diving	30" x 40"	1989	
40	oil	Maui Dawn	48" x 72"	1992	
42	oil	Orca Trio	48" x 60"	1984	
43	oil	Orca Realm (Ancient Travelers)	48" x 60"	1995	
44	oil	Whales Forever	30" x 50"	1997	
46	oil	Full Moon Over Diamond Head	36" x 48"	1988	
47	oil	Kauai Moon	36" x 48"	1996	
48	WC	Gray Whale Waters	15" x 23"	1992	
50	oil	Arctic Orcas	24" x 36"	1997	
51	oil	Belugas the White Whales	48" x 60"	1993	Wyland/Coleman
52	WC	Orcas Diving	30" x 40"	1989	
54	oil	Northern Mist	48" x 144" *(triptych)*	1991	
56	oil	Humpback with Dolphins	36" x 48"	1983	
58	oil	Ancient Travelers	18" x 57"	1996	
60	oil	Embraced by the Sea	36" x 48"	1996	
62	oil	Ocean Companions	36" x 48"	1995	
63	oil	Paradise Found	24" x 48"	1996	
64	oil	Dolphin Heaven	36" x 48"	1996	
65	oil	Children of the Sea	30" x 40"	1983	
66	oil	Dolphin Spirit	24" x 30"	1994	
68	oil	Ocean Travelers	36" x 48"	1994	
69	oil	Friends of the Sea	36" x 48"	1994	
70	oil	Sunset Celebration	30" x 40"	1996	
72	oil	Undersea Treasures	24" x 48"	1996	
73	UPP	Love in the Sea	40" x 60"	1997	
74	oil	Dolphin Life	25" x 50"	1996	
76	UPP	Dolphin Vision	40" x 60"	1993	
77	oil	King of the Sea	24" *Round*	1996	
78	oil	Living Reef	48" x 72" *(diptych)*	1991	
80	oil	Kissing Dolphins	36" x 48"	1990	
81	WC	Underwatercolor Dolphins	30" x 40"	1989	

PAGE NO.	MEDIUM	TITLE	SIZE	YEAR	COLLABORATOR
82	oil	Florida's Paradise	24" x 48"	1996	
84	oil	Surfing	48" Round	1992	
85	UPP	Underwater	40" x 60"	1994	
86	oil	Dolphin Tribe	36" x 48"	1996	
87	oil	Hanalei Bay	36" x 48"	1996	
88	oil	Waimea Moon	36" x 48"	1996	
90	oil	Kona Moon	36" x 48"	1998	
91	oil	Mysteries of the Sea	36" x 48"	1998	
92	oil	Surf's Up	36" x 48"	1995	
93	oil	Dolphin Paradise	48" Round	1989	
94	oil	Island Dolphins	36" x 49"	1988	
96	oil	Dolphin Days	48" Round	1990	
97	oil	Dolphin Playground	36" x 48"	1995	
98	oil	Dolphin Serenity	48" Round	1992	
99	oil	Manatees	8' x 12'	1996	
100	oil	Endangered Manatees	48" x 60"	1991	
102	oil	Manatee Visit	36" x 48"	1996	
103	oil	Sea Otters	48" Round	1991	
104	oil	Hanauma Bay	48" x 72"	1993	
105	oil	Shark Life	30" x 40"	1997	
106	WC	Sea Turtle Flight	30" x 40"	1996	
107	oil	Snow Pup	30" Round	1990	
108	WC	Manta Rays	30" x 40"	1996	
109	oil	Great White	36" x 48"	1992	
110	oil	Whale Song	36" x 48" (triptych)	1993	Wyland/Tabora
113	oil	Above and Below	48" x 72"	1991	Wyland/Tabora
114	oil	Moonlit Waters	48" Round	1997	Wyland/DeShazo
115	oil	Two Worlds of Paradise	36" x 48"	1994	Wyland/Walfrido
116	WC	Ocean Babies	30" x 40"	1996	Wyland/Stewart
117	oil	Ariel's Dolphin Ride	36" x 48"	1994	Wyland/Disney
118	oil	Paradise	48" x 60"	1992	Wyland/Coleman
119	oil	Life in the Sea	36" x 48"	1995	Wyland/Walfrido
120	oil	Island Paradise	24" x 48"	1996	Wyland/Hogue
121	oil	Aumakua & the Ancient Voyagers	18" x 25" Oval	1992	Wyland/Pitre
122	WC	I Want To Dive Into Your Ocean	30" x 60" (diptych)	1993	Wyland/Taylor
124	oil	Keiko's Dream	36" x 48"	1996	Wyland/Warren
125	oil	Dolphin Rides	36" x 48"	1992	Wyland/Warren
126	oil	Dolphin Moon	48" Round	1992	Wyland/Tabora
127	oil	Northern Waters	48" x 60"	1992	Wyland/Coleman
128	oil	Enchanted Oceans	24" x 48"	1995	Wyland/Tabora
129	oil	Whale Waters	48" Round	1992	Wyland/Tabora
130	oil	Whale Rides	36" x 48"	1994	Wyland/Warren
131	oil	Littlest Mermaid	36" x 48"	1994	Wyland/Warren
132	oil	Ocean Trilogy	2' 1/2" x 7' 1/2" (triptych)	1991	Wyland/Tabora

WC: *watercolor*
UPP: *underwater photography painting*

Gallery Directory—*Wyland's art is featured at these fine art galleries throughout the U.S.*

CALIFORNIA

Aliso Viejo
Wyland World Headquarters
5 Columbia
Aliso Viejo, CA 92656
1-800-WYLAND-0
949-643-7070
949-643-7099 Fax
www.wyland.com

Laguna Beach
Wyland Galleries
509 S. Coast Highway
Laguna Beach, CA 92651
1-800-WYLAND-1
949-376-8000
949-494-8357 Fax

Wyland Galleries
2171 Laguna Canyon Road
Laguna Beach, CA 92651
1-800-777-0039
949-497-4081
949-376-0737 Fax

Wyland Galleries
218 Forest Avenue
Laguna Beach, CA 92651
1-800-995-6509
949-497-9494
949-497-2298 Fax

San Diego
Wyland Galleries
Seaport Village
855 W. Harbor Drive, Suite A
San Diego, CA 92101
1-800-995-2635
619-544-9995
619-544-0945 Fax

San Francisco
Wyland Galleries
Upstairs Pier 39
Suite M-209
San Francisco, CA 94133
1-800-889-9526
415-398-1922
415-398-4105 Fax

FLORIDA

Celebration
Wyland Galleries of Florida *
671 Front Street, Suite 100
Celebration, FL 34747
407-566-1020
407-566-1249 Fax

Destin
Paradise Galleries *
Harborwalk
51 Highway 98 East
Destin, FL 32541
850-650-1800
850-650-2700 Fax

Islamorada
Wyland Galleries of Key West *
80925 Overseas Highway
Islamorada, FL 33036
1-888-323-9797
305-517-2625
305-517-2825 Fax

Key West
Wyland Galleries of Key West *
719 Duval Street
Key West, FL 33040
1-888-292-4998
305-292-4998
305-292-9164 Fax

Wyland Galleries of Key West *
102 Duval Street
Key West, FL 33040
1-888-294-5240
305-294-5240
305-294-5250 Fax

Lake Buena Vista
Wyland Galleries of Florida *
Disney's Boardwalk
2101 N. Epcot Resorts Blvd.
Lake Buena Vista, FL 32830
407-560-8750
407-560-8752 Fax

Naples
Wyland Galleries of Florida *
Coastland Center
1814 9th Street North
Naples, FL 34102
941-649-3232
941-649-6776 Fax

Orlando
Wyland Galleries of Florida *
The Crossroads
12541 State Rd. #535
Orlando, FL 32836
407-827-1110
407-827-1108 Fax

Sarasota
Wyland Galleries of Key West *
465 John Ringling Blvd.
St. Armands Circle
Sarasota, FL 34236
1-888-588-5331
941-388-5331
941-388-5234 Fax

HAWAII

Oahu
Wyland Galleries Hawaii
66-150 Kamehameha Hwy.
Haleiwa, HI 96712
808-637-7498
808-637-5469 Fax

Wyland Galleries Hawaii
Hyatt Regency Waikiki
2424 Kalakaua Avenue
Honolulu, HI 96815
808-924-3133
808-924-3622 Fax

Wyland Galleries Hawaii
Wyland Kalakaua Center
2155 Kalakaua Avenue #104
Honolulu, HI 96815
808-924-1322
808-924-3518 Fax

Wyland Galleries Hawaii
Aloha Tower Marketplace
101 Ala Moana Blvd. Sp. 191, 7B
Honolulu, HI 96813
808-536-8973
808-536-8981 Fax

Maui
Wyland Galleries Hawaii
136 Dickenson St.
Lahaina, HI 96761
808-661-0590
808-661-4467 Fax

Wyland Galleries Hawaii
711 Front Street
Lahaina, HI 96761
808-667-2285
808-661-4467 Fax

Wyland Galleries Hawaii
697 Front Street
Lahaina, HI 96761
808-661-7099
808-661-4467 Fax

Big Island
Wyland Galleries Hawaii
Waikaloa Beach Resort
Waikaloa, HI 96734
808-886-5258
808-886-5384 Fax

Wyland Galleries Hawaii
Waterfront Row
75-5770 Alii Drive
Kailua-Kona, HI 96740
808-334-0037
808-329-5398 Fax

Wyland Galleries Hawaii
King's Shop Waikaloa
69-250 Waikaloa Beach Drive
Waikaloa, HI 96743
808-886-8882
808-886-7219 Fax

Kauai
Wyland Galleries Hawaii
Kauai Village
4-831 Kuhio Highway
Kapaa, HI 96746
808-822-9855
808-822-4156 Fax

Wyland Galleries Hawaii
Poipu Shopping Village
2360 Kiahuna Plantation Drive
Koloa, HI 96756
808-742-6030
808-742-4739 Fax

ALASKA
Ketchikan
Northern Visions Gallery *
76 Front Street
Ketchikan, AK 99901
907-225-2858
907-247-2856 Fax

ARIZONA
Scottsdale
Desert Oceans *
4223 N. Marshall Way, Suite 2
Scottsdale, AZ 85251
1-888-365-6907
602-423-3535
602-423-3534 Fax

COLORADO
Aspen
Hidden Dreams Fine Art Gallery *
520 East Durant Avenue, Unit 111
Aspen, CO 81611
1-888-925-5091
970-925-5091
970-925-9362 Fax

MICHIGAN
Birmingham
Wyland Galleries of Birmingham *
280 Merrill Street
Birmingham, MI 48009
248-723-9220 or 9221
248-723-9223 Fax

NEVADA
Las Vegas
Wyland Galleries Las Vegas *
Fashion Show Mall
3200 S. Las Vegas, Suite 322
Las Vegas, NV 89109
702-699-9970
702-699-9965 Fax

NEW JERSEY
Avalon
Sea Life Galleries *
Shops by the Sea
2900 Dune Drive, #5
Avalon, NJ 08202
609-368-7300
609-368-6760 Fax
(Closed Winter Seasons)

NEW YORK
South Hampton
Chrysalis Gallery *
92 Main Street
South Hampton, NY 11968
516-287-1887
516-287-1884 Fax

OHIO
Put-In-Bay
Wyland Galleries of Key West *
495 Catawba Avenue
Via: Miller Ferry
Put-In-Bay, OH 43456
1-888-268-4721
419-285-3474
419-285-2118 Fax
(Closed Winter Season)

OREGON
Portland
Wyland Galleries
711 SW 10th Avenue
Portland, OR 97205
1-800-578-7316
503-223-7692
503-226-6148 Fax

SOUTH CAROLINA
Hilton Head Island
Endangered Arts *
841 William Hilton Parkway
South Island Square, Unit B
Hilton Head Island, SC 29928
803-785-5075
803-341-5075 Fax

TEXAS
San Antonio
Wyland Galleries of Texas *
849 E. Commerce St., Suite 303
San Antonio, TX 78205
1-800-WYLAND-6
210-472-1266
210-472-3749 Fax

VIRGINA
Alexandria
Oceans of Wildlife *
201 King Street
Alexandria, VA 22314
703-739-3202
703-739-3204 Fax

WISCONSIN
Madison
Nature's Gallery *
6712 Odana Road
Madison, WI 53719
608-827-5841
608-827-5844 Fax

* *Distributorship*

*For more information
contact:* www.wyland.com

And hasn't the sea been lent

for a brief time to the earth?

Won't we have to give it back

with its tides to the moon?

—*Pablo Neruda,* THE BOOK OF QUESTIONS